EUROPEAN MASTER PAINTINGS FROM SWISS COLLECTIONS

EUROPEAN MASTER PAINTINGS
FROM
SWISS COLLECTIONS
POST-IMPRESSIONISM TO WORLD WAR II

BY JOHN ELDERFIELD

FOREWORD BY WILLIAM RUBIN

THE MUSEUM OF MODERN ART, NEW YORK

Published in conjunction with an exhibition
made possible in part by generous contributions from
The Pro Helvetia Foundation, Zurich, and The Coordinating
Committee for the Presence of Switzerland Abroad

Library of Congress Catalog Card Number 76–24510
ISBN 0–87070–318–8
Designed by Steven Schoenfelder
Type set by The Clarinda Company, Clarinda, Iowa
Printed by Eastern Press, Inc., New Haven, Conn.

The Museum of Modern Art
11 West 53 Street
New York, N.Y. 10019

Printed in the United States of America

CONTENTS

ILLUSTRATIONS

Page numbers with an asterisk indicate
works reproduced in color.

FOREWORD

In relation to its size, Switzerland enjoys the highest concentration of fine modern painting in the world. Indeed, questions of geography and population apart, only the United States boasts more important twentieth-century art. Much of the modern art in Switzerland is, however, in private collections of especially difficult access (the Swiss are the most private of private collectors) or in museums in cities relatively unfrequented by Americans.

Our aim in "European Master Paintings from Swiss Collections" has been to introduce to the public of The Museum of Modern Art some of the comparatively unfamiliar riches of Swiss collections and—above all, quite simply—to provide a feast for the eye. The difficulties of obtaining some of the most important Impressionist and Post-Impressionist works (the Reinhardt Foundation cannot lend by reason of the donor's testament, and the Bührle Foundation recently adopted the same policy for its most important pictures) have led us to focus largely on the twentieth century, beginning with a simple overview of the Post-Impressionists. At the same time, the familiarity of The Museum of Modern Art's public with the best of post–World War II painting, which is largely American, led to our decision not to devote any of our limited space to the last three decades. While some Swiss museums have good collections of Abstract Expressionism and its succeeding movements, the inclusion of works such as the fine paintings by Clyfford Still and Mark Rothko from the Basel Kunstmuseum, for example, would have precluded the possibility of showing four or five easel-size early and less familiar twentieth-century pictures.

We have wanted "European Master Paintings from Swiss Collections" to display considerable variety; however, the choices are by no means intended to constitute a survey of styles or schools of early twentieth-century art. Faced with the dilemma posed by the extraordinary wealth of Swiss museum collections and the evident limitations inherent in making a selection, we have tried to borrow works from each institution that, installed together, would constitute a coherent sampling of a segment of its modern collection for which it is especially noted. Thus the group from Basel is all Cubism and Picasso (marking the first time Basel has ever permitted more than just one or two of its most important Cubist Picassos, Braques, and Légers to be lent simultaneously). The turn-of-the-century group from the Zurich Kunsthaus stresses that museum's special strength (its great late Cézanne, its Munchs, Rousseaus, Vuillard). The paintings from Winterthur (including important works by Monet, van Gogh, and Rousseau) are also mainly from that same period, and the group from the Bern Kunstmuseum stresses its forte—Cubism and its derivations (the Rupf Braques, an unusual Chagall, the artists of the Esprit Nouveau, and Klee).

In our selections, especially those from private collections, we have taken into account not only the quality of the works, but their unfamiliarity. Two-thirds of the privately owned works have never been exhibited in America (though many are known through reproductions), and the percentage is only slightly lower for the museum works. The van Goghs, the Gauguin, and the Cézannes have never been shown in America; five of the seven Picassos are being seen here for the first time, as are two of the four Rousseaus and three of the four Chagalls (which include the original *Praying Jew,* well known in America in later versions). Some of the works from private collections, such as Picasso's *Two Nudes,* have rarely been exhibited anywhere; the extraordinary 1911 Kandinsky, *Composition V*—the largest Kandinsky of this period outside Russia—was purchased by its owner shortly after it was painted, and has left the wall of his home for only a few weeks in the more than half-century it has been in his possession.

The emphasis we have given different artists broadly reflects their prominence in Swiss collections—as does the presence of a number of Swiss painters: Hodler, Vallotton, Amiet, Klee, Augusto and Alberto Giacometti, Taeuber-Arp, and Le Corbusier. Works by these painters constitute one-fifth of the exhibition. The strength of Swiss collections in Cubism and its derivations—especially in the

works of Picasso, Braque, Léger, Chagall, and Klee—is clearly reflected in the emphasis of our choices (as is their relative weakness in the work of Matisse). Indeed, the superb Swiss holdings in early Cubism, led by the magnificent collection of the Basel Kunstmuseum (the best in the world if one allows for the absence of *Les Demoiselles d'Avignon),* make it possible to see in a single visit to The Museum of Modern Art—between its own collection and this temporary exhibition—more great Cubist painting than has ever previously been assembled in one place at one time.

In organizing this exhibition, I have enjoyed extraordinary assistance from the directors of the four major museums involved: Dr. Franz Meyer of the Basel Kunstmuseum, Dr. Hugo Wagner of the Bern Kunstmuseum, Dr. F. A. Baumann of the Zurich Kunsthaus, and Dr. Rudolf Koella of the Winterthur Kunstmuseum. They have not only been generous with loans from their collections, but also arranged for their museums to serve as gathering centers for the works from private collections, aiding in the formalities of packing and shipping.

Support for this exhibition has come from a number of sources. The Pro Helvetia Foundation, Zurich, and The Coordinating Committee for the Presence of Switzerland Abroad have given generously, and the Director of Pro Helvetia, Mr. Luc Boissonas, has from the outset offered valuable advice and encouragement. SWISSAIR has been most cooperative in handling the shipments of the exhibition on a priority basis, and we are grateful for the signal efficiency and care exercised in this regard. The National Foundation on the Arts and the Humanities, Washington, through one of its first applications of the recently passed Art and Artifacts Indemnity Act, provided insurance coverage which would otherwise have been prohibitively costly.

Three friends must be cited in particular for the assistance they have given. Mme Monique Barbier of Geneva has helped me in numerous invaluable ways and has throughout smoothed the sometimes complicated paths through which arrangements for this exhibition had to pass. François Daulte, himself the organizer of early exhibitions of works from Swiss collections held at Lausanne and Paris, has similarly contributed generous and expert assistance. Phyllis Hattis, Visiting Curator at the California Palace of the Legion of Honor, has given me the benefit of her wide knowledge of Swiss collectors and collections.

While I have been selecting and arranging this exhibition, the more difficult task of writing the scholarly notes on the pictures—under pressure of an imminent deadline—has been superbly carried out by John Elderfield, Curator in the Department of Painting and Sculpture. My assistant, Sharon McIntosh, has dispatched many of the technical arrangements for the exhibition with her usual speed and aplomb; Judith Cousins, Researcher in the department, worked under great pressure with her accustomed thoroughness; Teri Varveris, of the Registrar's Department, aided by Eloise Ricciardelli and by Ruth Morton of the Department of Conservation, has ably coped with the shipping arrangements. Monique Beudert, Curatorial Assistant, has attentively coordinated numerous tasks associated with the exhibition, and Eva Bilinski both typed the manuscript and cheerfully dealt with the considerable secretarial work this exhibition involved.

In preparing any exhibition, there are a great many administrative details to be overseen, and Richard Palmer has done this with professional expertise. In our Development department, both John Limpert and James Snyder have worked tirelessly to enlist support for this exhibition.

Francis Kloeppel, with his customary goodwill and perceptiveness, edited the catalog; Steven Schoenfelder designed it; and Jack Doenias supervised its production.

William Rubin, Director
Department of Painting and Sculpture
The Museum of Modern Art

LENDER MUSEUMS

The Basel Kunstmuseum

The collection of the Basel Kunstmuseum has its origins in woodcuts and engravings collected in the city around the end of the fifteenth century by the printer Johannes Amerbach. This collection was inherited by Amerbach's son, who added to it works bequeathed to him by Erasmus of Rotterdam and by the family of Hans Holbein the Younger. In 1661 the Amerbach Kabinett was purchased by the City and the University of Basel, and thus became the first extant art collection in public ownership. Until the nineteenth century its acquisitions largely remained in the field of the Swiss and German Renaissance, based around the important print collection and paintings by Altdorfer, Holbein, Urs Graf, Grünewald, Konrad Witz, and others; but with the establishment of a major Böcklin collection it began to be concerned with contemporary art, and gradually acquired important Impressionist and Post-Impressionist paintings. The present museum building was opened in 1936. At that time, the collection was further expanded to embrace twentieth-century art, which has become its principal area of acquisitions over the past forty years.

The twentieth-century collection owes its unique character to a series of major gifts to the Kunstmuseum. Its core, however, was work by Corinth, Kokoschka, Chagall, Marc, Klee, and others purchased from the Nazi auction of "Entartete Kunst" in 1939. To this was first added the gift of the Emmanuel Hoffmann Foundation in 1940, consisting mainly of Cubist and Constructivist art. The Cubist collection reached its present magnificent status, in certain respects unparalleled, largely through gifts by Raoul La Roche in 1952, 1956, and 1962, which brought to the museum groups of masterpieces by Picasso, Braque, Gris, Léger, and Delaunay. The Kunstmuseum's representation of Constructivist art was enriched by gifts from the Müller-Widmann and Arp-Hagenbach collections,

and the Klee representation by the Doetsch-Benziger bequest. In 1961 a division of modern prints and drawings was established. That year saw the retirement of its director since 1939, Dr. Georg Schmidt, and the appointment of Dr. Franz Meyer, who has further extended the collection.

Already in 1959 the Kunstmuseum had acquired important examples of American painting, by Still, Newman, Rothko, and Kline. In recent years the avant-garde of both America and Europe has found increased representation. The Kunstmuseum also has a major collection of Swiss artists, including an important group of Hodlers, and displays a selection of works on loan from the Alberto Giacometti Foundation (based at the Zurich Kunsthaus) and from certain private sources, most notably perhaps the Rudolf Staechelin collection.

The Bern Kunstmuseum

he Bern Kunstmuseum was first established in 1809 in the form of Hall of Antiquities within the University of Bern, to which works of rt acquired by the State were subsequently added. In 1813 the ernische Künstlergesellschaft (Bern Artists Society) was founded nd, guided by Sigmund Wagner, began to form its permanent ollection. These two collections were then combined, and after ccupying several different premises were permanently housed in 879 in the present museum building, to which a new wing was dded in 1936. The museum's director is Dr. Hugo Wagner.

In 1952 and then in 1962, two major foundations donated their ollections to the Kunstmuseum, thus making it one of the great useums of twentieth-century art. The first was the Paul Klee oundation, containing by far the largest and most important col-ection of Klees in the world. The Klee Foundation, under its curator r. Jürgen Glaesemer, serves both as an exhibition place for the rtist's work and as a research and documentation center. The econd gift was that of the Hermann and Margrit Rupf Foundation. 1r. Rupf was an early collector of Cubist art, with the result that the oundation holds major groups of works by Picasso, Braque, Gris, éger, and Laurens, including seminal works by each of them. The aintings of Derain, Vlaminck, Masson, and Kandinsky are also epresented in considerable depth. Outside these two foundations, e Kunstmuseum also possesses a wide and varied selection of ventieth-century art, including a fine representation of artists of e Esprit Nouveau. The Kunstmuseum arranges a number of mporary exhibitions and thus complements the program of the ern Kunsthalle.

The Bern Kunstmuseum is supported both by the City and State and by two private associations: the Bernische Kunstgesellschaft (Art Society) and Verein der Freunde des Berner Kunstmuseums (Association of Friends). The first of these associations is princi-pally concerned with promoting the work of Bern artists and with educational facilities within the museum; the latter assists the growth of the permanent collection. The Kunstmuseum also houses the Art History Seminar of the University of Bern and maintains a research library in collaboration with the University.

The Winterthur Kunstmuseum

The Kunstmuseum, Winterthur, established in the mid-nineteenth century, began as exclusively a community museum, collecting works by Winterthur artists, but soon after its foundtion expanded to become national and then international in scope. It is now one of the major Swiss museums, with significant holdings in the three areas of its acquisitions program that were laid down when it moved into its current premises in 1916: the art of Winterthur since around 1700, Swiss art since the beginning of the nineteenth century, and European art since Impressionism.

The collection originated from a bequest to the City of Winterthur in 1851 by a local artist, Johann Karl Weidermann, and from the subsequent establishment of the Winterthur Kunstverein (Art Society), which was given administrative control of the City's art collection—both of contemporary and earlier art—and began collecting on its own behalf. From the 1870s the collection began to grow steadily in size and now contains over one thousand paintings and sculptures as well as drawings and prints. The Winterthur Kunstverein remains the controlling body of the Kunstmuseum, which contains the Kunstverein collection, together with works donated by the Winterthur Galerieverein (Gallery Society)—an organization founded in 1913 to purchase works for the Kunstverein—and by private bequest. The museum also holds long-term loans from various sources including the State, the Gottfried-Keller Foundation, the Canton of Zurich, and the Alberto Giacometti Foundation. Now under the direction of Dr. Rudolf Koella, the Kunstmuseum is subsidized by City and State funds. Its collection is complemented in Winterthur by the Jacob Briner collection at the Rathaus and by the collection of the Oskar Reinhart Foundation.

Of the three areas of the Kunstmuseum collection, the representation of Winterthur-born artists includes important holdings in the work of Anton Graff, David Sulzer, Johann Jakob Biedermann, and others. The Swiss collection is notable for major groups of Hodlers and Vallottons as well as for works by Amiet, Giovanni Giacometti, Taeuber-Arp, and Klee. In the field of European painting, the Kunstmuseum collection ranges from Impressionist to recent geometric painting. Of especial interest are major Post-Impressionist works by van Gogh, Monet, Vuillard, and Rousseau, the Cubist paintings of Gris, Léger, and Picasso, and important individual paintings by Arp, Kandinsky, and Mondrian.

The Zurich Kunsthaus

The Kunsthaus, Zurich, has both a major permanent collection and a flourishing program of temporary exhibitions. It is the public museum of the City of Zurich and is supported not only by City and State funds but also by the contributing members of the Zurich Kunstgesellschaft (Art Society), its governing body. This organization, founded in 1896, combines the functions of the Kunstlerhaus Zurich, an exhibition-organizing association formed the previous year, and of the longstanding Zurich Künstlergesellschaft, which had begun forming a collection in 1787. The Kunsthaus moved into its newly enlarged building in 1976, at which time its longstanding director, Dr. René Wehrli, retired and Dr. Felix Baumann became the new director.

The permanent collection comprises paintings and sculptures from antiquity to the present. The collection of Old Master paintings includes important fifteenth- and sixteenth-century works, the Ruzicka bequest of Dutch and Flemish art from the fifteenth to seventeenth centuries, and a significant representation of graphic art, especially that of Dürer, Goya, and Daumier. The dominant part of the collection, however, is the art of the nineteenth and twentieth centuries. Here the museum has benefited from donations and long-term loans from the Zurich Kunstfreunde association, founded in 1917 specifically to enlarge the museum's collection, and from various private legacies, including the Schuler bequest of 1920 and the Meisler bequest of 1970, which expanded the richest area of the collection, art of the late nineteenth and early twentieth century. In this area, the museum holds major Post-Impressionist, Cubist, and Expressionist paintings, with an especially fine representation of Bonnard, Vuillard, Monet, Cézanne, Rousseau, and Munch. In 1972 the museum installed a Miró ceramic mural it had commissioned, and in 1973 established a Chagall room containing fourteen of this artist's works. Naturally, Swiss art is well represented in the collection, with comprehensive holdings of Füsslis and Hodlers and of twentieth-century Swiss artists including the Zurich Concretists Bill, Lohse, and others. The sculpture collection too is rich in twentieth-century works, and is augmented by loans from the Alberto Giacometti Foundation, which is based at the Zurich Kunsthaus, with selected works also exhibited at the Basel and Winterthur Kunstmuseums.

The Zurich Kunsthaus has long been important for its temporary exhibitions. Among the early retrospectives it organized was a major Hodler exhibition in 1917, as well as the first museum retrospective of Picasso's work, in 1932. In recent years the exhibitions have ranged from Japanese art treasures to a Kienholz retrospective, and from a presentation of large-scale sculptures to the first comprehensive exhibition of photography in Switzerland. Some eight major exhibitions per year are organized, of which two are thematic in form. There is also a program for showing the work of Zurich and Swiss artists, exhibitions from the permanent collection, and graphic work, and in 1976 a photography gallery was established to present approximately six exhibitions a year.

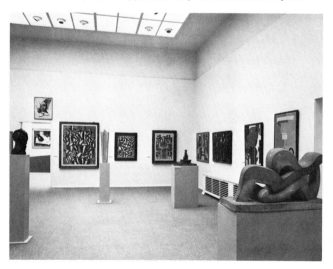

EUROPEAN MASTER PAINTINGS FROM SWISS COLLECTIONS

PAUL GAUGUIN
Nafea Faa ipoipo (When Will You Marry?). 1892
Oil on canvas, 40 × 30½" (101.5 × 77.5 cm)
Collection Rudolf Staechelin, Basel

Gauguin's decorative curvilinear style, using flat areas of rich and harmonious colors kept assertively to the surface of the painting and surrounded by a fluid but somewhat languorous calligraphy, marks probably the most personal and certainly the most sensuous of his works. This painting of Gauguin's *vahine,* Tehura, with another Tahitian girl in a landscape that mirrors the organic decorations of Tehura's dress, well reveals how the sensuousness of Gauguin's Tahitian paintings was expressed not only, or essentially, through their exotic subjects, but pictorially, through line and color, which created their own rhythms, accents, and feelings in his art.

"Art is an abstraction," Gauguin insisted; "derive this abstraction from nature while dreaming before it."[1] If dreaming began the process, it was nevertheless a fairly deliberated one. In his Tahitian period, Gauguin established a repertory of standardized poses which he used from painting to painting with slight variations. Here, for example, the image of Tehura is one which appears in four other contemporaneous works.[2] It derives from an only slightly shaded line drawing, one of the too few such studies to survive from this period, and now at the Art Institute of Chicago.[3] In the drawing, the figure is simplified into somewhat heavy but rhythmic outlines, with rather large hands and feet, and squared-up ready for transferring to the painting. In the painting, it becomes more elegant because the lines hardly exist except as the boundaries of areas of color. The relatively unshaded character of the drawing is preserved. The brightly colored costume is only lightly modeled, and is treated as softly painted juxtaposed zones of flat color. Because of the dark skin of his subjects, Gauguin was able to use just one narrow range of browns for the areas of exposed flesh, without needing to introduce additional colors to suggest volume convincingly, as he would have had to do with Caucasian subjects. This meant that those areas could also read as areas of color among the other ones; and where Gauguin was forced to introduce strong shading, he took advantage of the tonal contrasts this produced to make firm curvilinear contours between the lighter and darker areas in question. The areas of flesh do, of course, still present themselves as the most volumetric elements in the painting, but since they also function as colored shapes they tie themselves to the rest of the work.

Since the painting as a whole is so resolutely flat—indeed seeming in places to be stained into the coarse canvas—the volume of the exposed bodies appears to project in slight bas-relief effect. Their psychological importance is thus accentuated. What is more, their color engenders the chromatic balance of the work. The deep reds, oranges, and ochers on one side of the spectrum and greens, blues, and purples on the other are all tonally leveled to the warm brown—as well, of course, as being the constituent hues of the brown itself. In Tahiti, Gauguin tended to put aside the sharp contrast of vivid hues that often appeared in his Pont-Aven paintings for a harmony of adjacent colors. This does much to produce the restful and somehow meditative feeling the decorative landscape possesses.

As essential as the color, however, are the liquid contours that interweave throughout the work. The figures are foreshortened because seen from above and are presented as if close to the eye of the observer. Both attributes help to transform the figures into flat decorative patterns. Gauguin worked in the characteristic Symbolist method of formal analogy, using a vocabulary of similar lines and shapes to affirm the inherent compatability and common harmony of all that is represented. The pervasive sinuous lines reinforce the luxuriant, idealized mood of the painting.

If it is through the abstraction of line and color that feeling is expressed, then the dreaming before nature that produced the abstraction is communicated too. Gauguin's Tahiti is not a harshly primitive or a merely "foreign" one. The effect of a dream is important to his paintings—that sense of reality made up from the components of the external world but sealed off from that world. Gauguin's stay in Tahiti was itself an attempt to live in such a hermetic state, and his paintings there an attempt to paint a world of the imagination. It was an imagination, however, fostered in Symbolist Europe, and the melancholy, languid mood was one that Gauguin brought with him to the South Seas.

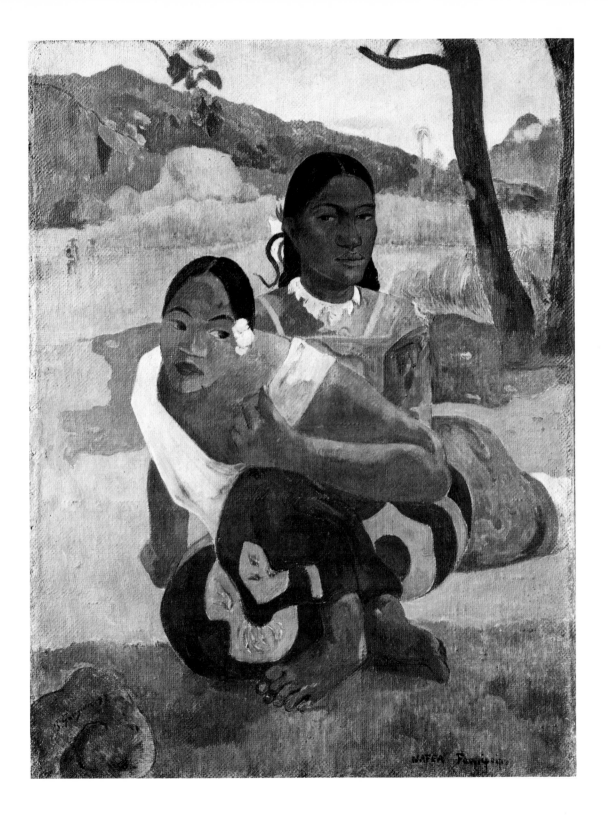

CLAUDE MONET
White and Yellow Water Lilies. ca. 1916–22
Oil on canvas, 78³/₄ × 78³/₄″ (200 × 200 cm)
Kunstmuseum, Winterthur

In 1890, Monet acquired an area of flood land adjacent to his home at Giverny. He subsequently developed it into a large curvilinear pond, crossed by a Japanese footbridge, surrounded by willows and rose arbors, and with water lilies floating on its surface.[1] By the late nineties this enclosed water garden was the principal subject of his paintings. Within the next few years he began to exclude from his paintings anything but the water itself, and the groups of lily pads which gardeners were kept busy pruning into circular units. In 1908 he started to think of combining groups of the water landscapes, initially for an exhibition of individual easel paintings to be called "The Water Lilies: A Waterscape Series,"[2] but then in large murallike compositions that would provide "the illusion of an endless whole, of water without horizon or bank," and offer "the refuge of a peaceful meditation in the center of a flowering aquarium."[3] Not until 1916—when Monet was seventy-six years old, with cataracts developing over his eyes—was the project actually begun. The initial conception was for a large ovoid salon with murals around its walls. This was eventually realized in the decorations placed in the Orangerie of the Tuileries in Paris. But the water garden soon became the subject of nearly everything that Monet painted.

Throughout his painting career, Monet offered quasi-scientific explanations for his preoccupation with the moods of nature, declaring that he sought to represent climatic or atmospheric conditions with a maximum of precision. It is clear, nonetheless, that he was emotionally involved with his subjects, and—more than this—that the kinds of natural subjects to which he was increasingly drawn were in a sense metaphors for the formal preoccupations of his art. That is to say, he sought to bring his subject matter into direct affiliation with the forms of his art. By painting flat surfaces of water—surfaces which contained within themselves a whole world of reflections and illusions—he could reinforce the balance of surface and illusion which was the principal formal concern of his art, and emphasize the symbolism of his painting as poetic and mysterious reflections of the external world.[4]

As substances which contained illusions other than they literally possessed, the surfaces of water analogized the surfaces of painting. In balancing the matter of the painting surface and the illusions in depth that surface denoted, Monet discovered that the more exaggerated and autonomous the components of surface became, the more fragile the balance became, the more vulnerable to almost any kind of specific disturbance or disruption, be it of hue or of value contrast. He had always sought a feeling of harmony for his art, but previously had risked disruptions to set off that harmony and heighten its effect. But as the surfaces of his painting became more and more painterly, he renounced specific contour and sudden shifts of tonal value for an open, expansive, and all-over manner of painting that was rigorously flat—with a flatness unviolated by illusions yet managing to contain them. To paint water was as if to paint pure illusions. To be accurate to such illusions was to detach the color of objects from their individual loci—and their weightedness—and to render it as disembodied optical phenomenon, inherent instead in the substance of water and therefore of paint itself. To paint in this way was to paint something very nearly approaching pure color: here, opulent greens, purples, blues, and yellows, all somewhat whitened to hold them to the same plane, and rendered in broad, open brushstrokes that give light and air to the painting. The surface of the painting becomes a skin of colored light stripped from the material world. Monet painted as if the objects of nature did not exist, but merely their effects. In his last paintings, this gives to his art a miragelike quality, and ultimately a metaphysical one.

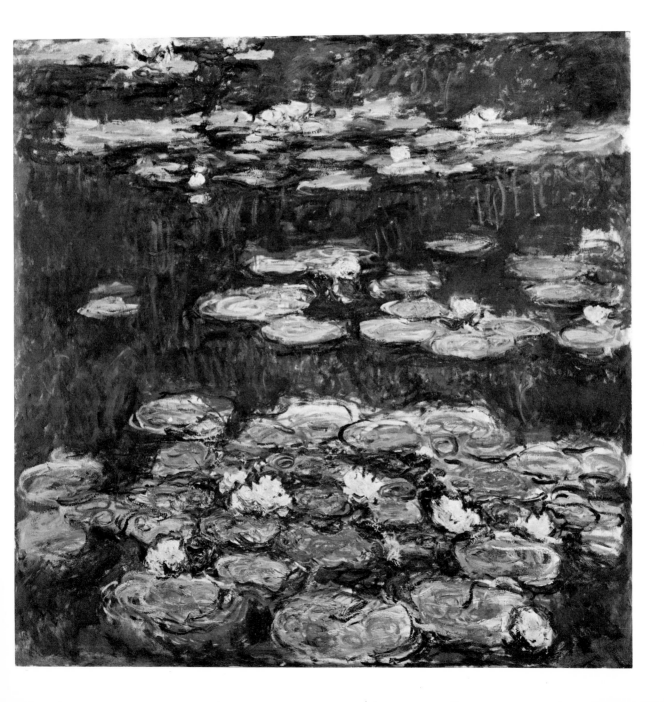

EDGAR DEGAS
After the Bath, Woman Drying Herself. 1896
Oil on canvas, 35 × 45⅝″ (89 × 116 cm)
Private collection

At the eighth and last Impressionist exhibition of 1886, Degas showed, to alarmed reactions, what he described as a "series of nudes of women bathing, washing, drying, rubbing down, combing their hair or having it combed."[1] These subjects were not in themselves provocative, though the deliberately unsentimental way in which Degas listed them prepares us for their total lack of idealization, which was what caused the alarm. The nudes were thought by some to be obscene and by others to be cruel in the dispassionate naturalism of their treatment. They were candidly and naturally presented in unaffected situations, surrounded by the tubs and basins with which they performed their ablutions and which Degas had installed in his studio for that purpose. "Hitherto the nude has always been represented in poses that presuppose an audience," he explained. Now they were to appear "as if you looked through a keyhole" at them.[2]

If, however, this was dispassionate naturalism at one level, it was nearly Expressionism at another. When Huysmans talks of seeing "attentive cruelty and patient hatred"[3] in Degas's methods, we may think he exaggerates, but when Degas confesses that he sought to show his models "deprived of their airs and affectations, reduced to the level of animals cleaning themselves,"[4] we are likely to understand the painter's reputation for misogyny—which was largely founded on these works and the ones like them which followed (for he was henceforth preoccupied with such subjects). However, when we do recognize that the candidness of paintings like this *Woman Drying Herself* is more than a neutrally "realistic" one, it is not cruelty or misogyny we see there. Degas compared his models to animals because he was seeking natural and habitual poses; yet, as his comparison reveals, what he found was that the natural state is a primitive one and that habitual gestures when seen for what they are have a look of ritual about them. Recording the familiar movements of women washing, drying, and taking care of their bodies, Degas created a pictorial vocabulary of ritualized and therefore impersonal forms.

It is often noted that by expressing what the body in motion looks like when that movement is arrested, Degas created an awareness of what the preceding and following movements are. This is true to a certain extent. At the same time, however, he enforces our indifference to movements other than the suspended one presented to us. If we are indeed made aware that this is, as it were, one frame of a sequence that could start up again, the very fact that such an expectation is disappointed as quickly as it is felt only serves to reinforce the instantaneity of what is before us, and to bring to our attention the physical suspension of the pose that the temporal one allows. Suspending a single moment of time revealed curious twisting forms, angular poses, and a pictorial drama of a new and audacious kind. Degas was inspired by "animal" and automatic movements because he sought in his models not psychological or sentimental expression, but pictorial drama. In the ritual movements of women washing and drying themselves he saw a play of sculptural masses, which in this instance are presented with almost Baroque splendor.

This is one of three paintings (for which there were at least two preparatory drawings) using the same pose.[5] All are fairly mat in appearance, though the reddish-brown monochrome of this one renders it unique. (The others are blue and pale rose in tonality.) It has been suggested that the coloration reflects Degas's preoccupation with the techniques of Venetian painting and that it has the appearance of an unfinished ground.[6] Because Degas was given to considerable technical experimentation in his last years and because he never exhibited his late work, it is impossible to know with certainty what his standards of "finish" were. However, the vivid, open expanse of color in this painting is entirely resolved within its own terms, and recalls, in fact, one of Degas's definitions of painting: "The art of setting off a touch of Venetian red in such a way that it seems to be vermilion."[7]

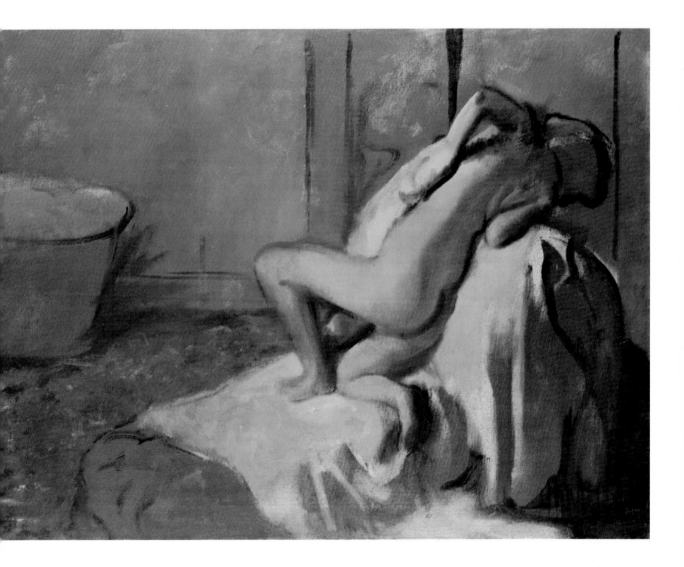

VINCENT VAN GOGH
Head of the Postman Joseph Roulin. 1888
Oil on canvas, 25½ × 21¼" (65 × 54 cm)
Kunstmuseum, Winterthur

"I am now engaged on a portrait of a postman in his dark blue with yellow uniform," van Gogh wrote on August 1, 1888. "A head somewhat like Socrates, hardly any nose at all, a high forehead, bald crown, little gray eyes, bright red chubby cheeks, a big salt-and-pepper beard, large ears. This man is an ardent republican and socialist, reasons quite well, and knows a lot of things."[1] Joseph Roulin, a huge man some six and a half feet tall, lived in Arles, in the rue de la Cavalerie, where van Gogh stayed upon arriving in the town from Paris in February 1888. Van Gogh came to know Roulin very well. He was not a letter carrier but loaded and unloaded mail at the railroad station, which was close to the yellow house where van Gogh settled in Arles.[2] Van Gogh made much of his being "a Socratic type"—and "none the less Socratic," he added, "for being somewhat addicted to liquor and having a high color as a result."[3] In all, van Gogh made one half-length and five head-and-shoulder portraits and three portrait drawings of Roulin, plus paintings of his family.[4]

This work is markedly different in style from the other four head-and-shoulder portraits, which are all highly decorative in conception, three of them being set against ornamental floral backgrounds. Those paintings show a flat, frontal, and somewhat square face dominated by a luxuriant curvilinear beard created from the linear patterns of van Gogh's brushstrokes. This portrait, in contrast, is far more structural, even sculptural, in appearance. The head is lifted and turned slightly to one side to make it seem solid and monumental, while the cap is tilted back to show more of Roulin's face. The subject is treated not in the flat patterns of the other portraits, but in terms of separate, somewhat angular planes; and the beard is a solid tactile mass, not an Art Nouveau-like decoration. "I should like to paint men and women," van Gogh wrote from Arles, "with that certain something of the eternal which the halo used to symbolize and which we seek to achieve by the actual radiance and vibration of our colorings."[5] The other Roulin portraits have an iconlike quality in their quasi-primitive flatness. This portrait is "eternal" in the sober dignity of the pose and in the solidity of its treatment; yet it is painted without a trace of idealization. It looks back to van Gogh's earliest portraits of common people, reminding us of the deep humanitarianism that underlies the purely pictorial brilliance of his art.

At Arles, van Gogh's art achieved new maturity, with heightened, more arbitrary and expressive color, simplified forms and spontaneous drawing. He no longer felt the need, he said, for preparatory drawings, but would draw directly in color.[6] The immediacy of this painting, with its bold, summary draftsmanship, well expresses the new confidence of this period. Within a few months of this painting, however, van Gogh had suffered his first serious mental seizure, had mutilated his ear, and his work in Arles was abruptly ended. It was Roulin, by now his devoted friend, who visited him daily in the hospital and took him home afterward before he was committed to the asylum at Saint-Rémy.

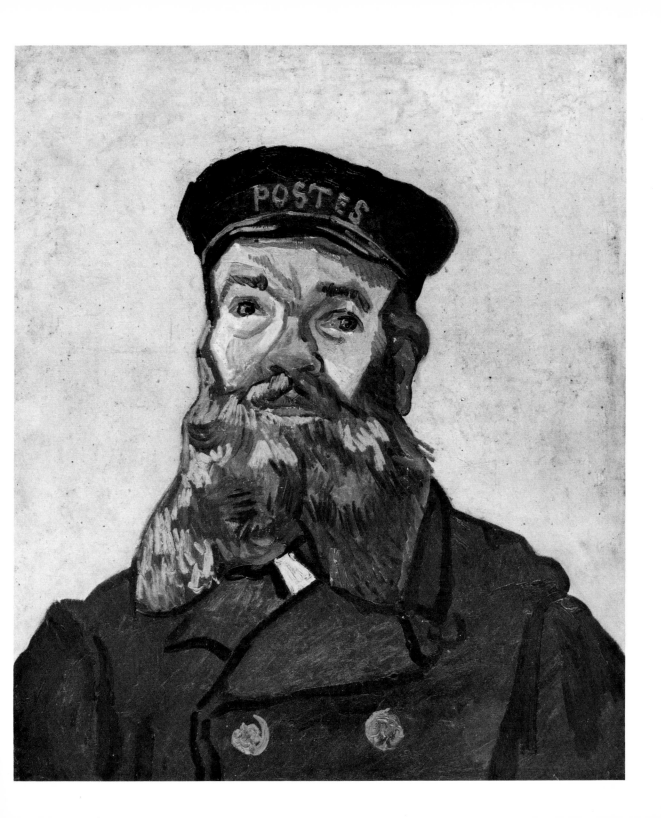

VINCENT VAN GOGH
Portrait of Trabu, an Attendant at St. Paul's Hospital, Saint-Rémy. 1889
Oil on canvas, 24 × 18¼″ (61 × 46 cm)
Private collection

In May 1889, van Gogh entered St. Paul's Hospital at Saint-Rémy, an asylum for the insane. This painting, made early in September of the same year,[1] is of Trabu, the chief attendant of the asylum. After the fit of madness at Arles during which he had mutilated his ear, van Gogh had seemed to recover fairly completely. By the end of February 1889, however, he was back in the hospital at Arles, having suffered a further attack, and it was while recovering this second time that he agreed to be committed to the asylum at Saint-Rémy. It was, his brother Theo claimed in a letter to the director of the asylum, merely "to prevent the recurrence of previous attacks and not because his mental condition is unsound."[2] In fact, van Gogh continued to suffer from mental seizures; when he was afflicted by them he was both helpless and dangerous, and of course unable to work. He was certainly unfitted to live alone, and although the care at Saint-Rémy was more custodial than clinical, van Gogh came to accept his bouts of insanity as part of "an illness like any other."[3] When he was not incapacitated he was perfectly normal, and began to paint again.

On September 4 or 5, 1889, he wrote: "Yesterday I began the portrait of the head attendant, and perhaps I shall do his wife too, for he is married and lives in a little house a few steps away from the establishment. A very interesting face, there is a fine etching by Legros, representing an old Spanish grandee, if you remember it that will give you an idea of the type. . ."[4] The type, as can be seen from the painting, was a somewhat taciturn one, with a touch of severity, or possibly just reserve, about his features. But at Saint Rémy, van Gogh had taken to using subdued, restrained colors which doubtless contribute to the gravity of this work.

Within its limited, almost monochromatic color range, however this is among van Gogh's most subtly orchestrated paintings combining tonally similar versions of gold, green, ocher, orange and gray within a framework of expressive drawing executed both in black paint and in the other colors themselves. The drawing is as spontaneous as ever. The open background is energized with broad brushstrokes in bending vertical configurations that lock around the form of the head, fixing image and ground into one plane. The swirling black-on-white stripes of Trabu's jacket are mirrored in the gnarled drawing of the chin and neck and in the curving strokes of paint that describe the high forehead. Set off by the orange-flecked cheeks, the averted dark eyes form the focus of the composition. The golden radiance of the painting, as well as the "grandee"-like presence of the sitter, gives to this work a monumentality and dignity which, matched by the psychological penetration, make this one of van Gogh's very finest portraits.

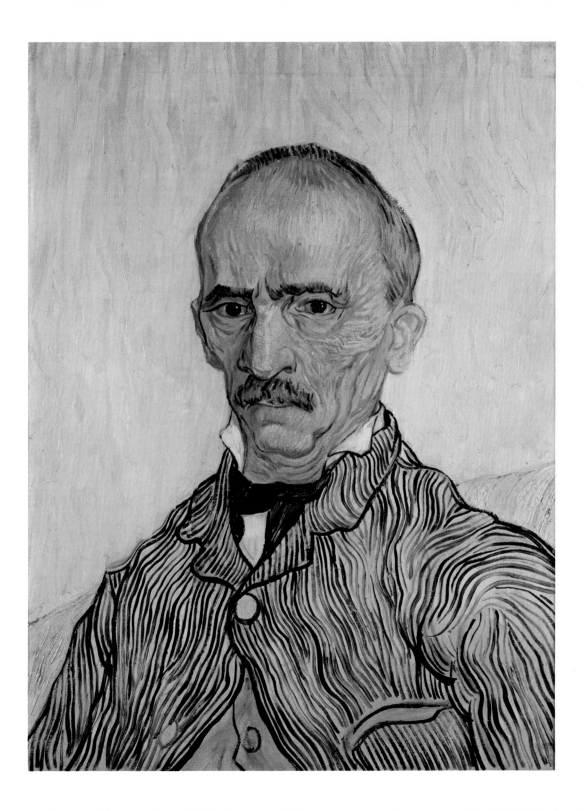

PAUL CÉZANNE
Still Life with Pot and Fruit. 1890–94
Oil on canvas, 25³/₄ × 32″ (65.5 × 81.5 cm)
Private collection

Of all the subjects of painting, still life is the one that most readily evokes common tactile associations, presenting as it does everyday objects we handle, use, and know through touch.[1] For Cézanne, it was a subject to be presented in purely visual terms. This is not merely to say what is true of all painted representations of solid forms—that they are illusions—but that the illusion of tactility in Cézanne's work (seemingly so evident at first sight) is a curiously elusive part of his painting.

The solidity of objects is not seen but inferred from their visible surfaces. Since an object viewed from a single vantage point presents only a segment of its surface to the observer, traditional chiaroscuro modeling became a way of suggesting in painting the continuity of surface right around the object in question. By being invited to imagine unseen surfaces, the observer was able to reconstruct, as it were, the experience of form as it exists in three-dimensional space. In Cézanne's work, however, such an imaginative reconstruction is not invited, at least not in the same way. Cézanne's illusions do not exist in a space mimicking that of the three-dimensional world. The picture plane does not open transparently as an extension of the viewer's space, but is flat and opaque. As he painted, Cézanne translated the surfaces of nature into small touches of paint, each describing or "realizing" a flat plane in the motif. Each was modulated in color to that of its neighbors, so that it both provided the necessary illusion of depth and coexisted with the other units of the surface mosaic. The observed objects were thus remade as attributes of the surface and fixed tangibly into Cézanne's two-dimensional continuum.

Space, in Cézanne's paintings, is not an exterior envelope in which objects exist. Space is established through a "strange complicity between the objects."[2] Formal analogy links the various parts. Here, a set of ellipses carry the eye diagonally down the painting, while the vertical rhythms give stability to this arrangement. The open rectangular area to the upper right (something Cézanne used in a number of still lifes of this period) not only gives air and lightness to the composition, but brings in the literal edges of the painting as part and parcel of the whole design, thus reinforc-

ing the incipiently geometric character of Cézanne's drawing. The crumpled tablecloth to the right is firmly prevented from entering this area, so that the still life is held down between the lower horizontal of the open area and that of the bottom picture edge. The cropped-off bottle to the left is similarly related to its nearby edge, and likewise compresses the forms beneath it. But a geometry is enforced so it is allayed. By aligning the axes of the two decorated pots in the middle of the painting with the left-hand edge of the open area above, Cézanne brought the geometric and nongeometric together. Moreover, the tablecloth to the bottom left (into which the lower pot intrudes) is the nongeometric, volumetric, and patterned counterpart of the geometric, flat, and open space in the opposite corner (into which the upper pot intrudes)—while the nonpatterned cloth to the right (into which both pots intrude) mediates between these two opposed areas.

Other, and complementary, contrasts can be noticed throughout the work. Most evident, perhaps, is the general contrast of severity and decorativeness: of bold, candid design made from such delectable and luxuriant sources. But this is, in part, a historical contrast in Cézanne's development. This still life was painted as he was passing from the spare structural works of the eighties toward a new, almost Baroque, exuberance, and is poised between the two modes. Most essential of all, and the real controlling aesthetic of the work, is the contrast of the two- and three-dimensional: our understanding of the three-dimensionality of each object represented depends upon our understanding of the two-dimensionality of the surface. This simultaneous vision of surface and object—or two- and three-dimensional space—means not only that the viewer is suspended and distanced outside the pictorial space, but that he is unable to reach to it, and to the objects inhabiting it, except in visual terms. Cézanne thus affirms the meaning of still life—with that of painting itself—as an object of contemplation and not of use. The order is solely the painter's, and the sensuous and decorative components express an idealized order of sensuousness and decorativeness all the more telling for being framed in so durable a form.

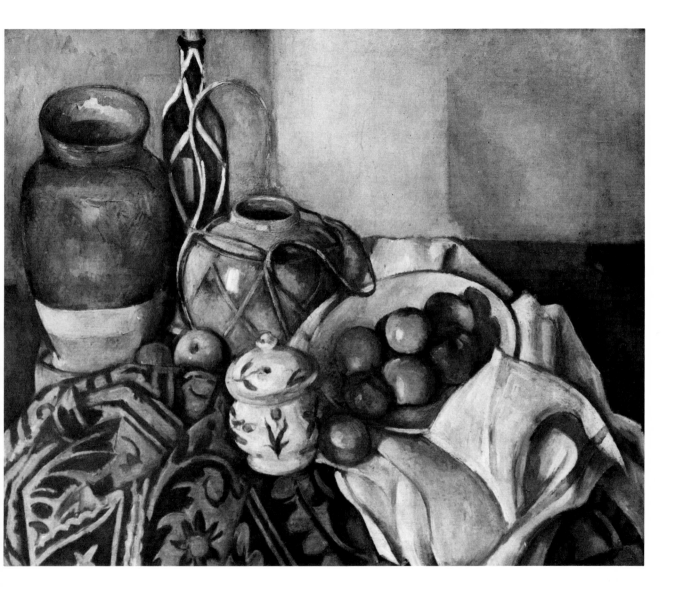

PAUL CÉZANNE
Mont Sainte-Victoire. ca. 1902–6
Oil on canvas, 25 × 32⅝″ (63.5 × 83 cm)
Kunsthaus, Zurich

This monumental image of Mont Sainte-Victoire, painted in Cézanne's very last years, exemplifies the duality in his art of an insistence on fidelity to nature and on two-dimensional pictorial construction—and the resolution of these conflicting claims in a painting that realizes the structural solidity of the motif but, in the methods of its realization, gives final authority to the structural solidity of the painted surface.[1]

To bind volumetric illusion to surface flatness was the principal formal preoccupation of Cézanne's art, and basic to this concern was Cézanne's consciousness of having to carry his surface across the contour of a depicted object without sacrificing either illusion or flatness. This, in its turn, meant coping with the tonal changes perceived in foreshortened planes where any form cuts back into space, and translating these tonal gradations into coloristic ones so that they would lie side by side on the flat surface. It also—and most crucially—meant rendering convincingly that final foreshortened plane which appears as an object's edge so that the object is not isolated from its neighbors. Cézanne kept objects both separate and interrelated by not completely closing their contours—a form of "lost and found" drawing which allowed the planes describing any object to blend with those describing contiguous ones. By the date of this painting, Cézanne was subordinating individual objects to the painterly fabric of the whole work. The *passage* between elements is here so exaggerated that the eye passes totally without interruption from plane to small plane, and freely circulates within a continuum of dissolved form.

Since the small dabs of paint both describe objects and are adjusted one to the next irrespective of the objects they describe and of the different spatial positions of these objects, there is a constant shuttling between surface and depth. The small dabs of paint, that is to say, both describe volume and, as parts of an allover surface mosaic, deny volume. They give and take back space at one and the same time. Since they are arranged in horizontal strata up the surface of the painting, they cannot but evoke a feeling of spatial recession—but this too is a double-edged device for the flat upright nature of the surface is also reinforced. Certainly, Cézanne's rendering of the sky with the same material solidity of brushstroke and color as used for the mountain and the plain below, further accentuates the continuity of the flat surface. So too does the highly regularized, almost geometric drawing.

By this stage in Cézanne's work it is difficult to speak of drawing as a separate component of his art. There is some feeling of reciprocation between plane and line here—between the hatched areas of color and the darker linear scaffolding which aligns itself to the geometry of the picture support—but the very disposition of the color areas themselves is incipiently geometric, while their hatched method of application creates a kind of drawing in paint. The horizontally stacked patches of vertical brushstrokes give to this painting the structural stability that we tend to associate with a linear art, but realized in fully painterly terms. The exactness with which the hues are matched does not thwart the free circulation of space. The severe limitation of the color range, suppression of localized textures, and standardization of touch only accentuate the contrapuntal and vibrant nature of the surface. The liquid flexibility of the pigment, along with the open touch (assisted here by the areas of unpainted canvas), makes for an unconstricted ease of effect, but one that is sure and specific for all that. Color is the direct exponent of structure. The dabs of color draw out structure. In works of this kind, Cézanne offered a lesson both to painterly colorists of the future and to artists mainly preoccupied with form.

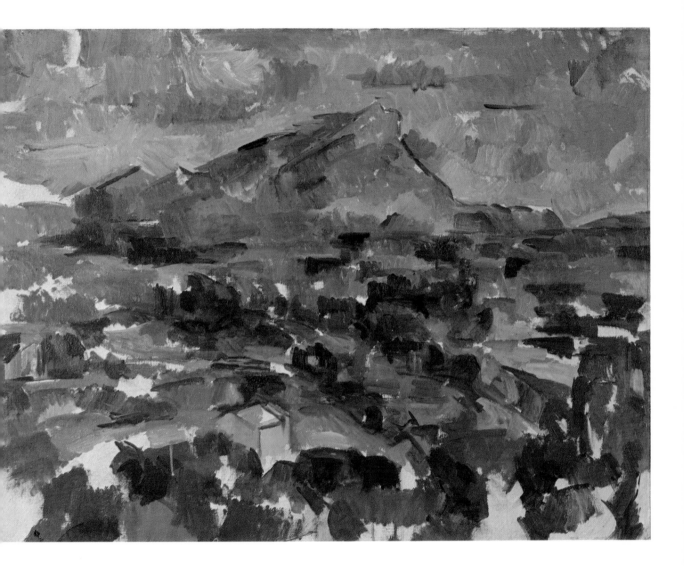

HENRI ROUSSEAU
The Walk in the Forest. ca. 1886–90
Oil on canvas, $27^5/_8 \times 23^7/_8''$ (70 × 60.5 cm)
Kunsthaus, Zurich

The Walk in the Forest is one of a trio of paintings dating from 1886–90 which were Rousseau's first ambitious works (the other two, and certainly preceding, paintings being *A Carnival Evening* and *Rendezvous in the Forest*).[1] All present what was to become Rousseau's central subject: a figure or figures before nature.

Rousseau once proudly described himself as "the inventor of the portrait-landscape."[2] He was thinking specifically of his paintings with identifiable figures; but putting the two modes together on an equal footing, as in this work, is entirely typical of Rousseau's conception of his whole art. Most of his paintings combine figures and landscapes, and part of their special power is due to the enigmatic nature of their combination. Figures are never simply accessories, no matter how small they become; the landscape is never merely a setting. The two exist in mysterious confrontation, each vying with the other for the control of our attention. Because each is painted with the same degree of intensity and obsession—because Rousseau was unwilling to relegate any object to a subsidiary role—there are no self-evident hierarchies within the subject matter of his paintings. Because everything is fixed in a static, silent, and (most important) timeless state— neither the single fleeting moment of Impressionism nor the dramatic climactic moment of Academic painting, but a trancelike suspension of temporality—even quite ordinary juxtapositions seem unexpected, and many of Rousseau's juxtapositions were far from ordinary. Rousseau's are narrative paintings, with the narrative arrested at an inconclusive point.

The Walk in the Forest is particularly inconclusive. A well-dressed but very ordinary lady, having walked past a deserted glade in the woods, pauses and looks back, standing beneath an arch formed by two strongly silhouetted trees and positioning herself so that her left arm exactly continues the line of one of the branches. She stands frontally to the surface of the painting (seems even to float there) just above one of a number of ornamentally lined-up bushes which is somewhat more stunted than the others, at least on one side, lest its branches overlap the woman's dress. (As it is, her tiny feet seem to be like its terminal leaves.) Behind her, a screen of sparse-leafed trees encloses the glade, with

denser, more atmospherically—even Impressionistically— painted woods beyond, then an almost artificially pale blue sky. Everything is flat and frontal. Where forms are not just silhouettes, they seem to be modeled on their front surfaces only, and thus press up to the picture plane. Deep space, as ever in Rousseau's work, is an attribute of color and light. We are led through the painting to the source of its illumination and eventually to open space, but these are things that belong to the background—which is one reason why the packed, detailed surfaces are so claustrophobic in feel.

This is Rousseau's first major painting that creates the special feeling of tension and disequilibrium that came to characterize his work. Whereas *A Carnival Evening* and *Rendezvous in the Forest* both show figures in fancy dress, the lady in *The Walk in the Forest* is conventionally, formally attired. There is therefore no excuse for her enigmatic presence in the woods. The eccentrically dressed figures in the preceding paintings seem more to belong to their settings than she does. Those paintings are self-evidently romances, and though the incidents they contain are still certainly mysterious, they are explicable in their own fantastic terms. Because the subject of *The Walk in the Forest* is more prosaic, the effect of the painting is finally more mysterious. Being so formal, the figure does not seem to belong to the rural scene; by the same count, her formality—her very incongruity—implies that she must be there for some more significant purpose than mere leisure, or that something has occurred to interrupt her leisurely walk. Nothing of course is revealed, except an atmosphere of unease. In such an atmosphere—most accurately described as panic— details take on special significance. We notice the fallen branch to the right, apparently broken off the tree above the woman's head—except that it lies too far away. We notice what seems to be a hole in the ground in the foreground. Such details may provoke explanations—sinister, or highly comic, even—of what has happened, but do not actually provide them. The most to be said is that nature is a disconcerting presence in Rousseau's paintings. Nature encroaches on Rousseau's figures. Eventually, of course, they are expelled, leaving only apparitions, aborigines, and animals.

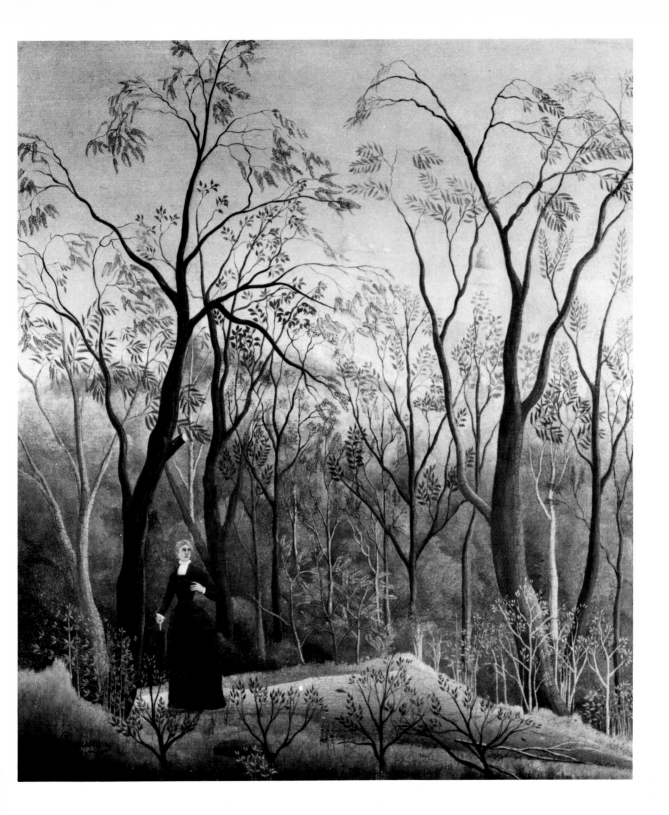

HENRI ROUSSEAU
Child with Puppet. 1903
Oil on canvas, 39³/₈ × 32″ (100 × 81 cm)
Kunstmuseum, Winterthur

Portraits of children form a small but particularly memorable group within Rousseau's oeuvre. Most of them were painted in the decade from the mid-1890s, and most show children of uncertain sex—and uncertain age, for the small but heavy bodies carry serious, somewhat adult heads—in small glades or meadows with flowers. In some of these paintings the children seem to hover over and in front of the backgrounds;[1] in others they are presumably intended to be seated on grassy banks, but look instead as if chairs had suddenly been pulled out from under them, leaving them momentarily crouched, suspended in midair.[2] *Child with Puppet,* certainly Rousseau's most ambitious and important child portrait, is exceptional for its standing figure—of childlike appearance and proportions—whose feet are as firmly planted in the grass as the tree beside it. Rousseau generally reserved standing poses for adults; children sat or floated. Here the situation is reversed: the child confidently stands, and what floats is the adult-looking puppet that hangs from the child's outstretched arm. The puppet has Rousseau's own features.

Rousseau was devoted to children. He had seven from his first wife, Clémence.[3] All but one died, however, and five of them in infancy. His second wife, Joséphine, died childless six days before this painting was exhibited at the Salon des Indépendants of 1903.[4] The *Child with Puppet* is certainly the most enigmatic of Rousseau's paintings of children, and almost impossible not to view in symbolic terms.

As usual in Rousseau's work, there are formal analogies between typologically disparate elements. Here they seem to take on special symbolic importance. The sturdy child in white lifting up the dress to hold flowers displays legs like tree trunks, is rooted to the ground, while the hair is like the open leaves that hang above and around it. The colors of the flowers the child carries are repeated in the costume of the puppet, but there become harsher as well as assuming flattened angular forms. Behind the figures stand two trees, one spare, one full and flourishing. The child and the puppet are easily seen as images of the natural and the mechanical, of innocence and experience, youth and age—the child the father of the man. We are also reminded of fairy-tale encounters between children and toys brought to life—emblems of the adult world in the control of children.

The puppet, of course, is dressed in a costume derived from that of a court jester and *commedia dell'arte* fool. Since it does have a face very like Rousseau's, it is tempting to see in this image—as in Picasso's contemporary paintings of Harlequins and fools—a portrait of the artist as an alienated entertainer and outsider, which Rousseau certainly was at this time. It has been said of Picasso's use of the Harlequin that his bright clothes "tend to remove him from the world of reality . . . [and to] link him with a more mysterious and generalized order of being having its own mystique and ritual."[5] Such an order sounds very similar to that of Rousseau's painting. With this image of an artist-fool controlled by an innocent child in a world of dream we have the nearest that Rousseau ever came to an outright statement on the nature and meaning of his art. It is as if illustration of the myths that soon came to surround him.

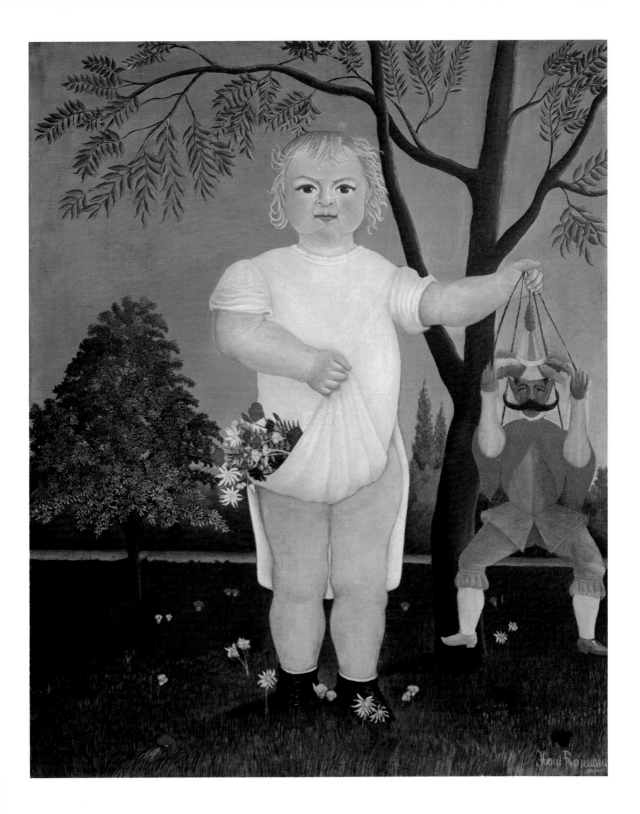

HENRI ROUSSEAU
Portrait of Pierre Loti. ca. 1891–1909
Oil on canvas, 24 × 19³/₄″ (61 × 50 cm)
Kunsthaus, Zurich

This *portrait-paysage,* because of its relative smallness, carries a special feeling of self-containment that approaches introversion; but the principal source of its power lies in the curiously disjunctive relationship between the objects represented. The objects in the painting—and parts of the objects, even—present themselves to us in a highly individualized and intense fashion, as if they were of a kind we had never seen before. They seem estranged one from another. Even the cauliflower ear claims for itself so much individuality as to separate it from the head. The hand with cigarette is independent of the body, as independent as the smoking factory chimney to which it is iconographically as well as formally related. We see the parts of the painting sequentially, each separately, one at a time, and are therefore denied any sense of an instantaneously apprehensible pictorial unity.

It is one of the basic attributes of Rousseau's paintings that, although they are still and timeless—perhaps, even, *because* they are—our experience of them is a durational one. Like other paintings intent on scrupulously objective representation—like Northern Renaissance painting, for example, and certain illusionist Surrealist ones later—they demand to be read in time. As the Surrealists were to learn to advantage, the durational experience allows of highly disparate combinations of objects, encourages it even, since the more disparate the objects, the more charged with meaning each one seems, and the more poetic and surreal our experience of their relationships becomes. In the absence of any instantaneously perceived unity we are forced to scan the work part by part and thus discover a chain of formal analogies—hand and chimneys, cat's stripes and the stripes of the city buildings, cat's table and Loti's fez, Loti's ear and the ear of foliage protruding from the tree—as we are empathically drawn into Rousseau's dissociated world.

It is difficult to find logical reasons for the juxtaposition of exotic figure and industrial landscape. The identity of the sitter—as well as the date of the painting—is in fact open to question. At the 1891 Salon des Indépendants, Rousseau exhibited a *Portrait de M.L.*[1]

That same year, Pierre Loti, the writer, world traveler, and lover of cats—who had recently published his *Au Maroc*—was elected to the Académie Française.[2] There is no evidence, however, that Monsieur L. was Loti, nor that this was the 1891 painting. The fez, cat, and general facial resemblance suggest Loti.[3] The smallish scale, somewhat cramped composition, and subdued color (subordinated to tone and drawing) suggest an early date, but one after the atmospheric paintings of the late eighties. Rousseau made his first *portrait-paysage* (a self-portrait with "modern" setting) in 1890;[4] in 1894 he is known to have painted a portrait of Alfred Jarry with his favorite animals.[5] The Loti portrait may well date from ca. 1891. On the other hand, the treatment of the foliage bears comparison with Rousseau's late urban landscapes, while the face has a strongly sculptural quality similar to that in the Brummer portrait of 1909 (which also has the hand with cigarette).[6] It is very likely indeed that this is an early painting subsequently reworked.

In 1905 or 1906 Edmond Frank, a writer, apparently commissioned his portrait from Rousseau—which he destroyed in 1911. When Frank saw the Loti portrait, he said he recognized it as a replica of his own. It is possible, therefore, that this is not Loti but Frank; but perhaps more likely—if the Frank story is true—that Rousseau reworked the 1891 portrait ca. 1906–10 using some of the features of Frank. According to Apollinaire, Rousseau liked to proceed very methodically when making portraits, actually measuring the model and transcribing dimensions onto the canvas.[8] When he painted someone he had never met—Loti—would be entirely natural to borrow and modify features from someone he had. All of Rousseau's faces are broadly alike, and most of them are like his own. Rousseau's left ear was slightly disfigured and is usually hidden in his self-portraits.[9] The left ear is missing in the Loti portrait (although the head is shown almost full face), suggesting that when Rousseau created the strong, confident, and romantic figure of Loti, he also portrayed himself, as an imaginary visitor to exotic places, but still a modern painter living in a modern world.[10]

38

HENRI ROUSSEAU
The Hungry Lion. 1905
Oil on canvas, 78³/₄ × 118″ (200 × 300 cm)
Private collection, on extended loan to Kunstmuseum, Basel

Of the many myths that grew up around Rousseau, one of the most persistent was that he had served with the troops of Napoleon III when they went to Mexico to support Maximilian. The source of this legend—as of many Rousseau stories—was Apollinaire, who noted, however, that the only things Rousseau remembered of his visit "were some fruits he had seen over there that the soldiers were forbidden to eat. But his eyes had retained other memories: tropical forests, monkeys, bizarre flowers . . ."[1] Needless to say, there is no evidence for such a visit. The idea that Rousseau made his jungle paintings while obsessed with memories of "forbidden" tropical fruits is simply an easier explanation for the appearance of these astonishing paintings—and one better suited to his supposed lack of aesthetic sophistication—than the truth of the matter, which is that Rousseau searched out his models in the Jardin des Plantes and in the Paris zoo, and that he shared—albeit in a unique way—a widespread contemporary interest in the primitive and the naïve as well as being celebrated for his own primitivism and naïveté.

Rousseau was painting when the Italian primitives were rehabilitated, when Gauguin's Tahitian paintings were being exhibited, and when African art as well as new classical-cum-primitive subjects was discovered by the Fauves (whose very title, the "wild beasts," was possibly inspired by this painting, *The Hungry Lion,* which was prominently displayed in the 1905 Salon d'Automne where the Fauves received their name).[2] Rousseau, however, had Academic ambitions. His "primitivism" was in effect a final eccentric flowering of Romanticism. He looked at Delacroix's lion paintings, at the North African paintings of Gérôme (who had been his advisor), at the exotic romances in the salons.[3] In the academicized Romanticism of salon art he saw a kind of exotic narrative art that he himself set out to emulate. The irony of course is that in innocently following debased Academic practices he perverted their effects. His ideal of finish was Academic in origin. (He idolized Bouguereau, and after seeing the Cézanne retrospective of 1907 said he "could finish all these pictures.")[4] But it manifested itself as the scrupulously detailed treatment of a surface composed of flat juxtaposed and overlapping planes—closer, in fact, to a detailed version of Cézanne than to Bouguereau. The scale of *The Hungry Lion* (nearly seven by ten feet) recalls a vast salon "machine." So does the lengthy title that Rousseau provided: "The hungry lion throwing himself upon the antelope, devours him; the panther stands by waiting the moment when he can claim his share. Birds of prey have ripped out pieces of flesh from the poor animal that pours forth its death cry! Setting sun."[5] The expansive friezelike effect and frozen detachment of the painting, however, strike us as particularly modern—and similarly struck Rousseau's more enlightened contemporaries. Caught up in the controversy surrounding the Fauves and criticized as being like a mosaic, tapestry, or Persian miniature blown up to the scale of a decoration, *The Hungry Lion* made Rousseau's reputation.[6]

The widespread admiration for Rousseau (an admiration in which the otherwise antagonistic Fauvist and Cubist factions joined) was that of self-conscious modernists prizing an unconscious or aboriginal one. "Rousseau was not only a decorator," Apollinaire insisted, "he was not merely an illustrator, he was a painter . . . He had a sense of order . . . His was a pure art."[7] Rousseau thought of himself as a realist painter, and in its details *The Hungry Lion* is a realistic painting. Rousseau collected leaves and branches from which to work[8] (a fact that helps account for the magnified scale of the foliage); a study exists for the owl in front of the sun.[9] Yet the realistic details are amassed in a way that is not at all naturalistic: as pure pictorial units from which to create a flatly ordered painting. Rousseau painted from top to bottom, one tone at a time, methodically filling the immense surface.[10] Everything is oriented to this flat surface: the frontal, silhouetted forms, the planar screens of the trees, the uniformly detailed treatment of the foliage. The steady back lighting provides a feeling of openness and depth, but flattens what it illuminates. In the jungle itself everything is so flattened and compressed that the animals inhabiting it—like the hardly noticed beast that stands to the left—become like shadows: immaterial mysterious forms in a formalized landscape.

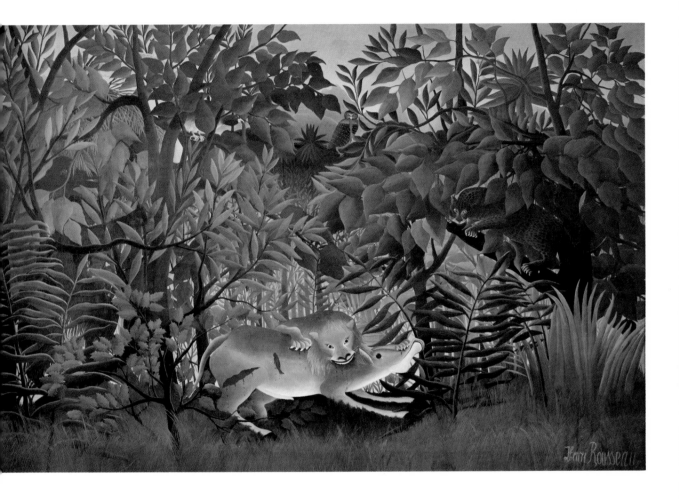

EDVARD MUNCH
Military Band on Karl Johan Street, Oslo. 1889
Oil on canvas, 40$\frac{1}{8}$ × 55$\frac{3}{4}$" (102 × 141.5 cm)
Kunsthaus, Zurich

Karl Johan Street, Oslo's main thoroughfare, was one of Munch's favorite subjects in the years around 1890 when he came to artistic maturity. His unique personal style did not fully emerge until 1892. In the preceding decade he practiced a variety of Naturalist- and Impressionist-based manners, some surprisingly lyrical in mood considering what followed later. Only the famous *Sick Child* of 1885–86 (Nasjonalgalleriet, Oslo) totally prepares us for the melancholy and oppressive atmosphere of his work in the nineties. Most of the paintings from the mid- and later eighties refer to Munch's awareness of modern French idioms. He had first visited Paris in 1885 and was especially impressed by the work of Manet, whose influence is readily discovered in the harmonious tonalities, contrasts of strong darks against lights, and assertive linear contouring in this painting.

Munch's description of the event which occasioned the painting reinforces its Impressionist ambience: "When a military band came down Karl Johan Street one sunlit spring day, my mind was filled with festival—spring—light—music—till it became a trembling joy—the music painted the colors.—I painted the picture and made the colors vibrate in the rhythm of the music—I painted the colors I saw."[1] The glistening puddles on the wide street, the festive subject, and the *plein-air* atmosphere speak of early Impressionism; and yet this is not, in fact, a vibrantly "musical" or joyous painting. Its mood is not particularly festive but somewhat formal. Compared to the democratic bustle of the Impressionist city, the crowd control here is so exemplary that the effect is of ritual, not of rejoicing. Despite the first-glance casualness of the scene, it cannot be mistaken for anything else than a stiff provincial city with more than a touch of that somber and claustrophobic atmosphere that Munch would soon particularize to such disturbing effect. Without knowledge of his later develop-

ment we might not see so clearly how Munch has adapted h[is] sources to confer what is in fact an anti-Impressionist mood on th[e] scene, but is it just hindsight that makes this innocent occasio[n] appear somewhat threatening? The strollers seem isolated an[d] alienated figures as they walk beneath the severe, forbiddin[g] facades of the buildings and beside the exaggeratedly wide stree[t,] a street ominously bare except for the two women crossing in th[e] foreground—their bodies metamorphosed into the shapes [of] cellos—and the military band itself, lined up to form what look[s] suspiciously like a barricade sealing off any exit. Though not as ye[t] dramatically expressed, there is nevertheless a certain feeling [of] unease about this fresh spring day.

Only in details can one see how the drama would develop. Th[e] curious stylization of the two women shows the emerging A[rt] Nouveau linearity in Munch's art, and the treatment of the stre[et] his interest in composing with scumbled, streaked areas of pain[t.] The arrangement of the figures into solid zones that carry one's ey[e] across the picture surface prepares for later, more fluid versions [of] the same theme. Particularly revealing is Munch's use [of] cropped-off figures, most notably the boy in the lower right fore[-] ground, whose severed head, sharply silhouetted against a re[d] parasol and pushed up flat to the picture plane, anticipates th[e] number of seemingly disembodied heads floating on the botto[m] edges of the later paintings. Munch has taken up a typical Impre[s-] sionist form—in Parisian painting expressive of a candid, sna[p-] shot view of the world—and dramatized it, so that it becomes ak[in] to a Mannerist *Sprecher* device, introducing us to incidents th[at] will become increasingly disturbing. In 1889, however, Munch ha[s] not yet crossed the threshhold of this internal world, and Osl[o] townsfolk, as he painted them, are still formal and emotional[ly] restrained.[2]

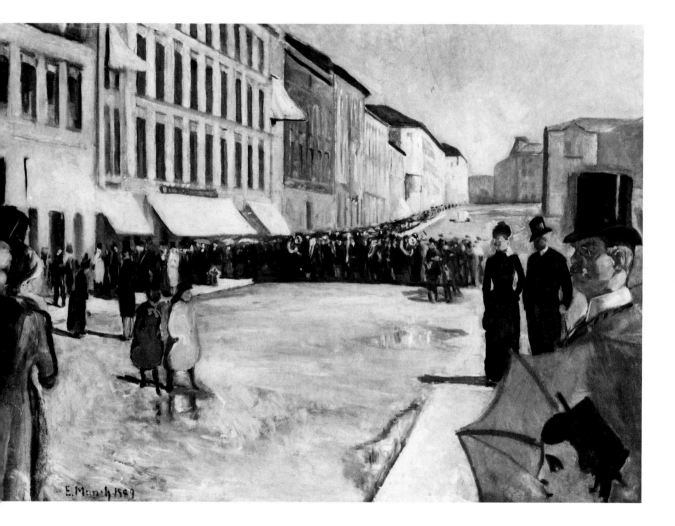

EDVARD MUNCH
Winter Night. ca. 1900
Oil on canvas, $31\frac{1}{2} \times 47\frac{1}{4}$" (80 × 120 cm)
Kunsthaus, Zurich

Pure landscapes are rare in Munch's art, at least before his breakdown in 1908. After his recovery, he presented a far more balanced picture of the world than previously, and landscape became more important to him. In the period of his most intense and typical work, however, landscape alone could rarely satisfy Munch's concern for emotional and psychological drama. That required the human figure. And yet, one's main response to Munch's work is directly to its form. The emotion is not primarily transmitted through the mediation of didactic allegory (though Munch did, of course, paint some directly allegorical works), but through the restless forms and rhythms of his paintings themselves. As a broadly Symbolist artist, Munch makes use of what Redon called "the effect of the abstract line acting directly on the spirit."[1] Although figures usually focus and specify the emotion of Munch's paintings, landscape alone can transmit it, as it does here. Indeed, the very absence of figures in this painting is part of its emotional impact.

This landscape was painted at Nordstrand, one of the North Frisian Islands close to the west coast of Schleswig-Holstein. Since 1892, when Munch's work had proven so provocative as to cause the closing of that year's Verein Berliner Künstler after only a few days and thus bring about the Berlin Secession movement, Munch had lived in Germany, though he had spent the years 1896–97 in Paris, coming into contact with Art Nouveau artists and designers.

The tortuous curvilinear rhythms of Munch's work are analogous to those in Art Nouveau, although they look back to the swirling forms of van Gogh's art, an early and crucial influence on Munch's style. Munch was a contemporary of some of the Post-Impressionists, yet belongs historically more with the great independent Symbolists like Redon, Ensor, and Hodler, unashamed literary painters who were also painters of mood.

Although at first glance *Winter Night* seems one of the least troubled of Munch's paintings, this landscape bare of human life is if not quite menacing, at least mysterious in its desolation. The intense deep blues and purples that dominate the work give to it somehow oppressive atmosphere. The open water and receding horizon which should lighten the painting in fact weigh down heavily upon it. The deep inky water seems to compress the form below, and Munch's nervous, interweaving line seems to ripple anxiety through the work. In the lower part of the painting, it impossible not to discover ambiguous presences in the patterns the snow seen through the tree branches. Gaps resemble eyes glowing sources of light. The shadow cast across the center looks like the shadow of a figure. There is here none of that feeling terror that Munch's art sometimes evokes. Nevertheless, a distinct expressive charge has passed through the forms of this cold northern landscape.

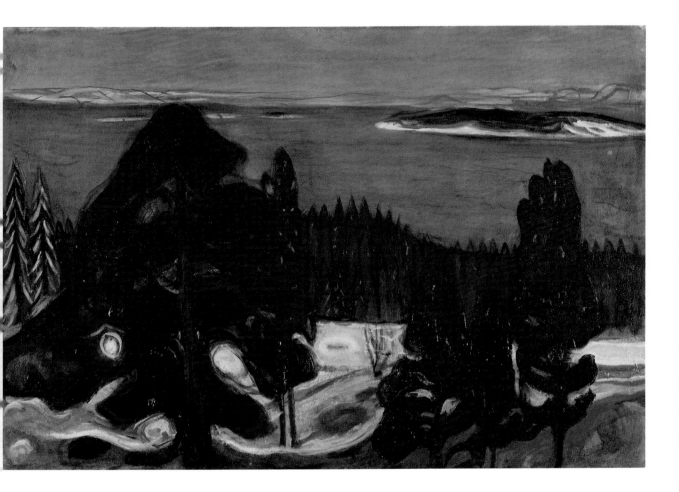

FERDINAND HODLER
Lake Silvaplana. 1907
Oil on canvas, 28 × 36³/₈″ (71 × 92.5 cm)
Kunsthaus, Zurich

Hodler's art readily divides itself into two parts: on the one hand, ambitious allegorical figure compositions on a murallike scale; on the other, smaller landscapes and portraits. The figure compositions make Hodler seem essentially a nineteenth-century painter, a contemporary of the Symbolists and a robust but somewhat morbid heir of Puvis de Chavannes. The landscapes, particularly the freely painted ones, seem to belong to the twentieth century. This, of course, is a somewhat artificial division, for although Hodler himself saw the two sides of his art in a very different light (underplaying the importance of the landscapes),[1] and although historically the important didactic compositions do generally belong to the first part of his career and the freer landscapes to the second, the landscapes are in fact as Symbolist in intention as the figure compositions and share many of their formal and theoretical preoccupations. Nevertheless, to modern eyes at least, the landscapes gain from being less overtly symbolical or didactic. Hodler's feeling for the monumental seems as well suited to the representation of mountains as of men. And he managed to paint Alpine scenes without ever becoming fantastic or nostalgic, and certainly never picturesque.

From around 1890, Hodler had developed his concept of "Parallelism," a system concerned with the incidence of similar patterns in nature—repeated shapes, parallel forms, forms and their reflections—the representation of which would affirm the structural and hence symbolical coherence of the natural world.[2] This meant for Hodler ignoring details and accidental effects, affirming unity rather than diversity. "I love clarity in a painting," he said, "and this is why I love Parallelism. . . . When I began painting, I turned toward Impressionism. But slowly, with many years of study and observation, I came into my current procedure: clear form, simple representation, repetitions of motifs."[3] In this painting of Lake Silvaplana, forms are repeated in a system of double symmetry built around the visible horizontal axis of the far shoreline and an invisible vertical one dividing the oppositely banked mountains and two pairs of clouds in the sky. The matched blues of the lake and sky lighten toward the horizontal axis and then form similar golden auras around the mountains and their reflections. The vertical division is emphasized by the changes of color across the horizontal axis. At the left, the reddish brown of the mountains is principally set off by deep purple-blue shadows, with subsidiary greens. To the right, the greens dominate the purples with the point of change between the two color schemes being the center of the painting.

Hodler's highly calculated effects were intended to emphasize the basic, elemental forms of the landscape. In an essay on the "Physiognomy of Landscape,"[4] he stressed the emotional impact of nature and his belief that it could only be communicated in a style of essential clarity. "The draftsmanship," he wrote, "must always be clear and outspoken, so that the essential structure of the landscape can be visible and impressive. Also, the composition must be striking so that it creates its impact at first sight. The essential emotion, the main accent, must be stressed so that no doubt is possible." Nothing incidental should be allowed to interfere with the striking impact of the work. "Figures or anecdote not only add nothing, but weaken the deep and direct emotional impact. The painter must have the will to be clear and the capacity of rendering his own feelings frankly and without hesitation. Only then will the painted landscape grip the spectator without fail and convey a deep and lasting impression." For Hodler, lake, mountains, and sky were basic elements of his iconography which, put together, could symbolize the underlying order of the entire visible world.

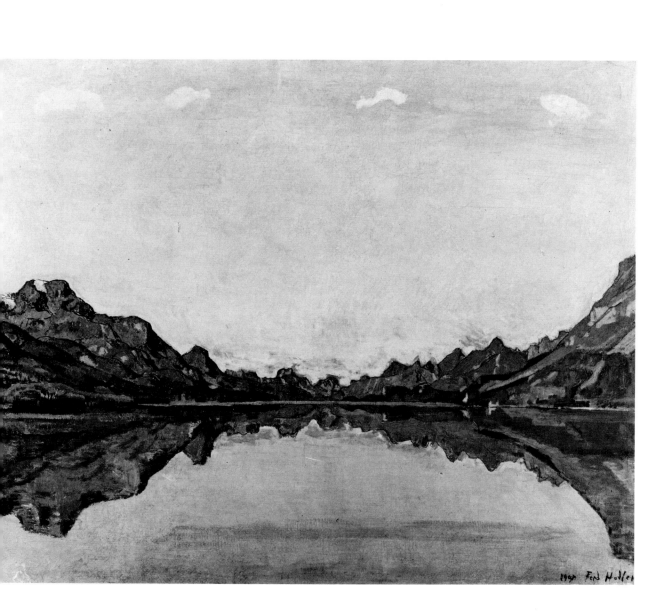

FERDINAND HODLER
Eiger, Mönch, and Jungfrau in Moonlight. 1908
Oil on canvas, 28³/₄ × 26³/₈″ (73 × 67 cm)
Private collection

Hodler was always a very sturdy Symbolist. Even his most decorative allegories are characterized by a highly concrete and objective sense of order, and the most visionary of his landscapes never lack a sense of permanency and reality despite their cosmic implications. He was, in the best of his paintings, a structural realist of a very high order first and a Symbolist second. That is to say, insofar as his paintings are symbolic, their symbols are derived from Hodler's preoccupation with the structures of nature and the representation of these in a pictorially appropriate style. The representation of essential structures with a solidity appropriate to them was itself a symbolic act, indicating the permanency and cohesiveness Hodler saw in nature. At first this meant a highly stylized manner of painting dominated by precise draftsmanship—so that clarity of structure could be recorded—but in this great painting, *Eiger, Mönch, and Jungfrau in Moonlight,* and in the later landscapes, monumental images presented in a far more generalized manner brought a new sense of grandeur to Hodler's art. A specific sense of solidity remains, but is created in almost abstract terms. Precise contours give way to expressionistic brushwork, yet the experienced sense of place still remains. The architecture of nature is given more epic expression as Hodler focuses more closely on the mountains which were his principal subject.

Hodler would climb high in the mountains to get close to the large peaks and to experience the atmosphere of isolation in the silent landscape. A part of the power of this painting is due to its evocation of atmosphere: of the three dramatic peaks showing through the mist surrounding them, and above, in the clearer sky the two dark clouds, outlined by bright moonlight and seemingly frozen next to each other, encircled by the large, curved bank of cloud. There is a strong sense of night cold evoked by the various sharp blues, and of mystery by the veiled forms. In the final count however, Hodler is no more concerned with temporal moments or incidents than he had been previously. He has put aside the dogmatic Parallelism of his earlier work but is still intent on the representation of unified and permanent states. The mission of the artist, said Hodler, in a lecture of that title, "is to express the eternal element of nature . . . The deeper we penetrate into the spirit of nature, the more completely we can express her."[1] Hodler's empathic relationship to nature led to his using a vocabulary of analogous forms and elemental juxtapositions, such as those on which this painting depends. The balance of the three mountain peaks by the two dark clouds; of the semicircle of clouds above by the further veiled peak below; of the solid, opaque nature of the clouds by the dissolved, luminous state of the mountains—such features contribute to the visionary quality of this work, to the sense of mystery and eternal isolation the painting conveys.

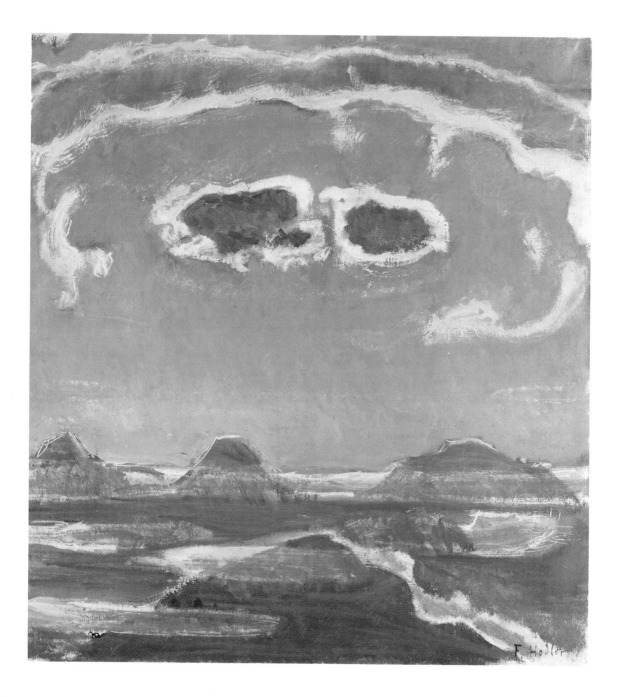

When Henri Rousseau saw this painting he is supposed to have taken Vallotton by the arm and said, "Eh bien, Vallotton, marchons ensemble."[1] There is indeed more than a touch of naïveté about this clearly very ambitious composition, which Vallotton described as "women bathing in a brick swimming pool in the open air." When it was exhibited in the Salon des Indépendants of 1893, under the title *Summer,* the critics were none too kind in their reception of it. One found it "hysterically comical"; another was astonished by what he called the *derrières immondes.*[2] To modern eyes it does in fact seem to walk a narrow line between the pornographic and the ridiculous. Like Rousseau's work, however, it has an obsessional quality that wins out over all else and gives to it a compelling and certainly a memorable power.

Vallotton was born in Lausanne in 1865. He came to Paris to study art at the Académie Julian and established friendships with Vuillard, Roussel, and other members of the Nabi circle, becoming known as *le Nabi étranger.* He is perhaps most celebrated for his black-and-white illustrations in magazines and newspapers and for his posters. Like the other Nabis, he was importantly influenced by Gauguin's belief in a decorative art freed from a close dependence upon nature, and the flat-patterned style of this painting is certainly indebted, if not directly to Gauguin, then through Maurice Denis's interpretation of his art, to the declaration that "a picture—before being a warhorse or a nude woman or an anecdote—is essentially a flat surface covered with colors assembled in a certain order." The order, however, is not entirely of the curvilinear, Art Nouveau kind, derived ultimately from Gauguin, for which Nabi art is best known. The twisted forms of the women's bodies, and especially of their hair, and the organic patterns of the landscape are certainly in this tradition. The landscape with curving road is in fact close to that of Denis's *April* painted in the same year.[3] But the stiff, hieratic geometry of the picture looks strongly to Puvis de Chavannes, whom Vallotton greatly admired.

It may not be amiss to see here the influence of Hodler as well. The sleeping figure to the right of the center is close to one in Hodler's *Night* (1890), which was exhibited in Paris in 1891, while the generally symmetrical organization of the picture around the figure in the center and especially the repeated verticals suggest that Vallotton knew of Hodler's concept of "Parallelism," which gave to his compositions their architectonic unity.[4] But Hodler too was learning from Puvis, the principal late nineteenth-century exponent of large-scale programmatic decoration, and it was to Puvis' schematic silhouettes, open friezelike arrangements, and frescolike treatment, and to Puvis's subjects as well, that Vallotton—like others of the Nabis—turned to create his idiosyncratic version of an idealized land.

There is, however, little precedent in Puvis's work for the often blatant eroticism of this picture. Nor does the deeper sexuality of Gauguin's painting prepare us for this exhibitionist array. There is something in the conception that recalls Ingres's *Turkish Bath,* but the types of femininity represented here are manifold: from the demure maiden at the upper left to the more solid, Renoir-like women beside her; from the spiritual figure in the center of the painting to the erotic naiad in the left foreground, who, joined to her reflection, twists into piscine form. There is inevitably a baptismal connotation to the subject depicted, though the exhibition title, *Summer,* suggests a possible allegorical meaning, concerning the growth from youth to maturity. The young, mature, and indeed the old are all represented, but so are the beautiful and the plain, the pure and the lascivious. It is as if Vallotton had sought to catalog the variety of feminine types, showing them undressing and relaxing in an idealized landscape beneath the stylized rays of the setting sun. If the spell is broken somewhat by the brick-lined swimming pool in which they bathe, this curious combination of *doux pays* and modern plumbing is, for post-Surrealist viewers at least, part of the fascination of this amazing work.

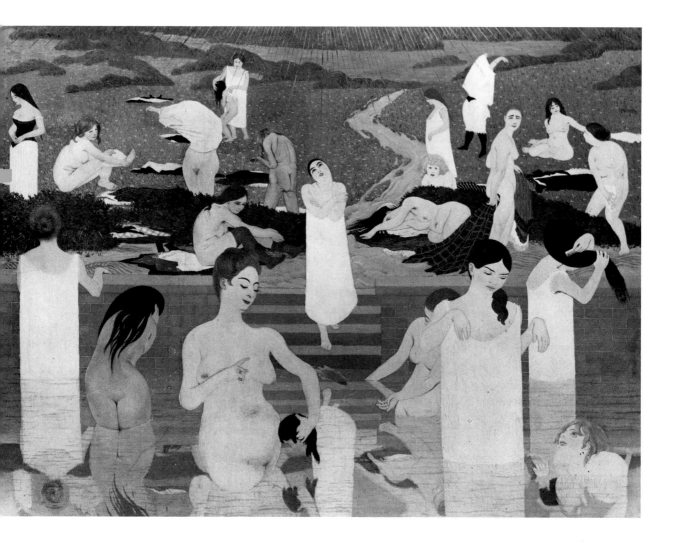

FÉLIX VALLOTTON
The Visit. 1899
Oil on cardboard on wood, 32 × 43⁷/₈″ (81 × 111.5 cm)
Kunstmuseum, Winterthur

None of Vallotton's other paintings are as extravagantly Symbolist as his *Summer.* He apparently intended painting a *Spring* as a pendant to it, but never managed to finish it, and henceforward he presented, by and large, only observed subjects.[1] Closer contact with the Nabis in the mid-nineties led him to appreciate the *intimiste* rather than imagined side of their art, and to pursue the modern subjects that coexisted in the Nabi circle with pastoral and primitive ones. He began to apply his strongly designed style of firm graphic silhouettes, dramatic contrasting areas of lights and darks, and open, often stark compositions to ordinary bourgeois scenes, such as those which Vuillard or Bonnard favored—a woman washing, figures in a café, a domestic scene—and to paintings of friends and colleagues.

By the end of the nineties Vallotton had begun to turn away from the utter decorative flatness that had dominated the decade in French painting, and like others of the Nabis was starting to fill out the bare silhouettes with new incident. But whereas Vuillard and Bonnard filled them with sparkling patterned ornament and with joyously sensuous brushwork, Vallotton opted for form. A firm graphic sense remains, with sharply defined planes and contrast-ing shadows, but from around the time of *The Visit,* Vallotton'[s] figures take on a new bulk and solidity, becoming heavier an[d] apparently more serious in mood.

Vallotton was married in 1899, the date of this painting, to Mm[e] Rodrigues-Henriques, née Bernheim-Jeune, sister of the famou[s] picture dealers, and occupied a milieu very different from that [of] his bachelor days. This, however, may have nothing to do with th[e] fact that, in his paintings from the period around 1900, there [is] often an unexplained narrative content that makes them see[m] broodingly atmospheric and even enigmatic when compared wit[h] the far more straightforward celebrations of the bourgeois li[fe] style of Vuillard and Bonnard. With their paintings we are neve[r] impelled to ask questions about the psychological relationship[s] between the figures represented. With Vallotton's of this perio[d] what is happening, has happened, or is about to happen ofte[n] seems a mystery. In *The Visit,* a sense of unease—or perhaps ju[st] boredom—is transmitted in the two isolated figures, sitting sepa[-]rately under their own lamps, whose gaily painted shades speak [of] a far more carefree life than that presented in this dark and clau[s-]trophobic interior.

GUSTAV KLIMT
Goldfish. 1901–2
Oil on canvas, 71¼ × 26¼" (181 × 66.5 cm)
Private collection

It is one of those telling coincidences that Klimt developed his characteristic, highly erotic style of painting at the very same time that Freud, in the same city, Vienna, was discovering sexual meaning in the imagery of dreams. Klimt began this painting, *Goldfish,* a year after Freud's *The Interpretation of Dreams* appeared in print, though it would be another decade before Freud talked not only of dreams as the locus of expression for repressed desires, but of the artist as a dreamer "who turns away from reality because he cannot come to terms with the renunciation of instinctual satisfaction which it at first demands, and who allows his erotic and ambitious wishes full play in the life of fantasy."[1]

The implicit sexual connotations of Klimt's undersea fantasy world of *Goldfish* require as little comment as do the overtly sexual poses of the women who inhabit it, except that Freud's interpretations of dream images concerned their content and not their form, and here it is as much through form—through almost abstract means—as through specific images that the meaning of the work is expressed. Indeed, much of the painting is not immediately decipherable. Although it is focused on a prominent and suggestively posed nude in the foreground, above this there is—at first sight, at least—merely an impression of curvilinearly twisting forms, flashes of intense and exotic color, and passages of luminous flesh. This ornamental style itself is what principally accounts for the erotic mood of the painting.

Klimt's sources were of a linear-Symbolist nature. Becoming acquainted with contemporary art in the mid-nineties, he admired the exotic and allegorical subjects, graphic, ornamental styles, an air of dramatized decadence in artists like Toorop, Burne-Jones, Beardsley, and Khnopff. He also looked at Oriental and at Byzantine art, from which he derived the use of real gold in his ornamental backgrounds, a practice followed in this painting. By 1897 the distinctive style of the *Goldfish* had been established. That year the Vienna Secession was founded, and Klimt became one of its principal members. The Sezessionstil is distinguishable from other forms of Jugendstil and Art Nouveau by its abstract geometric form and use of applied-art techniques in pictorial contexts. That high Art Nouveau style is adumbrated in works like *Goldfish* but was not fully developed until a year or two later. There is no purely abstract ornament in this painting. Instead, the contours of realistic forms are abstracted to create a continuous and sensual curvilinear rhythm. The never-ending lines produce a feeling of somnolent flux, floating the smiling, pearly-skinned women between twisting tendrils, sparkling underwater creatures, the shining primeval goldfish, and wave upon wave of fetishistic red hair, like that in Pre-Raphaelite paintings but curved into serpentine forms.

The *Goldfish* was exhibited to a hostile critical outcry. One paper, *Der Liebe Augustin,* ran a front-page cartoon showing an aged Viennese citizen standing before the painting, giving it a thumbs down sign and spitting onto the ground.[2] The motto beneath the cartoon was "Apage Satanas," surprisingly, since Sappho would have been far better a personage to invoke than Satan when describing this Lesbos under the sea.

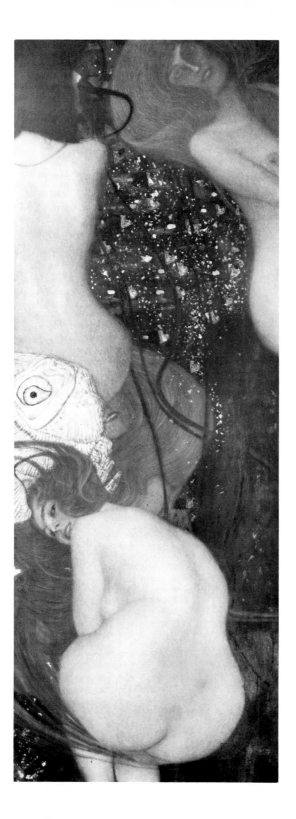

PIERRE BONNARD
After Dinner (The Cherry Tart). 1908
Oil on canvas, 45¹/₄ × 48³/₈″ (115 × 123 cm)
Collection Dr. Peter Nathan, Zurich

Although he came to maturity in the Symbolist climate of the 1890s, and was one of the Nabis—the "Nabi très japonard," in fact, of that circle of painters influenced by the doctrines which Paul Sérusier had discovered in the work of Gauguin at Pont-Aven—Bonnard was not a Symbolist. He was, indeed, a Nabi more by virtue of friendship than by adherence to the anti-naturalist and anti-Impressionist ideology of the group—though he was, of course, affected by Symbolism and by the popular nineties interests in the creation of a decorative art. As early as 1891, however, he was already insisting: "I belong to no school. I want only to do something of my own . . ."[1]

A part, even a large part, of Bonnard's importance lies in his combination of certain aspects of Symbolism and naturalism, two normally antithetical forms. The atmosphere of Symbolist reverie and introspection that pervades his naturalist, petit bourgeois subjects is one of the essential features of his art, as is also his blending of decorative, Post-Impressionist forms of composition and a muffled, painterly handling derived (together with his subject matter) from Impressionism. He once wrote to a critic that all his life he had "floated between intimism and decoration."[2] He began, in fact, with decoration—with Post-Impressionism and Symbolism, that is to say—and only later gravitated toward Impressionism and intimism. Even at his most decorative and arabesque, however, Bonnard never succumbed to the cloying atmosphere of the fin de siècle, but instead was attracted to the playful and even the anecdotal, using decorative Symbolist forms to record the pleasures, both public and private, of French petit bourgeois society. Around 1900 this relaxed manner was enriched by the stylistic impact of Impressionism. Bonnard's surfaces became richer and more im-

pastoed; their decorative shapes filled out with incident and detail. By 1908, when *The Cherry Tart* was painted, Bonnard's lyrical and hedonistic style had been firmly established.

Bonnard used zones rather than shapes of color. There are no sharp contrasts or divisions in his paintings. Because of their assertive facture and because of Bonnard's spatial compression of even the most open vistas, his paintings are assertively surface ones. Everything is pushed up flat to the picture plane; all incident belongs to the allover painterly continuum of the surface. In the enclosing screen of foliage in *The Cherry Tart* changes of tone seem like tears or fissures in the flat surface. Throughout the painting, the zones or areas of color reach out across space rather than cut back into it. Greens push down from the top and blues up from below, with the red-dressed figure wedged in between. Reds float across the blue table and dot the lower limits of the green foliage. They reinforce the circular forms of the dishes on the table and the painting focuses around the segmented red circle of the cherry tart, the dog's eyes above it, and the anomalous square tile below. (Bonnard said that a good painting must be constructed around a hole or an unimportant element.)[3] The figure—by no means the center of attention—seems as if in a dream.

"Bonnard makes his own everything that nature can offer to his pictorial genius," his friend Signac once said. "He understands, loves, and expresses everything he sees: the pie for dessert, the eye of his dog . . . Then, wholly by instinct, without even attempting to give an appearance of reality to these often illegible objects, he expresses his love of life in magnificent pictures, always novel in composition, which have the unexpected flavor of unfamiliar fruits."[4]

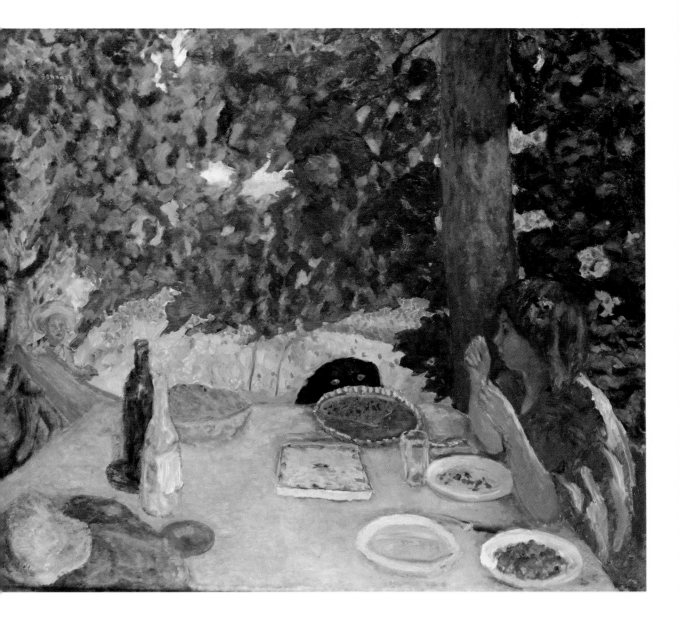

PIERRE BONNARD
Nude in the Morning. 1917
Oil on canvas, 48³/₈ × 47¹/₄″ (123 × 120 cm)
Private collection

The female nude figure either bathing or dressing occupies a major place in Bonnard's art. The theme, of course, is an ancient one, but Bonnard's particular interpretation of it derives importantly from Degas, who established the *nu à la toilette* on a new level of realism and formal invention. Unlike Degas's figures, however, Bonnard's are not presented in dramatic suspended action but in relaxed, self-contained attitudes and are intimately related to their surroundings. If at times they seem to lack a usual bone structure it is because Bonnard is content to treat them as pliant luminous surfaces. Their anatomical distortions are not to be explained as attempts to create new mobile poses; they derive from Bonnard's willingness to tailor the forms of his figures to the demands of compositional unity.

Bonnard's compositional methods were part and parcel of the surface-assertive quality of his work. "A painting," he said, "is a series of spots which are joined together and ultimately form the object, the unit over which the eye wanders without obstruction."[1] The feeling of unobstructed movement over an open surface was created by flattening forms to the surface and by positioning them so that one becomes conscious of the part-to-part nature of their arrangements and, at the same time, is fluently led from one to the next. "A well-composed picture is half-completed," Bonnard stated.[2] He had, he said, been "carried away by color" in the years before the First World War; "I was almost unconsciously sacrificing form to it. But it is true that form exists and that one cannot arbitrarily and indefinitely reduce or transpose it."[3] From 1915 to 1920, therefore, he became particularly involved with questions of form and composition and sought new stability in his work. But form had been, if not sacrificed, then at least accommodated to

color and to its natural tendency to create a series of flat zones an areas across the surface. Bonnard's new preoccupation with forr did not mean he abandoned this and began working with precor ceived structures. It meant, rather, that his naturally fluent styl achieved a new strength and feeling of solidity.

The most immediately striking feature of *Nude in the Morning* i the way in which the figure is abruptly cut off by the bottom edge o the picture. At first sight it gives a quality of candidness and snap shot casualness to the work. The feeling of candidness remains. soon becomes obvious, however, that this is very far indeed fron an arbitrarily framed view. The cropping is highly sophisticate and creates, in fact, the whole pictorial logic of the work. The cut-o figure at the bottom is matched by the cut-off drapery at the top o the painting, by the bisected chair to the left and door to the right The composition is held together by the framing edge. Th greatest pictorial weight is given to the perimeters of the composi tion rather than, as is traditional, to its center. One is again re minded of Bonnard's remark that a good painting must be con structed around a hole.[4] In effect, this is what happens here. Th four edge-linked forms mirror each other across the painting—th curve of the drapery opposite the woman's head, the vertical of th chair opposite that of the door—and leave an illusion of slightl deeper space at the center. Yet Bonnard does not simply allow th center to fall away spatially. With great compositional subtlety h carries the flatness of the edges across the composition. Th lined-up pieces of draped furniture not only advance themselve pictorially but bridge across the composition (forming a chain o cool colors across the warm ones top and bottom), both pushin and opening it out and tying it together at one and the same time.

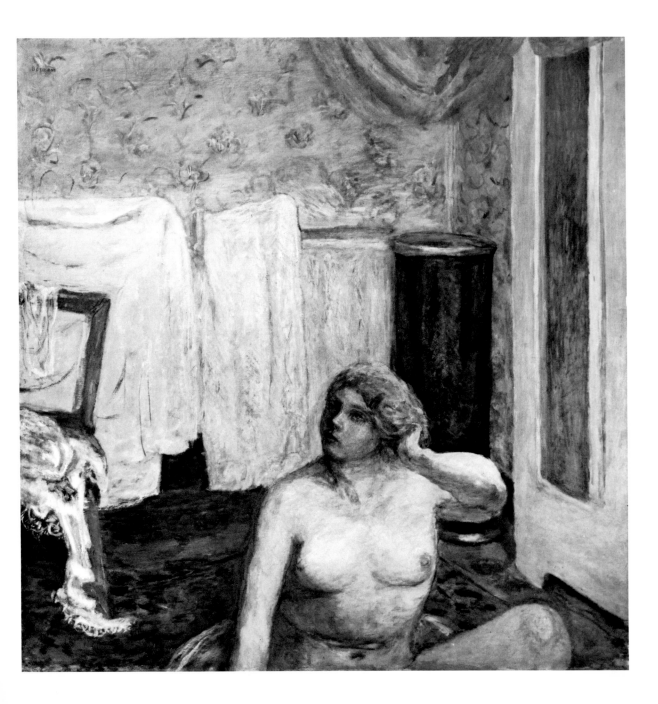

PIERRE BONNARD
Landscape at Le Cannet. 1926
Oil on canvas, 40½ × 46⅛" (103 × 117 cm)
Collection Gustav Zumsteg, Zurich

In 1925, Bonnard purchased a house outside Le Cannet, a small village near Cannes. "It is a little house with pink walls, all white on the inside," wrote his nephew Antoine Terrasse. "The garden, where bushes and flowers grow at will, slants down to the street. At a distance one can see the red roofs of Le Cannet, the mountains, the sea."[1] Bonnard had been visiting the south of France since 1910, spending more and more of his time around Saint-Tropez and Cannes, until a house of his own in that area became a necessity. It was the bright light of the south that had helped to liberate Bonnard's color in the period around 1910, and he continued to value the stimulus it provided: not only to heighten and intensify color, but to flatten volumetric forms into decorative patterns. Although his main friend in the south, Renoir, had died in 1919, Bonnard still followed his advice. Renoir had insisted, "It is important to embellish"[2]—meaning that the sheer quality of paint was important. Hence the open and airy quality of Bonnard's surfaces and his absorption in touch and texture that gives the most ordinary subjects a quality that is almost voluptuous.

Bonnard still had his house at Vernonnet, near Giverny in the Seine Valley, where Monet was his near neighbor. It may not be amiss to see the impact of Monet's late decorative paintings on Bonnard's landscapes of the teens and twenties. Whereas his figure paintings of this period evidence more rounded, sculptural forms, in his landscapes Bonnard was willing to submerge specific motifs in an overall pattern of light and color quite negligent at times of the illusionistic properties of its constituent parts. It is symptomatic of his concern for allover patterning that Bonnard painted few very open landscapes. They are mostly gardenlike and enclosed. Where a distant prospect is offered, as is the case here the farthest part of the scene is surrounded by diverting foliage and contrived back to the surface of the painting. The sense of enclosure that Bonnard valued was part of his fondness for intimacy. Everything is crowded up to the viewer. The meadow with figures spans the breadth of the picture, at each side flanked by trees cut off by the picture's edges. The trees, though at different places in depth, seem equally to belong to the flat wings of the picture space tied to their respective sides, with the meadow stretched out between them. All else can be related to this principal span: the centrally placed tree, advanced by virtue of its growing in the meadow, the trees and bushes behind by virtue of growing near to that tree. At first, the whole structure can seem random, flimsy somewhat precarious, but through a kind of accretion, of form added to form, one shape supporting another, the painting holds.

Since his involvement with the Nabis in the early 1890s, Bonnard had pursued a decorative, murallike style. With his awareness of Impressionism, he had pursued his style in terms of full, spontaneous brushstrokes, high color, and an *intimiste* version of *plein-air* effects. This pairing of Impressionist colorism and Nabi decorative ideals was basic to Bonnard's mature art, just as it was to that of the other great hedonistic master of the School of Paris, Matisse. And just as Matisse idealized the scenes that he painted, so Bonnard's landscapes exude an air of luxury, calm, and voluptuousness that transforms the Midi scene into an arcadian garden. In Bonnard's case, however, the Symbolist sources are more obvious. With the setting sun, this idealized landscape is bathed in an unreal, uneasy, and emotive light.

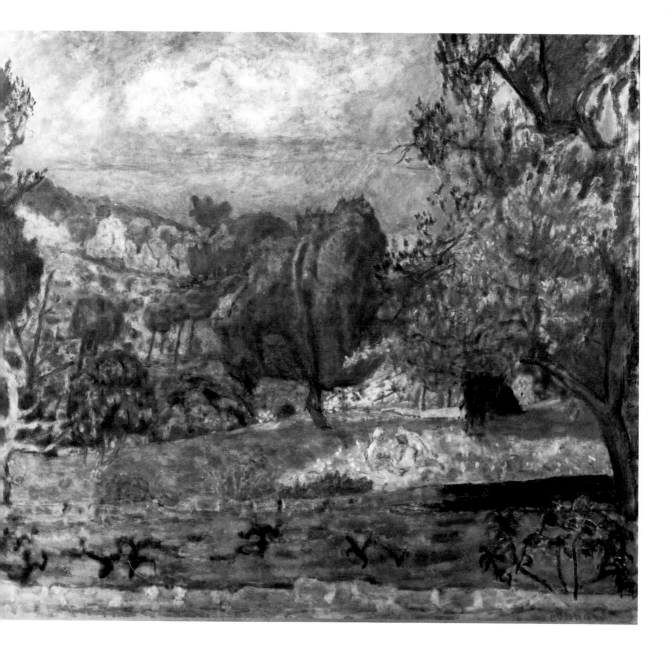

PIERRE BONNARD
The Provençal Jug. 1930
Oil on canvas, 29³/₄ × 24³/₈″ (75.5 × 62 cm)
Private collection

Bonnard worked exclusively from memory. "The presence of the object, the motif, is very disturbing to the painter at the time he is painting," he said. "Since the starting point of a picture is an idea, if the object is there at the moment he is working, the artist is always in danger of allowing himself to be distracted by the effects of direct and immediate vision, and to lose the primary idea on the way."[1] By the primary idea or conception Bonnard meant what attracted him to a motif and what he felt had to be communicated about it in his painting. Since he was not strong enough, he explained, to resist noticing new qualities in a motif as he painted, it was better not to consult the motif at all.[2] He worked instead from remembered images (occasionally helped by small sketches) and did not therefore so much record or reproduce objects as create pictorial equivalents for the essences of things as he saw them preserved in his visual memory. "Through attraction or primary conception," he said, "the painter achieves universality. It is attraction which determines the choice of the motif and which conforms exactly to the picture."[3]

One result of Bonnard's not working in front of a motif but concentrating solely on the canvas, distracted by nothing around him, was that the very focus of his attention was not broken. He painted in an exclusively two-dimensional context, where everything was flattened and spread out and where objects existed only in two-dimensional terms. Instead of painting on stretched canvases, Bonnard tacked pieces of canvas directly on the wall. Sometimes several paintings were executed on the same piece.

Finished works were then cropped to size before being stretched

To realize that as Bonnard was working he was concentrating c the representation of an isolated mental image helps to explain th curious sense of detachment that underlies the intimism of h work. Objects—even the most insignificant of them—have a ce tain mystery about them. With some of them, their very identity in question. To the left of the Provençal jug here there is a dish c bowl, flattened to the surface of the painting and surrounded b the jug's shadow. To the right there is an upright architectur feature, and then, disconcertingly, a hand and arm reaching up th side of the painting and cut off by the edge. Since it is difficult t understand where the jug is situated—possibly on a mantel, wi dowsill, or doorstep—it is impossible to imagine the stance of th person to whom the arm belongs. Formally, the arm belongs to th painting, balancing the bowl on the opposite side. At the sam time, it seems to make the painting somehow incomplete, as if should continue and thus explain what is now enigmatic. Howeve the fact that what is happening beyond the immediate area of th jug is revealed but not thought worthy of explanation serves on to heighten the importance of the primary subject all the more

In paintings like this, formed around a single image, one vividly made aware of Bonnard's concentration on the remer bered motif, the way he builds out the painting around the mot expanding it to include adjacent forms until he chooses to sto then cropping it to shape once the "primary conception" ha finally been realized.

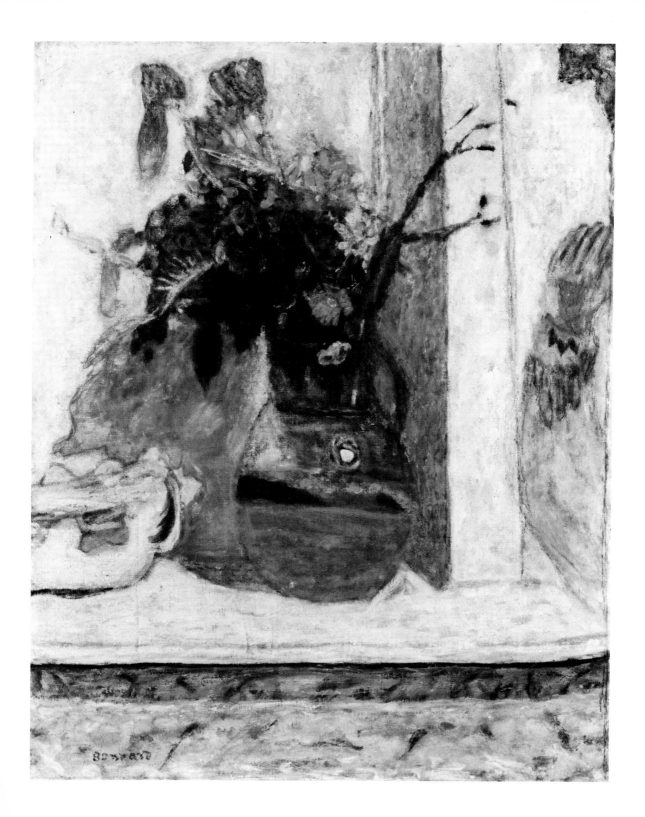

Edmond Duranty's essay *La Nouvelle Peinture* (1876), which Vuillard greatly admired, was dedicated to the subject of contemporary life.[1] Although it was originally produced to defend Degas's work, a great deal of it applied to Vuillard's too. For like Degas, and Duranty, Vuillard believed that a painter's task was to record contemporary subjects in a contemporary manner; that there should be no separation between his daily life and his life in art; indeed, that there could be no more natural subject for an artist, nor one he could hope to know more intimately, than his own surroundings.

Vuillard's *intimisme* is the most commented-on feature of his art. His friend Thadée Natanson wrote of him that "he was receptive to impressions, constantly, unremittingly, almost tirelessly. Thus there arose a state of intense emotion, a kind of love, for things as well as for human beings . . ."[2] We understand and readily accept this observation, for in paintings like the *Large Interior with Six Figures* Vuillard's obsessive care for familiar objects is very evident indeed. Such an intense preoccupation, however, meant a new kind of painting—for in painting unposed reality Vuillard found, to borrow Duranty's words, that "the look of things and of people has a thousand ways of defeating expectation. We are not always standing in the middle of the room, with its walls running neatly away on either side of us. Cornices do not always form up with mathematical symmetry. There is in the foreground an expanding space which we cannot always suppress. That space can be very high, and it can be very low. It can lose the ceiling, it can pick up objects on the floor, it can cut off the furniture at unexpected angles. Our line of sight is cut off at each side, as if by a frame, and whatever is sliced off by that frame is invisible to us."[3] These words apply very well to this painting. It should not be supposed, however, that it is an arbitrary slice of life. Rather, Vuillard capitalized upon the newly flexible space that appeared to his eyes when looking carefully and not ideally at an interior, and found there the way toward not only an intimist art but a profoundly decorative one.

Vuillard's formal means were crucially determined by his membership in the Nabi group. With Bonnard, Sérusier, Roussel, Denis, and the others, he learned of Gauguin's belief in a decorative art independent of nature to a new degree. Like Bonnard, but unlike the others, however, Vuillard absorbed the decorative lesson but not the anti-naturalistic one. He was never attracted to the peasant or primitivist themes of the Nabis, but allied the new compositional freedom to the domestic subjects he clearly loved. In 1892–93, after he had been painting for two or three years with bare flat shapes, these shapes began to fill out with detail and with patterning. At the same time, Vuillard began to receive commissions for large-scale paintings. In the mid-nineties he perfected the grand decorative interior. The remarkable Vaquez decorations of 1896 repress deep space for the flatness of a *mille-fleurs* tapestry.[4] The *Large Interior,* painted a year later, allows of more space, while still returning it to the flat surface—seeming, in fact, to play off the flatness of the painting against the perspectively distorted flatness of the patterned fabrics and carpets in the work. Space is spread out laterally, closed off by the decorations that push themselves up to the surface. The picture is a frieze of intersecting and overlapping patterned planes, its intervals marked by the upright forms—the figures, furniture, drapes, and striped blinds—and the whole dominated by the sumptuously painted chromatic spectacle of the papers and books on the table at the center.

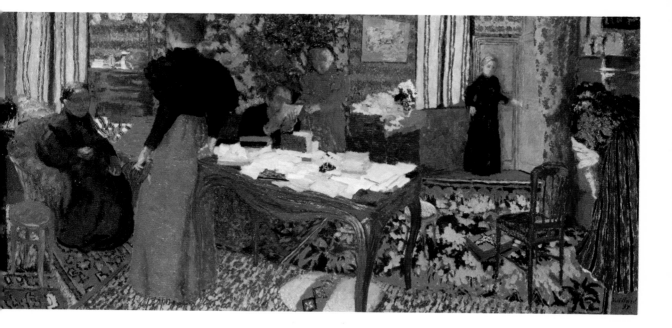

CUNO AMIET
Apple Harvest. 1907
Oil on canvas, 39⅝ × 39⅝" (100.5 × 100.5 cm)
Private collection

Cuno Amiet was introduced to modern painting in the thirteen months he spent at the famous Pension Gloanec at Pont-Aven in 1892–93. Gauguin had already left Europe by this time, but Bernard, Sérusier, O'Conor, and several other members of the Gauguin circle were still there. Through them Amiet learned a light, decorative version of the Synthetist style. He subsequently came under the influence of Hodler and of Klimt, then made a number of paintings that parallel those of the Fauves. In 1906, he joined the Brücke group at the invitation of Erich Heckel, and from 1908 until the early thirties painted in an Expressionist manner. Amiet was a willfully eclectic painter who readily acknowledged his indebtedness to a very wide range of international modern art,[1] but the principle of open decorative painting that he discovered at Pont-Aven—if not the specific forms of that style—was the one which served him best throughout his career.

Amiet gradually refined the broad *cloisonniste* contours and Art Nouveau morphology of the Gauguin circle to create a far more simplified combination of pencil-thin drawing and flat decorated shapes that in its very simplicity has a somewhat naïve or primitive quality. This development may in part be explained by the influence of Hodler's economical style: "Even in drawing," Amiet observed, "he [Hodler] knew precisely how to insert the line of shadow so that the desired modeling could be achieved by the simplest means. I recalled that already at Pont-Aven my older friend O'Conor had spoken to me of such a way of drawing."[2]

Combining the decorative quality of Pont-Aven art with the preci sion of Hodler's, and infusing this combination with a happy vital ity that was all his own, Amiet produced in 1907 some of his most charming and confident works.

This *Apple Harvest* of 1907 was the first important representa tion of what became a favorite theme in Amiet's art. Shortly after returning from Pont-Aven he had painted a *Garden of Eden,* whose stock biblical figures were overshadowed by a massive apple tree filling nearly half of the picture.[3] Here the tree has grown to gigantic proportions. This vast image of abundance—itself the shape of a huge upturned apple—cannot even be contained by the frame of the painting. Before their impossible task, the harvesters shrink into minuteness. Clearly, Amiet attached some symbolic meaning to this image of inexhaustible fertility. It is not far from being a primitive version of the theme of a pastoral Golden Age which attracted considerable attention among painters around the beginning of this century.

When Amiet discussed his artistic methods, he used the image of a tree by way of illustration, and could almost have been think ing of this particular painting when he talked of the number of individual greens to be observed, of the contrasts between different forms, and of the need for patient analysis of their relationships. "From all of this," he insisted, "from all these particular observations, a calm, clear whole must be born—just as it appeared to us on first glance."[4]

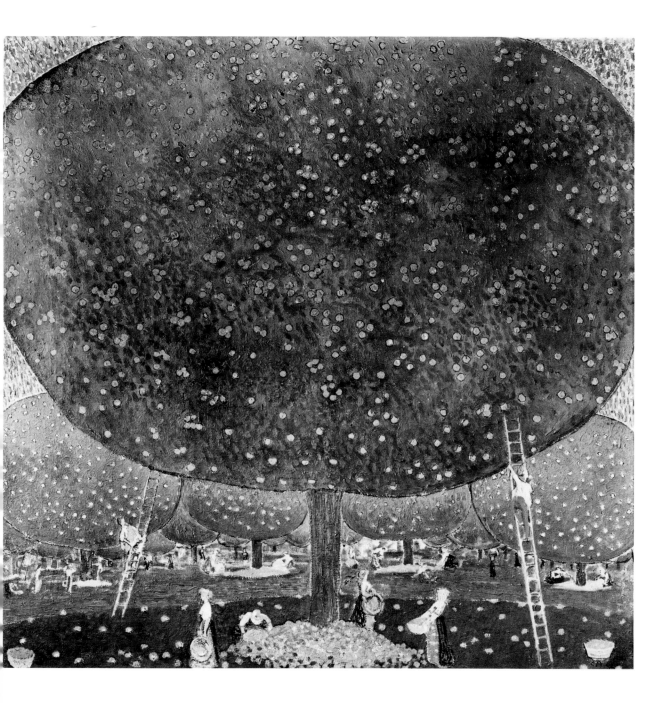

ODILON REDON
The Turquoise Vase. ca. 1910–12
Oil on canvas, 25⅝ × 19¾" (65 × 50 cm)
Private collection

In the early 1890s, after working for twenty years primarily in black and white, Redon began to use color. It crucially changed his art. "Colors contain a joy which relaxes me," he said; "besides, they sway me toward something different and new."[1] The very joyousness of his work in color was certainly new. The somber, introspective vision of his charcoal drawings and prints was replaced by happier fantasies. He was still concerned with "putting—as far as possible—the logic of the visible at the service of the invisible,"[2] that is to say, with dreaming before nature and "docilely submitting to the arrival of the 'unconscious.' "[3] That was not changed. What the use of color did change was the forms in which the unconscious arrived. No longer did his dreams produce monsters.

By using color, Redon said, "I have recovered the hope of giving my dreams greater plasticity."[4] He was referring to his first colored works, in pastels. By the late nineties, however, he was working in oils. The changes in medium were crucial. "I believe," Redon insisted, "that suggestive art owes much to the stimulus which the material itself exerts on the artist. A truly sensitive artist does not receive the same inspiration from different materials since these impress him differently."[5] His submission to the arrival of the unconscious meant also submitting to the properties of a specific medium and the way it allowed images to form. Hence, in his pastels he would start by scrawling colors on a sheet to evoke inspiration and from these random marks begin to create images. The character of Redon's imagery thus changed with the changes in media. In the progression from charcoal drawing to pastel and from pastel to oil it is as if Redon's dreams gradually emerge from deep chiaroscuro gloom, float in a soft atmospheric space, and then achieve more sharply focused form. When imagery from the earlier work was carried over to the oil paintings it took on a far more factual character. Redon became absorbed in the different surface qualities possible in oil painting and with the new, more physical reality it gave to his images. In 1910—at the age of seventy—he turned to realistic subjects in his series of still lifes of flowers.

That year he had inherited a country house outside Paris where his wife began to cultivate flowers and arrange them for him in different vases.[6] *The Turquoise Vase* is not as detailedly realistic as some of the still lifes but nevertheless gives the impression of concern for the minutiae of nature. This had been the starting point of Redon's art. "Only after making an effort of will to represent with minute care" the objects of nature, he once said, was he "overcome by the irresistible urge to create something imaginary." Now, the real itself takes on an imaginary character. The mottled gray-beige background and turquoise vase, both painted with frescolike flatness, create something of the effect of antique art already idealizing and mythicizing the painting. The flowers themselves are created from delicately adjusted impastos and color that cause them to float in strangely disembodied harmonies. The color itself is intense, exotic, and of a jewellike brilliance. Nature is represented yet seems unreal. However realistic Redon's art became, it was but the realism of a painted dream.

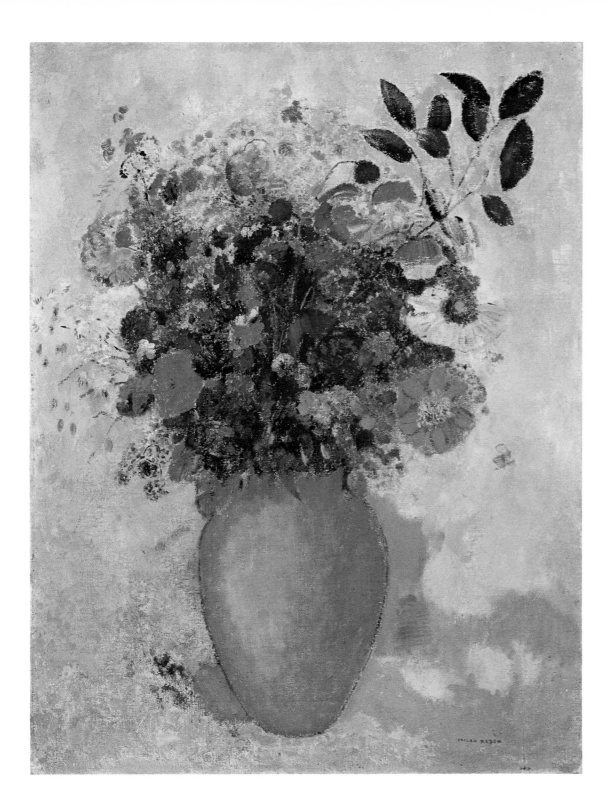

Georges Rouault
Condemned Man. 1907
Oil on paper, $11^1/_2 \times 16^1/_8''$ (29×41 cm)
Private collection

Rouault developed to artistic maturity at the same time as the Fauves. He had been a fellow pupil with Matisse at Gustave Moreau's studio in the 1890s, and when the Fauves burst on public attention at the Salon d'Automne of 1905, Rouault—who also showed in this salon, though not with the Matisse circle—was taken to be one of them, and has been popularly associated with them ever since.[1] Rouault, however, was not a Fauve painter. He was never a close affiliate of Matisse. The primitivized Rembrandtesque style he began to develop around 1902 (having previously followed the Dutch master even more slavishly) has little in common with Fauve art—apart from the primitivism. Fauvism, in essence, was construction in color. Rouault's art subsumes the purity of color to create rich, luminous glazes, and eschews the flat surface organization of Fauve paintings for more traditional chiaroscuro effects. The critic Louis Vauxcelles called him a "dark lyricist."[2] In drawing, however, Rouault is often more than lyrical, and sometimes even brutal in his rendering of the human form, for he sought to link his methods of painting to the representation of inherently expressive images. Expression, for Rouault, resided in what Matisse rejected: "passions glowing in a human face,"[3] and particularly in the faces of a dark dramatis personae of clowns, prostitutes, entertainers, and of criminals and their judges.

In 1907 Rouault started making visits to trials at the Seine courts, visits arranged by the Deputy Prosecutor, Garnier.[4] It was Garnier who made it possible for Rouault to see the sentencing of a man called Vacher which is documented in this painting, *Condemned Man.* "They're all true to life," Garnier apparently said of Rouault's judges, "and I know them like a book."[5] Rouault's daughter has stated that her father was shocked by some of the decisions he heard, by the lack of insight of the judges, and by their inadequac which is recorded in the paintings.[6] In this monumental but morb scene, the somber white-shirted figure of the defendant is flanke by two judges in black caps, one in a red gown and one in blac There are undoubtedly religious as well as moralistic undertone in part an allusion to the judgment of Christ, in part a commenta on human equality—for all of the figures are lined up as equa similarly rendered in gloomy tones, with masklike faces with roug red highlights. "The reason I gave my judges such woeful faces Rouault said, "was doubtless because I expressed the anguis myself feel when I see one human obliged to judge another. An when I mistook the judge's face for that of the defendant, I w merely betraying my own distress. Nothing in the world cou make me accept the position of judge!"[7] Here the head of th judge to the left is indeed almost identical with that of the co demned man.

Although dark and even sinister, Rouault's imagery is not much pessimistic as harshly realistic. Rouault occasionally fell in a kind of pathos we now find unconvincing, but the best of his ear paintings convey a chilling sense of fact. Their moralistic realis carries the tradition of the late Goya and of Daumier into th twentieth century. Reviewing the Salon d'Automne of 1907, whe the *Condemned Man* was shown, Vauxcelles well expressed th menacing power of this particular painting: "In these unforgett bly terrifying pictures, both these representatives of authority ha faces that are as sinister as those of the gangsters over whom th authority is exercised; all are grim and low-browed, battered base passions and frenzied excesses. They look at us like so ma live puppets in a burlesque marionette show, at once terrifying ar splendid."[8]

HENRI MATISSE
The Idol (Portrait of Mme Matisse). 1906
Oil on canvas, 28³/₄ × 23⁵/₈" (73 × 60 cm)
Collection Jacques Koerfer, Bern

In the winter of 1905–6, Matisse worked concurrently in two different styles of painting. One extended the spontaneous mixed-technique manner of the work he had exhibited in the notorious Salon d'Automne of 1905, where he and his friends had gained the name *les fauves,* or "the wild beasts."[1] The other turned away from the informality of that manner for something more severe and structured in appearance, though equally brilliant in color. Only in rare images, such as this exuberantly painted but hieratic "idol," did the two come together. *The Idol* uses the methods of mixed-technique Fauvism to create a decorative and monumental effect.

Stylistically, *The Idol* recalls the famous 1905 portrait of Mme Matisse known as *Woman with the Hat,* with its violently colored millinery, face, and costume.[2] Both paintings are based on the contrast of the complementaries red and green, and both use a variety of methods of paint application to engender a feeling of uninhibited directness and spontaneity. From the summer of 1905, when Matisse's Fauvism first fully emerged, he released color composition from a dependence on tonal values and discovered pictorial coherence in the sheer interaction of hues. With this emerged a new stylistic self-consciousness with reference to the physical components of painting. In all paintings, the spots, lines, and areas of color which describe objects can be viewed as individual and autonomous pictorial components. In Fauvist paintings, however, they force themselves to be viewed thus to an altogether unprecedented degree. In the mixed-technique style of Fauvism, the varied methods of paint application reinforce our awareness of the paintings as physical constructions of color.

The very nature of the color in *The Idol* furthers this impression. Flat, pure colors little modified by tonal gradations affirm the planarity of the painting surface as a taut, stretched membrane, and especially do so when the colors clash in complementary contrasts as here. The dazzling vibration of red and green holds th eye on the surface of the painting. All of Matisse's work came to b a continuing investigation into the properties of this wafer-thi sheet of the picture surface, which resists optical penetratio inviting the eye to cross and recross it but never to disrupt its unit Even the excited handling cannot disguise Matisse's insisten upon the tangible painted surface, his insistence that everything b resolved in the terms that this surface prescribed.

Matisse's investigation of the reciprocations between colors an surfaces cannot, of course, be isolated from the subjects the serve. It was not merely the reality of color but the reality availab in color that Matisse was concerned with. The *Woman with the H* of 1905 used a decoratively posed subject to challenge conve tional notions of the decorative in painting. Matisse's second f mous 1905 portrait of his wife, *The Green Line,*[3] invested a simp frontal head with an austere monumentality created by col alone. *The Idol* combines the decorative and the monumental, an infuses this combination with a luxuriant and somewhat primitiv mood. We must remember that Matisse was at this same tim working on his idealized and arcadian *Bonheur de vivre.*[4] Th garlanded figure is without doubt related to the nymphs wh populate the larger painting. Although its excited technique an vibrant color make *The Idol* a vitalist Fauve painting, it is also a image of the ideal and resplendently artificial state of existence t which Matisse was increasingly becoming drawn. "Underneat this succession of moments which constitute the superficial exis tence of things," he wrote in the "Notes of a Painter," "it is ye possible to search for a truer, more essential character."[5] In *Th Idol* we can already recognize, beneath the immediacy and flux Matisse's Fauvism, that feeling of ideal and internal calm he cam to guard so jealously in his subsequent art.

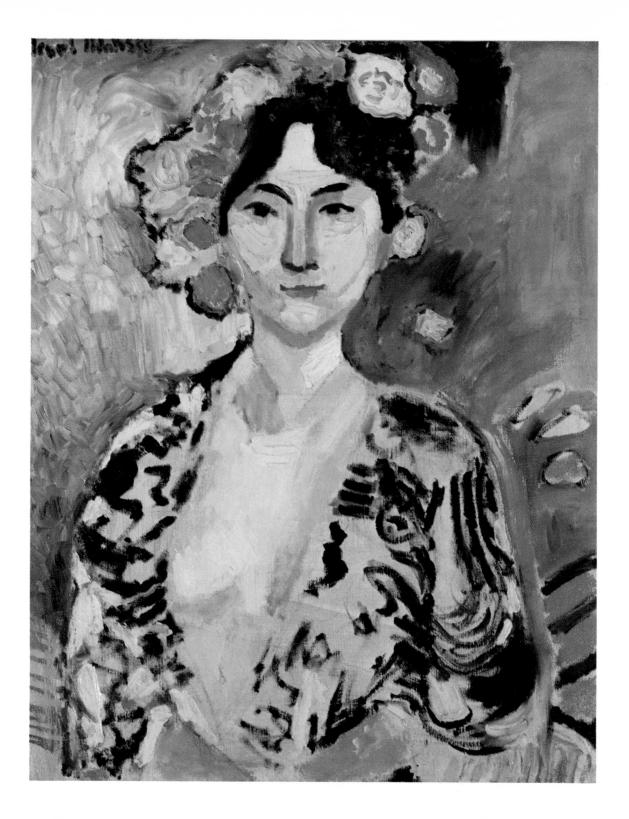

HENRI MATISSE
The Chair with Peaches. 1919
Oil on canvas, 51¼ × 35⅛" (130 × 89 cm)
Private collection

"To copy the objects in a still life is nothing," Matisse told his students; "one must render the emotions they awaken in him. The emotion of the ensemble, the interrelation of the objects, the specific character of every object—modified by its relation to the others—all interlaced like a cord or a serpent."[1] In this still life of a Lorrain chair with three golden peaches in a silvery white scallop-edged dish, the elements are interlaced together on a symbolic as well as a pictorial level as an image of the natural world is displayed in a decoratively artificial setting.

The connotations of this setting, however, are ambiguous. The top of the chair is strangely distorted away from the rest of its structure, so that it looks somewhat like a separate entity, like a tray, in fact, that has been placed diagonally across the chair's seat. This accentuates the sense of an intrusion of the natural world into that of the painting—as if the tray of fruit had recently been carried into the geometrically organized ensemble. The fruit itself intrudes its three-dimensionality on the two-dimensional surface and expresses the distinction that Matisse certainly recognized between the tactile quality of objects in the world and the purely optical parameters of his own art. His *Harmony in Red* of 1909 was the first of his great decorative paintings on this theme.[2] Now, ten years later, he returns to the same *toile de Jouy* fabric which enveloped that painting and presents its flattened stylizations of fruit and arabesque branches as a background to the "real" fruit placed upon the chair. The fabric—the ornamental version of nature—is flattened to and identified with the plane of the canvas, appearing therefore to push off the surface the volumetrically rendered fruit on the dish. (Accentuating this effect, the fruit and dish cast shadows—on the surface of the painting itself, it seems—while no other forms do so.) The pattern of the fabric, however, is picked up in the decorations on the chair, which itself belongs both to the flat geometry of the surface and to the protruding volumes of the still life and mediates between these two worlds, the flat and artificial on the one hand and the volumetric and organic on the other. This is yet another instance of Matisse's image of art as a "good armchair" which transforms literal tactile nature into something that is "a soothing, calming influence on the mind."[3]

The painting, however, may be understood in rather a different way. If the fabric is artificial, it is also natural—not merely because it reproduces natural forms but because, when seen in conjunction with the flattened green-gray floor, the background of the painting becomes analogous to a landscape. The color is soft and atmospheric—natural, not artificial color. The pattern of the *toile* is not tightly drawn as with the *Harmony in Red,* but fluid and open, even to suggesting the open space of a sky. The fruit, on the other hand, being solid and volumetric, does not belong to this atmospheric pictorial landscape. It is the tangible constant of the painting, pushed forward toward the viewer, yet tied to the surface at the junction of its vertical and horizontal geometry. The three golden orbs may draw to one's mind Matisse's earlier representations of an ideal Golden Age, something fixed, eternal, and calm that isolates itself from transitory nature.[4] These bold, solid forms might also be seen as symbols for the order and clarity that Matisse sought for his art.

It is not to be wondered at that Matisse's painting allows of different levels of interpretation. He abhorred the idea of a fixed language of symbols. In painting, he was concerned with creating what he called "signs" for objects, each of which contained "the sum total of its [the object's] effects" on him.[5] "I can't play with signs that never change," he said.[6] Each object that he painted is a veritable storehouse of meanings. Each subject he treated is tailored to match and to consolidate his pictorial interests. The serenely understated composition fuses form and meaning in quiet contemplation on the function of his art.

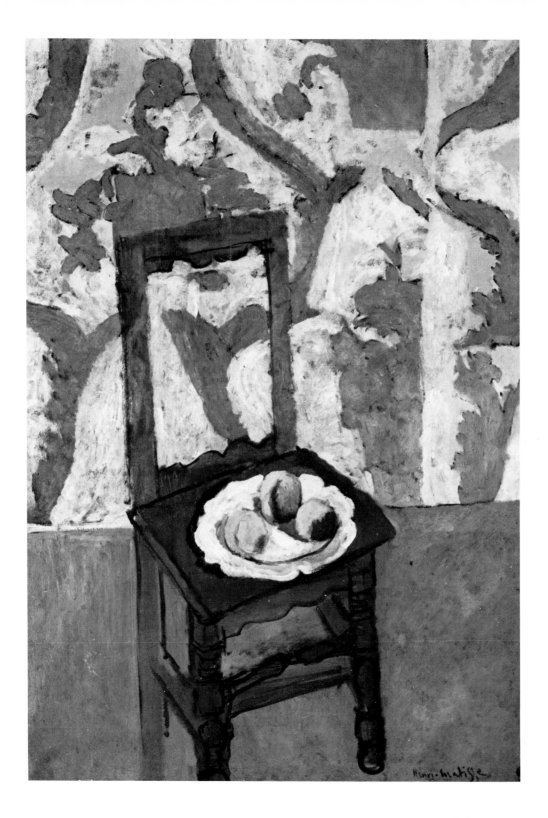

HENRI MATISSE
Blue Nude I. 1952
Gouache on cut and pasted paper, $45^3/_4 \times 30^3/_4''$ (116 × 78 cm)
Galerie Beyeler, Basel

Matisse is first known to have used paper cutouts in planning his mural, *The Dance,* for the Barnes Foundation in 1931.[1] Some twenty years later, in his late series of *papiers découpés,* he made this preparatory technique into an independent and major medium. The most ambitious of these late works were often conceived on a murallike scale; this is true both of the polychromatic découpages and those consisting of blue-colored papers fixed on a white ground. There is, however, one group of major works that conforms far more to the conventional scale of easel painting and therefore expresses the continuity of the late works with those of Matisse's past, namely the group of four magnificent seated *Blue Nudes* of 1952.[2]

The pose that Matisse used for these figures—intertwining legs and an arm reaching behind the neck—was a favorite of his. One is particularly reminded of the large number of seated nudes from the period 1920–27,[3] but variants of the pose go still further back in Matisse's art, for the seated figures of the twenties were developments of the famous *Blue Nude* of 1907 (and accompanying sculpture, *Reclining Nude I*) and, before that, of one of the figures from the *Bonheur de vivre* of 1906.[4] Matisse's entire oeuvre reveals a deep sense of continuity in the persistence of certain basic themes. *Blue Nude I* and its companions bring one of these themes—the decoratively posed female form—to an appropriately audacious conclusion.

From at least the time of the *Bonheur de vivre,* Matisse had sought an expressive and emotional decorative art founded on the human figure. "My models," he once said, "are the principal theme in my work." He continued, however: "The emotional interest aroused in me by them does not necessarily appear in the representation of their bodies. Often it is rather in the lines, through qualities distributed over the whole canvas or paper, forming the orchestration or architecture."[5] In *Blue Nude I,* specific representation is shunned for a decorative arabesque, but one that still suggests an emotional appreciation of the female form, and largely because of the tactile associations that the work allows.

"Cutting to the quick in color reminds me of the sculptor's direct carving," Matisse said, with reference to his découpages.[6] Something of the physical control of sculpture was brought to the picto-

rial framework of painting, in a medium that was neither painting nor sculpture but partook of the character of both. Matisse always insisted that each individual means of expression has its own unique methods and effects. The découpages are close to painting but their method of creation allowed Matisse a very direct contact with his materials, a contact reminiscent of his experience of sculpture. Matisse cut into color much as if he were making a relief. The cut edges of the paper directly reveal the actions of his hand. The painted blue shows variations in density that stress its material nature. The improvisational, cumulative method of the composition is confirmed by the signs of Matisse's revisions, which can be seen from close to. Matisse was sensitive to the particular physical nature of these works; while they were in progress he would leave them lightly pinned to the wall, where they would tremble in the slightest breeze.[7]

In feeling as well as in method they relate to Matisse's sculpture as well as to his painting. They reveal a sense of latent energy, freedom—and even at times abandon—that characterizes some of the most important of his sculptures; and this sense is here combined with the serenity and order of his pictorial art. *Blue Nude I* may usefully be compared with sculptures like *La Serpentine,* 1909.[8] In *Blue Nude I,* a narrow, arabesque torso twists down the whole design and is stabilized by the strong vertical of the model's left arm. The oppositely placed breasts and exaggerated broad legs are treated in a highly manual fashion and with a sense of freedom that also characterizes the early sculptures. The implied overlapping created by the separate flat forms, however, is utterly pictorial. If the method of the découpages relates to sculpture, it nonetheless was adopted mainly to present color with new directness. Of his paintings Matisse said that color must not "simply 'clothe' the form: it must constitute it."[9] "When I use paint, I have a feeling of quantity—a surface of color which is necessary to me, and I modify its contour in order to determine my feeling clearly in a definitive way." To "contour" color was to fuse descriptive form and emotive color in one pictorial sign. By cutting into color and physically penetrating into forms, Matisse found "the simplest and most direct way to express myself." "I have attained a form," he said, "filtered to its essentials."

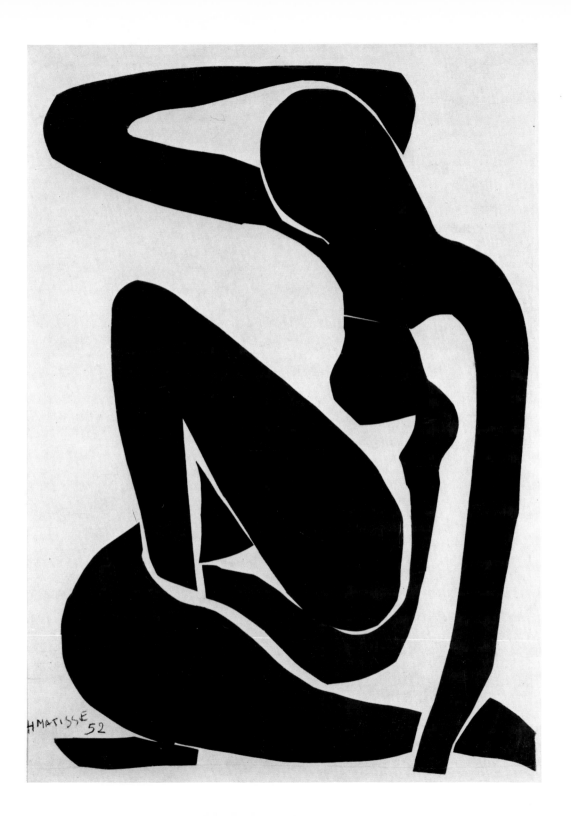

PABLO PICASSO
Two Nudes. 1906
Oil on canvas, 59¹/₂ × 39³/₈″ (151 × 100 cm)
Private collection

In 1906, Picasso's art underwent a swift and remarkable transformation. The year opened with his stripping his paintings of particularized references as, under the influence of antique art, he turned from the representation of melancholy saltimbanques to that of an idealized, lyrical, and classicist world. It closed with his studies for the *Demoiselles d'Avignon* and the opening of the Cubist epoch.

Two Nudes, from the autumn of 1906,[1] stands balanced between the lyrical classicism which dominated the year and the more somber, hieratic, and impersonalized art which ended it. Picasso spent the summer of 1906 at Gosol, in Spain. There the classicizing impulse of his art was broadened, particularly in paintings of large rose-ocher nudes. At the same time, however, a certain sculptural monumentality, and even primitivism, began to enter his work; and it was this which he consolidated back in Paris in the autumn.

This painting is one of a series of compositions of two full-length figures.[2] It was preceded by two preparatory studies, one of which—an ink-and-watercolor drawing[3]—simplified the figures' limbs and torsos into somewhat tubular forms, each shaded without regard to a consistent source of light. In the painting itself, the heads seem to be illuminated from opposite directions. The patterning of light and shade is thus as much a pictorial as a mimetic device. As he developed into Cubism, Picasso used shading in an increasingly autonomous fashion: to analyze the structure of the motif even at the expense of verisimilitude. We see the beginnings of such an approach in this painting.

The scumbled treatment of the left-hand figure is close to the generalized *sfumato* modeling of the second study for the painting.[4] It also recalls the loose, sketchy brushwork of Picasso's pr Gosol work. In the right-hand figure, however, Picasso's mo "finished" treatment creates the sensation of a shallow surfa relief. Although the figure is undoubtedly solid and sculptural, relieflike effect gives the painting a remarkably flatten appearance—the frontal modeling seeming to push up to th picture plane rather than excavating space behind it.

In the autumn of 1906 Picasso was importantly affected by Ib rian sculpture and by Mannerist painting, particularly El Grec These sources are only marginally visible in this painting. The hea of the left-hand figure is the more stylized in form. The stro division of light and shade on the forehead and simplification planes on the cheeks and neck look forward to the fragmentation forms in early Cubism. Nevertheless, the still wistful, introvert expression of the face reminds us more of Picasso's earlier wo than of the Expressionist distortions which are to follow. Likewis only the elongation of the figures speaks of Picasso's interests Mannerism. The crooked arm of the left-hand figure recalls a sim lar form in the dramatic, El Greco-like *Composition: The Peasan* of August 1906.[5] The angular deformation of planes in that paintir directly prepares for the *Demoiselles d'Avignon.* Here, howeve and for almost the last time before the dramatic Cubist revolutio Picasso's art rests in a feeling of indolent calm and serene terr cotta classicism.

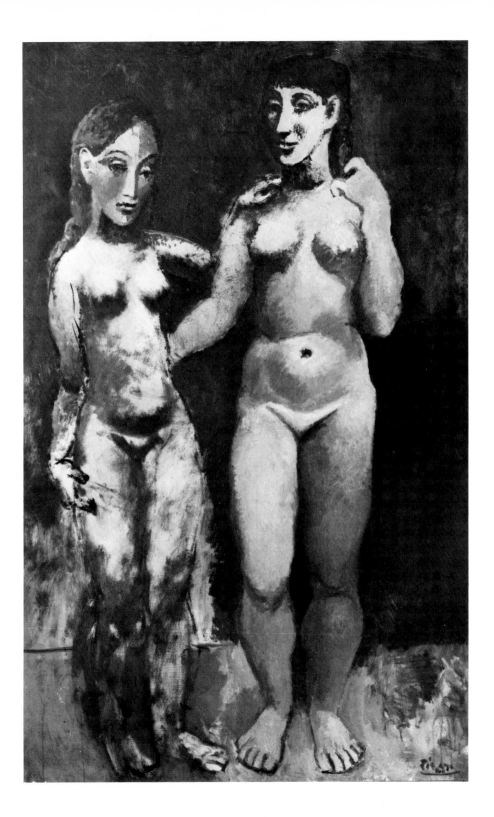

PABLO PICASSO
Bread and Fruit Dish on a Table. 1909
Oil on canvas, 64⅝ × 52¼″ (164 × 132.5 cm)
Kunstmuseum, Basel

Picasso's *Demoiselles d'Avignon* of 1907 synthesized the two directions of his immediately preceding art: a somewhat Mannerist direction, using angular and distorted planes, and a solidly sculptural form of painting, deriving ultimately from his interest in classical art. After the *Demoiselles* had been painted, these two directions concurrently reappeared. The figure paintings of the so-called Negro Period of 1907–8 extended the "barbaric" and Expressionist side of the *Demoiselles*. At the same time, however, Picasso was painting simple still lifes in sculptural monochrome. By the second half of 1908, solid and impersonal forms had begun to win over angular and primitivist ones. While the *Demoiselles* was an epoch-making work, whose daring analyses opened the way to Cubism, its "Expressionist" potential—which Picasso developed most forcibly at first—appears in retrospect to be something anti-Cubist. Only when Picasso consistently returned to a more restrained and classicized art did Cubism itself begin to emerge.

Bread and Fruit Dish on a Table is one of an impressive series of still lifes from the winter of 1908–9 and the early spring of 1909[1] which reveals Picasso's confrontation with the classicism of Cézanne—and also his combination of Cézannist forms with ones derived from the study of primitive art. Since the *Demoiselles,* the Cézannist and the primitive had been explored separately, in a polarity of the classical and the barbaric. Now the analysis of simple, sculptural forms learned from primitive art supported a new structural and conceptual interpretation of Cézanne. Hence Picasso was drawn to the solid, monumental aspects of Cézanne's painting. Forms are severely drawn, with firm, unbroken contours. The shading emphasizes the separate three-dimensional identity

of each object, and except in one isolated case (the apple wi... complementary green shadow to the red-brown illuminated zon... is entirely a matter of lights and darks and not (as was the case wi... Cézanne) of different hues. Although the area of background dra... ery and crumpled cloth suggests a degree of interpenetration b... tween the different planes (as does the planar simplification of th... table itself), Picasso does not here explore the Cézannist techniqu... of *passage*. He focuses instead on Cézannist simplification, trea... ing the subject "in terms of the cylinder, the sphere, the cone, a... placed in perspective, so that each side of an object or plane ... directed toward a central point."[2]

In some respects, this work seems exactly to follow Cézanne... "program": the simple geometric forms point into the center ... the painting. Yet none of Picasso's forms (nor Cézanne's, for th... matter) seems fully three-dimensional. Space is so narrowed th... each object appears to be cut off flat on the reverse side—thu... extending the bas-relief effect that had characterized most ... Picasso's work since 1906. The broken horizontal line of the far sid... of the table is strongly Cézannist, as is the tilted-up appearance ... the composition. The use of different viewpoints for different ob... jects is new: for example, the pure elevation rendering of th... upturned cup is inconsistent with the downward view into the to... of the fruit bowl. As yet, however, Picasso's firm separation of on... object from the next means that such ambiguities inflect a spac... that can still just be interpreted as a naturalistic one. It was not unt... the summer of the same year, at Horta de San Juan, that Picass... opened up the contours of objects and transformed the lessons ... Cézanne to far more radical effect, in the first mature statements ... Analytic Cubism.

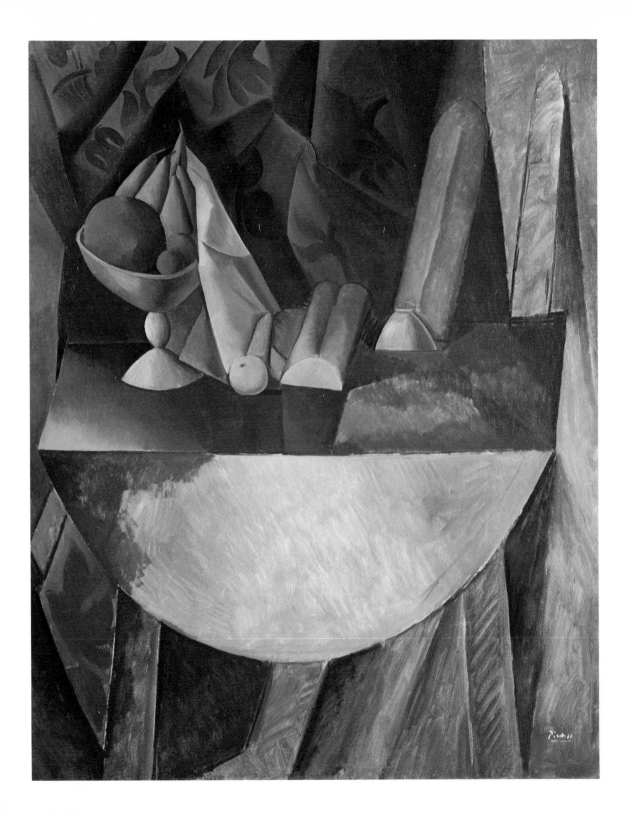

PABLO PICASSO
The Aficionado. 1912
Oil on canvas, 53^1/$_8$ × 32^3/$_8$" (135 × 82 cm)
Kunstmuseum, Basel, gift of Raoul La Roche

In 1912, the allusive, painterly forms of high Analytic Cubism began to give way to a more explicit and geometric kind of painting. Late that year, what is usually called Synthetic Cubism began to emerge. The invention of collage in May 1912 was critical to the development of the later Cubist style, since the "foreign" materials it used introduced into the work of Picasso and Braque large, flat shapes and a vocabulary of preexisting forms which, when rendered in paint, formed the essential characteristics of Synthetic Cubism. But Synthetic Cubism was not merely a painted version of collage. The gradual flattening and geometricization of high Analytic Cubist painting in 1912 was equally important for what followed.

Picasso's *Aficionado* is a particularly instructive painting when viewed in the light of subsequent developments. It is also, in its own right, one of his finest, most important paintings and the apogee of the high Analytic Cubist style. It was painted in the summer of 1912 at L'Isle-sur-la-Sorgue near Avignon.[1] The subject (somewhat more easily recognized than in Picasso's immediately preceding paintings) is a man at a café table, a guitar on one side and a carafe on the other. The bullfight periodical *Le Torero* lies on the table, and behind the aficionado is a tricolor pennant carrying the name of Nîmes, a principal site of the French Corrida.

Compared even to Picasso's own paintings of 1911 and early 1912 this is a highly architectonic work. Part of the gravity and profundity it evokes is due to the firmness of its drawing, the locked-in stability of the vertical-horizontal scaffolding inflected by

diagonals which mirror the triangulation of the whole image. It altogether less meditative and lyrical than Picasso's previou paintings, creating instead a feeling of sonorous grandeur in th hieratic forms of its geometry. Here the linear scaffolding, unli that in the previous high Analytic Cubist paintings, does not ble into a painterly continuum of atomized shading. Picasso abandor the use of small, horizontal, allover brushstrokes; here he shade each plane separately with summary multidirectional infilling. As result, the fragmented forms begin to come together again ar become synthesized into larger, more firmly contoured, and mo explicit shapes. All of the planes are resolutely frontal. Even th disengaged contours of the face slide laterally across each other create only a slight feeling of depth. Throughout the painting ther is far less recessional space implied than was the case before. Th surface itself seems to block off all but the shallowest illusions space.

As the planes become more particularized again, touches local color begin to intrude within the allover monochromy. (Th head was originally painted a bright flesh pink, then reworked i the usual darker Analytic Cubist tones.) The signlike drawing details becomes more diagrammatic. (The moustache and bear appear to have been combed into the paint.)[2] Throughout, tha feeling of flux which characterized Picasso's and Braque's pain ings of 1911–12 is giving way to a new sense of the particular ar the tangible. This is still far from the jigsawlike structure of Sy thetic Cubism, yet it points in that direction.

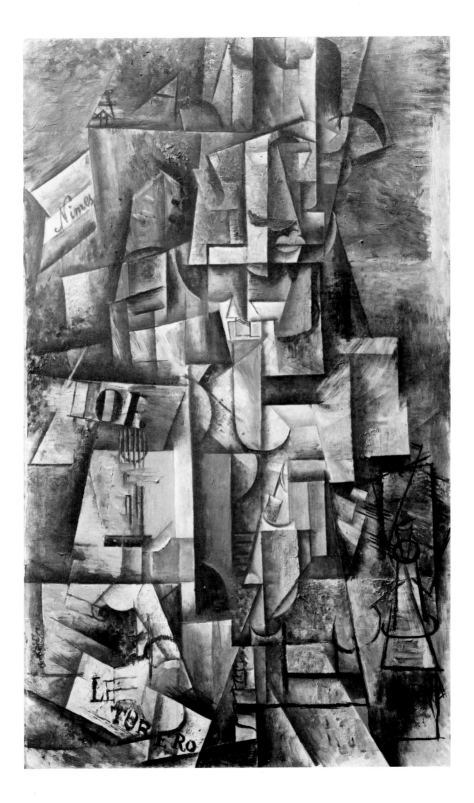

PABLO PICASSO
Souvenir of Le Havre. 1912
Oil on canvas, 36¼ × 25⅝" (92 × 65 cm)
Private collection, Basel

Braque had spent the summer of 1912 with Picasso at Sorgues. At the end of the summer he made a visit to Le Havre to see his family, and Picasso accompanied him. Picasso's "souvenir" of this harbor town was painted upon his return to Paris in the autumn.[1] It is one of the liveliest paintings to have been produced in the high Analytic Cubist manner, and shows the sheerly exuberant brilliance Picasso was capable of as he worked with ease and confidence across the full stylistic arsenal that he had been developing over the preceding few years.

This is a freer, less geometric painting than *The Aficionado;* far softer and more atmospheric in feeling. Nevertheless, a strong grid structure underlies the more playful forms, and in the upper part of the painting it is laid out with as much regularity as Picasso ever allowed. Toward the bottom, however, free forms increase, seeming to tumble down the sides of the picture until they are joined across the two halves of the curvilinear lettered scroll from which the picture takes its title. In the autumn of 1912 Picasso was very much preoccupied with *papier collé.* This may account for the playfulness of some of the forms as well as for the richly varied surfaces of the work. Picasso's use of schematic illusionistic drawing that overlies the flat painted planes, and seems therefore to float above the picture surface, is certainly related to his drawing over the flat pasted planes of the *papiers collés.* The loose, summary brushwork (with now only a few vestiges of the earlier squarish strokes), the stenciled and hand-drawn lettering, the trompe-l'oeil drawing and trompe-l'oeil wood-grain effects—all these features point to a deep interest in the tactility of the surface in Picasso's work of late 1912.

With surface given this prominence, Picasso's painting becomes noticeably flatter and more objectlike in character. Although there are areas of deep space here (and, indeed, truly cubic volumes to the upper left), in general the flat planes press themselves up to the surface. Although the varied treatment gives the painting a certain atmospheric feel, it is not the indeterminate spatial atmosphere of a year earlier: the recessional space is more or less abolished for

something far more opaque and tangible in character. The ov[al] shape allows the centralized composition to develop equidistan[t] to the edges, so that at the point the imagery begins to dissolv[e] and the space therefore to deepen, the presence of the framin[g] edge reaffirms the flatness and objectlike quality of the work.

But if this stamped-out oval gives tangibility to the painting, [it] also gives to its imagery a certain feeling of weightlessness or fr[ee] suspension that is particularly appropriate to such an evocativ[e] work. This *Souvenir of Le Havre* shows how the specific mood [or] atmosphere of a location could as efficiently be communicated b[y] Cubism as by any conventional pictorial means, if indeed not mo[re] so—for the juxtaposed and superimposed images evoke the feel[ing] of a bustling port more vividly than any single representation [of] Le Havre could hope to do. Around the bottle and glass— presumably now back in Picasso's Paris studio—the memories [of] the visit revolve. Down the right-hand side we first see the form o[f a] porthole or life buoy, then a shellfish (or possibly a coil of rope[);] below that, abstract angular planes and drawn lines derived prob[ab]ably from ships' sails, and at the very bottom, a ship's cabl[e] splitting the festive ornamental scroll into two parts. On the oppo[o]site, left-hand side another ship's cable overlies the uppermost of [a] number of wooden packing cases. At the top they are stacke[d] regularly, but farther down the side they fall at eccentric angle[s,] one revealing its destination, HONF[LEUR], stenciled on its sid[e.] Beside it, the bottle at the center of the composition is identified b[y] its label as containing OLD JAM[AICA] R[UM].[2] Below, to the le[ft] beyond the glass half-filled with rum, there is another seashell, an[d] what might well be harbor steps. To the right of the glass we see [a] further pile of crates, the top one of which bears only the upper ha[lf] of the R of the stenciled HAVRE, caught up in the angular drawin[g] of sails. Talking of the "realism" in Cubist art, Picasso said that "it [is] not a reality that you can take in your hand," but "more like a pe[r]fume . . . The scent is everywhere, but you don't quite kno[w] where it comes from."[3] The reality of Le Havre presented in th[is] picture is exactly of this kind.

84

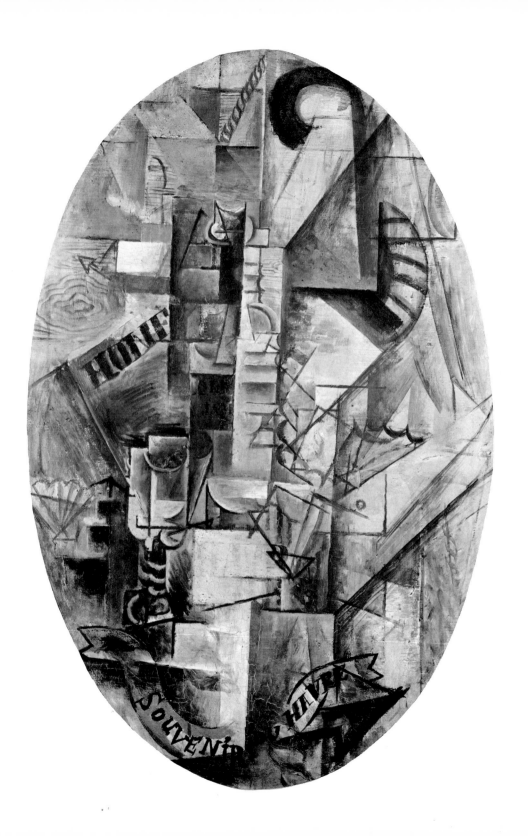

PABLO PICASSO
Seated Harlequin (Portrait of the Painter Jacinto Salvado). 1923
Tempera on canvas, 51³/₈ × 38¹/₄″ (130.5 × 97 cm)
Kunstmuseum, Basel

In 1915, the sequential development of Picasso's painting was suddenly ended. He turned to realistic imagery, and henceforward a remarkable diversity of styles (some of them concurrent) characterized his art. Picasso's stylistic diversity—previously unknown to the history of art—is something as peculiarly modern as the most advanced of his individual paintings, speaking as it does of a stylistic self-consciousness so developed that the artist can choose a style of painting in the same way as he previously chose, say, a color from his palette. Picasso's volte-face in 1915 was not, then, a retreat from the modern. It was, however, at least in part, a temporary retreat from the ''impersonality'' of Cubism and a return to the more autobiographical imagery of his pre-Cubist art.

Before he moved into Cubism, circus figures and entertainers had been among Picasso's most important sources of subject matter.[1] In 1915, even as he turned to realism, the forms of his Cubism concurrently took on a more expressive character, and first did so in the painting of a Harlequin. Imagery of the *commedia dell'arte* became increasingly prominent in his art from 1915 to 1925. From the start, the clown had represented for Picasso either his own alter ego—the artist as an alienated entertainer—or that of one of his friends. When he sought to infuse a new and personalized expressiveness into his art after 1915, it was to this

subject that he often returned. In this portrait of his friend t[he] painter Salvado,[2] we see neither a melancholy saltimbanq[ue] such as had appeared in Picasso's Rose Period nor a decorative[ly] patterned figure in the Cubist mold. Instead, the serene, se[lf-] contained feeling of this work combines something of the Ingr[es-] like quality of his contemporaneous drawings with a more weigh[ty] rendering of form derived from his paintings of monumen[tal] figures of the previous few years. In 1923 Picasso abandoned t[he] colossal Neo-Classic figures that had featured in his art since 19[]. Nevertheless, this Harlequin partakes of their monumentality[. It] was not—as had so often been the case previously—the surfa[ce] patterning of the costume that attracted Picasso. Its colors har[dly] disturb the essentially sculptural treatment of the figure. Ev[en] here, however, with Picasso at his quietest and most realistic, [the] underlying lessons of Cubism are not entirely dismissed. The f[lat]tening of the torso, advancement of the far shoulder, and, m[ore] noticeable, the off-center placement of the neck speak of his c[on]cern to accommodate sculptural form to the two-dimensio[nal] plane of the canvas. Although undertaken within the confines [of] an obviously more conservative style, such structural distortio[ns] as these would have been inconceivable without the exam[ple] of Cubism.

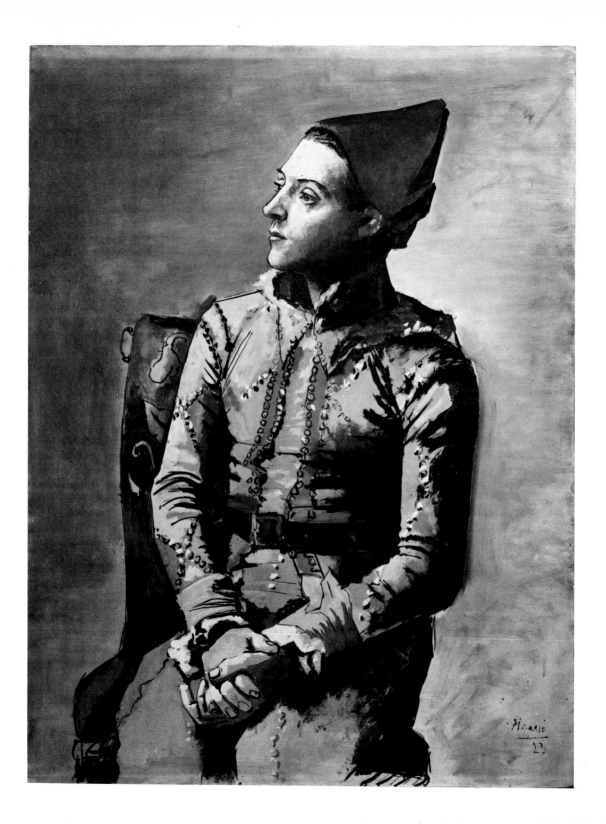

PABLO PICASSO
Women on the Banks of the Seine, after Courbet. 1950
Oil on plywood, 39^5/$_8$ × 79^1/$_8$" (100.5 × 201 cm)
Kunstmuseum, Basel

"What is a painter, fundamentally?" Picasso once rhetorically asked. "He's a collector who wants to obtain a collection by making for himself the paintings he likes."[1] Particularly in the early part of his career, Picasso used the art that he liked as inspiration for his own paintings: from Mannerist and classical art in the early years, to Iberian and African sculpture at the time of Cubism, and to Ingres immediately afterward. In doing so he was following well-established traditions—learning a formal vocabulary from the art of the past—although in learning from primitive as well as European art he was partaking in a new stylistic self-consciousness that developed hand in hand with the emergence of modern painting. In the latter part of his career, however, he began to make copies after individual paintings, of which this work—after Courbet's 1856 painting in the Louvre of the same title—is one.[2] This was also, of course, a well-established practice, although it had declined as a pedagogical method as the modern, more eclectic one took over. Clearly, Picasso's versions of earlier masterpieces are not—or not primarily—forms of self-education. They are, rather, reinterpretations, through favorite paintings, of themes or images that had constantly fascinated him.

In 1944 Picasso made a copy after a Poussin Bacchanal. In 1950 he painted this interpretation after Courbet and another after El Greco. Then came the three series after single canvases by three painters: the *Femmes d'Alger* series after Delacroix in 1954, the *Las Meninas* series after Velásquez in 1957, and the *Déjeuner sur l'herbe* series after Manet in 1959–61. This painting is the first of the "copies" on an ambitious scale. The choice of the Courbet seems curious at first since Picasso's preferences generally tended to a more classicist direction. One wonders whether Courbet's realistically modeled rendering offered a special challenge to the abstracting tendencies of Picasso's style, or even whether the title *Demoiselles des bords de la Seine* recalled the *Demoiselles d'Avignon.* It was the theme, however, which attracted Picasso: that of the "sleepwatcher,"[3] of awake and slumbering figures together.

In a group of early works, Picasso depicted himself watching sleeping girl. He returned to the theme in the early thirties. On again, artists inspect sleeping models, but sometimes the slee watcher is a minotaur, as in one of the 1933 etchings from the *Su Vollard* with superimposed horizontal figures which presage t Courbet interpretation.[4] Of the etching Picasso is reputed to ha said, "He is studying her, trying to read her thoughts."[5] All Picasso's renderings of this theme ask us to consider just what available to sight, and what is more real, the images of wakef ness or those of the dream. In the Courbet interpretation—as some of the earlier works—both figures are of the same se Picasso may have been fascinated by the ambiguous, possib Lesbian interpretation of the Courbet, but this would only suppe the principal theme: the representation of two opposite state waking and dreaming, as complementary aspects of a single, ambiguous, existence. Each figure is dissolved into compartme talized pockets of space, and both figures are melted togeth along one undulating contour.

This is a profoundly decorative painting. The mingled figur merge also with their background, though each is separately ide tified in the blues, reds, and surrounding greens and browns th dominate the work. To find a comparable balance of the expressi and decorative in a similar theme one must go back to Picass *Girl before a Mirror* of 1932,[6] which likewise fuses a double ima in an organic version of a "stained glass" effect. As in that earl painting, Picasso uses a curved linear scaffolding, derived u mately from Cubism, as the vehicle for luxuriantly sensual effec Clearly the relaxed feeling of Courbet's painting was important Picasso; but these two women are not simply young Parisienn escaped from the city for an afternoon. Their rural isolation d tances them from reality, and only the face of the watcher allowed to break the spell. The whole composition focuses up her staring left eye, and through the medium of vision we are giv access to the internal, dreamlike world of the painting.

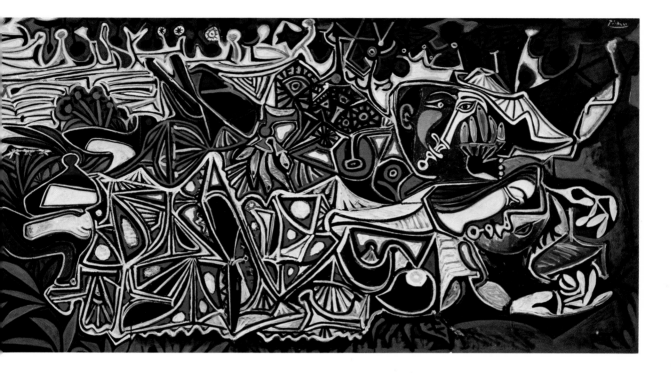

PABLO PICASSO
Large Heads. 1969
Oil on canvas, 76⅝ × 50⅞″ (194.5 × 129 cm)
Galerie Rosengart, Lucerne

Apart from the large heads that dominate this painting and give it its title, the composition is not easily deciphered. Indeed, it is impossible to situate with certainty the two bodies that should go with the heads. Picasso's paintings of the last decade of his life are often characterized by a spontaneity and bravura of execution.[1] In part of this work, the painterliness is so exaggerated as to create the effect of a charged drawing in color—one which appears nearly to be disengaged from the form it describes. This almost autonomous painterliness contrasted with the harsh iconic treatment of the heads gives to this composition a dramatic internal tension, and a certain effect of mystery—of something hidden in the painting—not to be dispelled by the brightness of the colors or by the sheer exuberance of the brushwork itself.

If something is hidden in the painting, it is hidden by the very strokes that represent it. This is the curious paradox which the lower part of the painting presents: form dissolves under the pressure of its representation. This, however, was one of the first lessons of Cubism. Sixty years earlier Picasso was certainly more deliberate and more methodical, but a Cubist transformation of solids into two-dimensionality by opening them up and making them seem transparent is still evident in this work. The outline drawing of the body with the larger head—laid over broad flat patches of summarily painted infilling—creates an open painterly web within which a few specific details can be seen (the left hand, right foot, general disposition of limbs), but which is spatially fluid and ambiguous when compared with the dark sculptural head above. This head is ambiguous in its own way and spatially mobile in its own way too, but it has nevertheless far more solid a presence than anything around it. The other head, in contrast, and the area it inhabits, is the flattest part of the picture, and in many ways the calmest. For this reason it seems to be the focus of the work.

The flat white area that contains the smaller head is almost certainly a canvas beside which the right-hand figure, presumab the artist, is standing. The head on the canvas recalls Picasso's ov cut-out metal sculptures of the early sixties.[2] (It seems to be pr sented on a sculpture stand.) If this is indeed its source, it adds y another dimension to the play on modes of representation that the subject of this painting. As it is, the painted image is mo easily deciphered than the image of the painter, though the paint is represented by way of two separate volume-suggestive conve tions (open and linear for the body, dark and sculptural for th head). The painted image also recalls certain paintings of youn artists with striped shirts that Picasso himself had made.[3] Th artist, in contrast, is strangely ambiguous. We presume it the artist—the figure seems to be reaching up to touch th painting—yet there is no sign of brushes or palette. These mea of representation may well be hidden in the brushstrokes th create them. But the gender of the figure poses the real ambigui What seems to be long black hair and a flowered hat would ma the image not the artist at all, but a model come to inspect th artist's self-portrait. On the other hand, the deliberately clum silhouette is one that Picasso frequently gave to his represent tions of painters, as is the intensity of the almost mesmeriz painter beside the serenely calm painted head.[4] The internal prof of the small head matches that of the large one, and seems to be younger mirror reflection, suggesting that they are alternati states of the same figure. And yet—unless the painter be disguis or in fancy dress—this cannot be so.

The painting, being about representation and ambiguity in re resentation, is necessarily also about disguise and the hide-a seek between the painted and the real—so the unresolvable a biguity of its subject matter is but another of Picasso's games th set opposite states in confrontation. The painting is focused on t two sets of eyes, and the story it tells is essentially about lookin

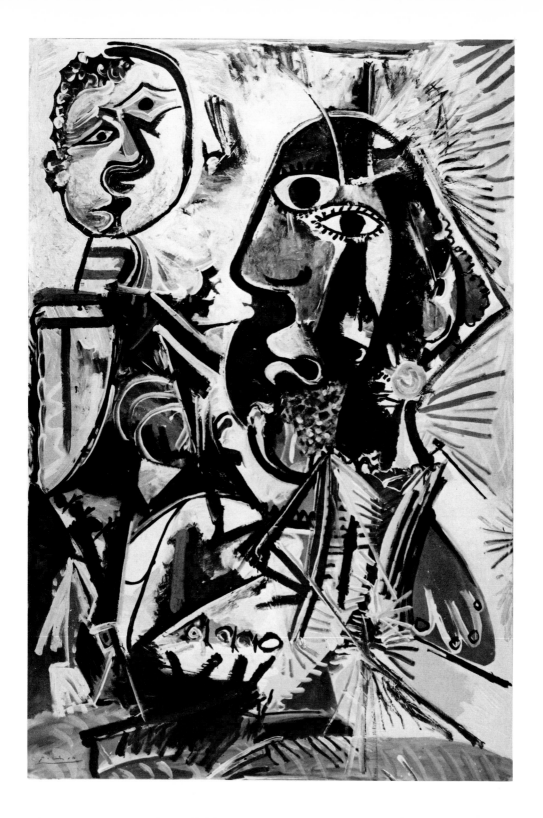

GEORGES BRAQUE
Houses at L'Estaque. 1908
Oil on canvas, 28³/₄ × 23³/₈" (73 × 59.5 cm)
Kunstmuseum, Bern, Rupf Foundation

In the spring or early summer of 1908, Braque visited L'Estaque and there painted what are widely accepted as the first Cubist paintings.[1] *Houses at L'Estaque* is the most important of these works. It was probably the one Matisse disparagingly referred to as being made up of *petits cubes* when, as chairman of the selection committee of the 1908 Salon d'Automne, he rejected Braque's submissions.[2] The paintings were exhibited at Kahnweiler's gallery that November. Reviewing the exhibition, the critic Louis Vauxcelles took up Matisse's comment, noting that Braque reduces everything "to geometric complexes, to cubes."[3] By the following year, the name had caught on and Cubism was baptized.

Although at first sight *Houses at L'Estaque* does seem to be composed of *petits cubes,* the space in which these volumetric masses are depicted is so flattened and compressed that it is difficult to imagine them as fully three-dimensional forms. In effect, none of them seem to have backs.[4] It was from Cézanne—whose large memorial exhibition at the 1907 Salon d'Automne profoundly affected many Parisian artists—that Braque learned to accommodate modeled sculptural forms to the two-dimensionality of the picture surface.

Braque also began to adopt Cézanne's method of *passage:* he broke the enclosing contour lines of objects at certain points and shaded away from contours on both sides so that the eye is allowed to pass uninterruptedly across the picture surface, one plane eliding into the next to create the effect of a shallow surface relief unbroken by any significant illusion of depth. At this stage, a framework of enclosing contours remains, but to inflect rather than restrict the relationship of plane to modeled plane.

At L'Estaque, Braque was clearly concentrating on the structu rather than the coloristic aspects of Cézanne's art. While Cézann form of *passage* was effected by changes of hue as well as value, Braque's relies solely on the modulations of lights a darks. The previous summer, Braque's paintings had been steep in vivid color as he reached the climax of his short-lived alignme with Fauvism.[5] The browns and greens of this painting are possi indebted to Derain's Cassis landscapes of 1907,[6] but also reveal t new conceptual bias of Braque's art. Likewise, while the archite tural forms of Braque's subject undoubtedly helped him to simpl this painting,[7] the very extent of the simplifications represent turn away from depicted subject matter toward a newly archite tonic form of painting itself.

In *Houses at L'Estaque* all inessential details are eradicated. T drawing is organized around a rigorous vertical-horizontal gr Forms are built up one above the other without concern for aer perspective (if anything, the uppermost forms are stronger value). The same parallel hatched brushstrokes uniformly co the picture surface, irrespective of local textures. The sever restricted color conceptually rather than perceptually identifies t different classes of forms represented; and the drawing so flo the canons of traditional perspective as to contain and connect the depicted solid forms to the two-dimensional solidity of t picture surface. Implicit in Braque's Cézannist or Sculptu Cubism of 1908 are all the elements of the Analytic Cubism whi began to emerge the following year.

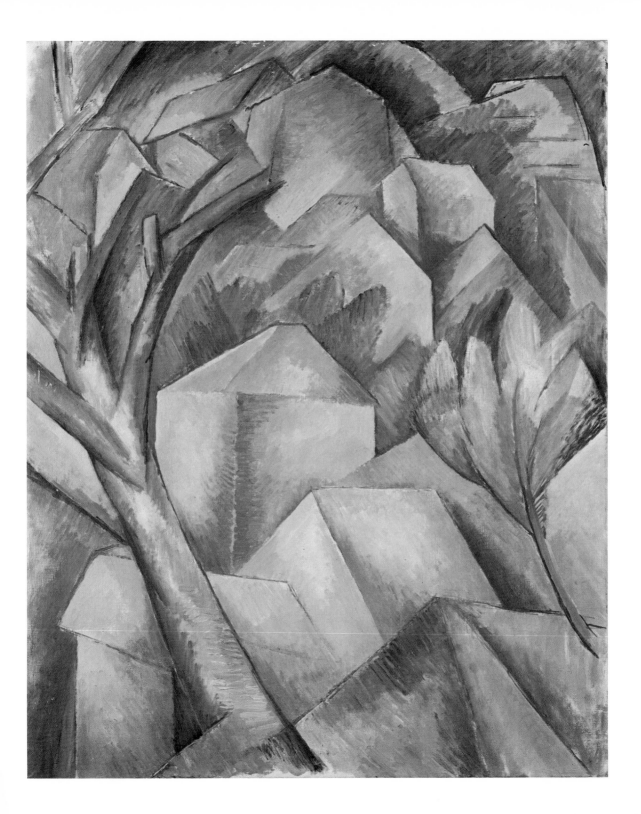

GEORGES BRAQUE
Guitar and Fruit Dish. 1909
Oil on canvas, 28³/₈ × 23⁵/₈" (72 × 60 cm)
Kunstmuseum, Bern, Rupf Foundation

By early 1909, the bold sculptural forms of Braque's Cézannist Cubist style were giving way to consistently smaller units of composition. *Guitar and Fruit Dish,* with its large, broadly treated guitar and surrounding complex of more detailed incident, is at once the climax of his Cézannist Cubism and the beginning of the Analytic Cubist style.

The fragmentation of forms visible in this painting is its most immediately striking feature. Although the various objects depicted retain simplified versions of their natural contours, many of these contours are far more radically broken or distorted than in such 1908 paintings as *Houses at L'Estaque.* The elisions between objects are therefore less abrupt. Moreover, particularly in the lower section of the painting, the surfaces of each object have been divided or analyzed into smaller complexes of related planes that fuse with similar complexes describing adjacent objects. As a result, the eye slips from plane to plane—across individual objects—without abrupt transition. The surface of the picture is beginning to dissolve into the soft atmospheric continuum which comes to characterize Braque's Analytic Cubist style.

In *Houses at L'Estaque,* the browns, greens, and grays had each separately identified the houses, foliage, and tree trunks of the subject matter. Here the same colors are freed from providing even that simplified descriptive function. Braque interweaves the colors just as he does their forms—lest they detach any object from the fabric of the surface. Any definite source of external illumination is abandoned for the same reason; and here there begins to emerge that sense of an internal light which, supported by the seeming transparency of the hatched planes, gives to Analytic Cubist paintings their distinctly poetic character.[1]

Braque later talked of his early Cubist painting as "a research into space," specifically a "tactile" or "manual" space which allowed "a complete possession of objects."[2] Hence, conventional perspective is replaced by a system of multiple viewpoints which better "possess" or encompass far more aspects of any object. Further, the facet planes between objects take on an assertive physical character, rendering the space itself as "manual" and real as the objects it surrounds. Braque's increasing predisposition toward still-life subjects might also be explained this same way: the space they present to the eye is more restricted and therefore more inviting to touch than the open spaces of landscape.[3] Of course, the special power of this and similar paintings is that tactile sensations are transmitted in so purely visual terms. A feeling of the interrelation of the senses themselves is crucial to Cubist painting, and may even be discerned in the fruit, musical instrument, and book or newspaper depicted here. They are all objects that are experienced manually. (Braque enjoyed painting musical instruments because "it was possible to bring them to life by touching them.")[4] But each evokes another sense besides touch: taste, sound, or sight. Certainly, this particular combination of objects became utterly central to the iconography of Cubism.

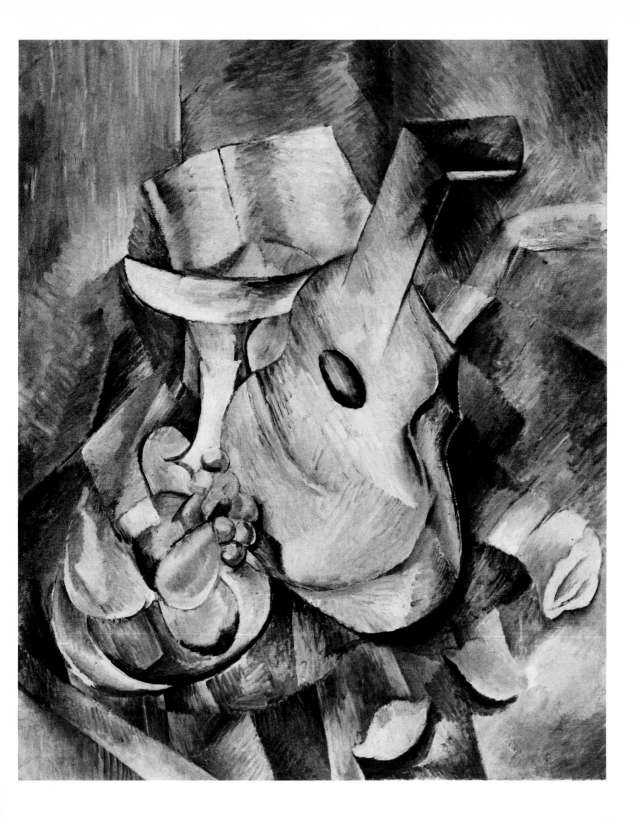

GEORGES BRAQUE
Violin and Pitcher. 1910
Oil on canvas, 46$^1/_8$ × 29" (117 × 73.5 cm)
Kunstmuseum, Basel, gift of Raoul La Roche

In the winter of 1909–10, Braque painted a group of still lifes that bring to a culmination the period of his analysis of sculptural form, begun at L'Estaque in the summer of 1908.[1] They were his most complex and ambitious—and most completely resolved—paintings to date. *Violin and Pitcher* is the largest of the group (some forty-six inches in height), probably the latest, and is in many ways the most advanced. Speaking of his fragmentation of form, Braque said that "it was a means of getting closer to objects within the limits that painting would allow."[2] Now, the particular means or methods of representation open to Braque within the medium of painting were being analyzed along with the objects themselves. Braque's decomposition of solids has reached such a stage as to create rich and fascinating ambiguities of form and space, which in turn force us to consider—in a way, more fully than ever before—the very rivalry between reality and its representation.[3] That rivalry, and the special tension it evokes, is the real subject of this painting.

Both the objects represented and the spaces between them are fused in a continuous prismatic mass of small interpenetrating planes. Within this continuum, Braque tests the conventions of representation. The feeling of greatest sculptural relief occurs toward the lower left of the painting, that is to say, in a passage of "empty" space. As a result this "tactile" space seems actually to envelop the violin adjacent to it. ("I was unable to introduce objects until after I had created space," Braque said.)[4] The violin itself is more dislocated—and seems therefore more transparent—than the pitcher above it, which may well be made of glass but seems relatively opaque. The zigzag contours up the left of the painting perform an enclosing function for the composition and therefore seem as flat and upright as the edge of the painting itself. But since the contours also seem to represent folded planes—and match the shift in direction of the molding to the right—they also create the illusion of depth. The molding too, however, is brought up flush with the picture surface. Thus the entire surface oscillates in depth, as it were in movement, and in this is supported by the flickering contrapuntal relationships of grays and ochers and by the shifts in direction of the facet planes themselves.

Against the overall pattern of small planes, two features stand out: the firm schematic drawing that represents details of the violin and, strikingly, the trompe-l'oeil nail with accompanying shadow at the very top of the painting. Both add separate modes of representation to the overall "analytic" one. The schematic drawing forms a series of discrete clues to the identity of the violin, each one synthesizing a feature of this object and rendering it in the form of condensed sign or symbol. The nail is illusionistic in a firm, traditional way. In one sense, it seems to add a touch of straightforward "reality" to the painting—but it is, of course, no more "real" than the still life below, and the signs that denote the violin are no more real than Braque's analysis of the violin's structure. Nevertheless, the concern for representational means other than the analysis of sculptural form starts to show itself in Braque's art from this period. As the analysis of forms led increasingly toward abstraction, alternative modes of representation began to be explored.

Both the nail and its shadow and the symbols for the violin have an additional pictorial function: they appear as squarely frontal silhouettes that reassert the flatness of the picture surface against the shifting illusions of depth suggested by the surface planes. Thus, while on the one hand they affirm the "reality" of the subject matter, on the other they affirm the autonomy of the painting as a two-dimensional flat object. The body of the composition appears to hang down from the painted nail, while the painting itself can be interpreted as a flat colored surface that is tacked against the wall.

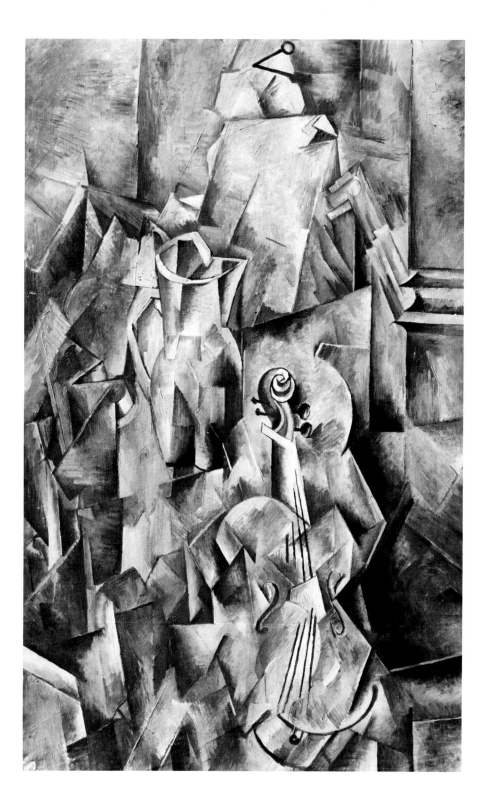

GEORGES BRAQUE
The Portuguese. 1911
Oil on canvas, 46¹/₈ × 32¹/₈″ (117 × 81.5 cm)
Kunstmuseum, Basel, gift of Raoul La Roche

The Portuguese, from the spring of 1911, is one of four major figure paintings that Braque made that year.[1] It is perhaps his most important work in the style that has come to be known as high Analytic Cubism. Braque's analysis of form into small shaded facet planes had gradually reduced the pictorial depth of his paintings. By now, few rounded, sculptural forms remain. The shading is almost entirely frontal, and is atomized into small horizontal strokes of light and dark (deriving ultimately from Braque's experiments with Neo-Impressionism in 1906).[2] As a result, the subject of the painting is opened out and flattened across the wafer-thin sheet of the picture plane. The sensation of an illusory shifting space nevertheless remains. As the shading is carried up to the strong linear armature, which gives new architectonic stability to Braque's painting of this period, it increases in density and therefore produces the illusion of a turn into depth. Neither the direction nor the continuity of the shading is altered, however, and this contrives the illusion of depth back up to the picture surface. Illusion itself becomes a property of the surface in a radically new way, and the allover flatness of the painting is not violated.

The linear armature of this work is in part an extension of the signlike drawing which first appeared in paintings like *Violin and Pitcher* the year before. Now that the shading is so abstracted, the subject of the painting is almost entirely revealed by the drawing. It is only through the drawing that one can recognize a top-hatted figure playing a guitar—an image based apparently upon a sailor Braque saw in Marseilles.[3] The drawing is also, of course, compositional, and combines with the horizontal brushwork to create an assertive grid structure enclosed within raking, tentlike diagonals. Until 1910, Braque had shown himself fond of compositions weighted toward one edge; in 1911 he established his art in a firm hieratic symmetry of centralized frontal forms, seated on the bottom edge of the painting and floated clear of the other three side

Braque has spoken of himself and Picasso as being "rop together like mountaineers" through the development of Cubisr In 1911 their styles were particularly close. But as had be the case up to this time, it was Braque who still tended to be more strikingly inventive. The use of stenciled lettering, which fi appears in the upper sections of *The Portuguese,*[5] was one of most vital of his inventions.

Like the trompe-l'oeil nail in *Violin and Pitcher,* the lettering *The Portuguese* affirms the flat literal surface of the painting. "I ing themselves flat," Braque wrote, "these letters were not space, and thus, by contrast, their presence in the picture mad possible to distinguish between objects situated in space a those which were not."[6] As a *repoussoir* element, the lettering one moment, seems to force all else back into deeper space. At next, it is itself drawn back into depth, its rectilinear struct merging with the pictorial grid. Then the rectilinear framewor drawn up to the lettering. There is a shuttling between surface a depth even more dramatic than in any of Braque's previous wo Surface and depth are telescoped and separated at one and same time.[7]

Braque also described his use of lettering as a means "to ge close as possible to reality."[8] These copied fragments of pos advertising a [GRAN]D BAL and [GRAN]D CO[NCERT] do ind add yet a further dimension to the multiple forms of representat in Cubist art. As elements "foreign" to painting they bring in outside world in a far more literal way than before. As applie stenciled—elements they draw attention to the material, object reality of the painting itself. In both of these functions they pare for the invention of collage and for a whole new chapte Cubist art.

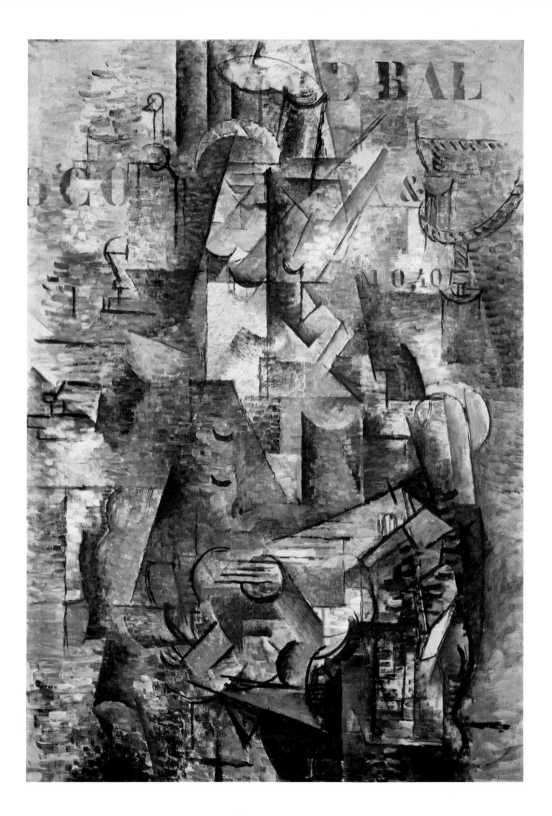

JUAN GRIS
The Pierrot. 1919
Oil on canvas, 39³/₄ × 32¹/₄" (101 × 82 cm)
Kunstmuseum, Winterthur

This grave as well as decorative *Pierrot* is one of a series of Pierrots and Harlequins that Gris began to paint in the spring of 1919.[1] The series looks back to some isolated Harlequin images that he made in 1917, but also to Picasso's use of the same theme. Whereas Picasso's *commedia dell'arte* figures of this period were rendered in one or another of the new realistic styles he had adopted since 1915, Gris's, in contrast, are locked into the structures of his exact form of Synthetic Cubism.

Gris had joined the Cubist orbit in 1911. From the start, his paintings were more precise and explicit than those of Picasso and Braque, making greater use of a strong linear framework and insistently geometric forms. After developing a serious interest in collage in 1914, he began to think of the surfaces of his paintings as grounds for an almost mathematical combination of abstract shapes, shapes which were then materialized into subject matter. "I try to make concrete what is abstract," he once wrote. "I proceed from the general to the particular, by which I mean that I start with an abstraction in order to arrive at a true fact. Mine is an act of synthesis and deduction . . ."[2]

Since this painting is one of a series, we must assume that Gris did have a subject in mind from the start. Even so, comparison of the paintings of the series shows that they are linked not merely by subject matter but in their use of the same basic forms, which were subsequently transformed into different variations of the Pierrot or Harlequin image. Each painting uses a group of polygonal planes so superimposed that diagonal lines radiate from a point, just above the center of the composition, where the neck of the costume forms into a V-shape. Taken as a group, the series indicates just how much variety Gris could develop from one basic formal conception. Taken singly, each painting reveals how Gris's unique method of working brought special unity to the disparate objects represented. Because Gris worked from shapes to objects, we see in each of his paintings formal analogies between iconographically unrelated forms. Here the Pierrot's head mirrors the shape of the guitar, his arms compare to the folding drapery to the right of the composition, and his legs relate to the legs of the table. Because adjacent objects sometimes share common contours (the under side of the right arm and the edge of the table, for example), the sense of an underlying geometric structure that links together all objects, both animate and inanimate, is further accentuated. With this subject, of course, it gives to the Pierrot a necessarily mechanistic character—as does the radiating, clocklike nature of the composition.

Although the subject of this painting is immediately legible, its space is highly abstract. Whereas Analytic Cubist paintings are frequently more difficult to decipher than Synthetic Cubist ones like this, their spaces are still, to a greater or lesser degree, atmospheric and illusionistic. In Synthetic Cubism, by contrast, there is a nonillusionistic flatness of discrete frontal planes pushed up to the surface and so jigsawed together that their flatness remains unviolated by any representational function they might serve, particularly by such a schematic form of representation as exists here. Depth is implied: in the shifts of tone within the several grays, ochers, and browns; in the division of the figure into simultaneously frontal and profile views; and in the area of Harlequin-tiled floor to which the Pierrot is pointing. But even in the last, most extreme instance, depth is suggested in such a diagrammatic way that the eye is soon returned to the literal surface. The patterned floor is drawn back into the upright decorative surface, so that it becomes a part of imagery so emblematic, even heraldic, in nature that it cannot but draw attention to the playing-card flatness of the entire work.

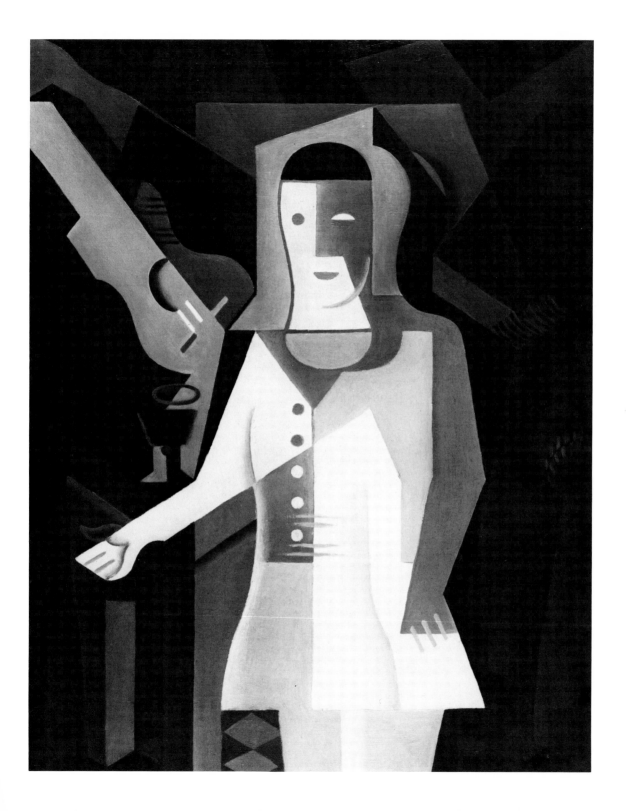

ROBERT DELAUNAY
Homage to Blériot. 1914
Tempera on canvas, 98⅝ × 99″ (250.5 × 251.5 cm)
Kunstmuseum, Basel

Apollinaire once drew a comparison between the way in which a painting by Cimabue had been carried in procession through the streets of thirteenth-century Florence and the way Blériot's airplane was cheered through twentieth-century Paris on its way to being placed in the Conservatoire des Arts et Métiers.[1] Blériot in 1909 had become the first person to fly across the English Channel. Delaunay's *Homage to Blériot* evidences an enthusiasm for modern life comparable to that of his friend Léger. Léger, however, describing his love for airplanes, talked of the "beautiful, hard metallic objects, firm and useful, with pure local colors . . . dominated by the geometric power of the forms."[2] Delaunay, in contrast, was inspired not by the solidity but by the flux in modern life: "Sky over the cities, balloons, towers, airplanes. All the poetry of modern life: that is my art."[3]

Delaunay described this painting as follows: "Analysis of the sun disk at sunset in a deep, clear sky with countless electric prisms flooding the earth, from which airplanes rise."[4] The "electric prisms"—the concentric circles that dominate the painting—are the aureoles of electric lights. Among them can be seen the forward end of a grounded airplane with a massive propeller; mechanics at work; the Eiffel Tower and above it Blériot's biplane; and at the very top of the painting another airplane shooting straight up above the partly veiled form of the sun. The disk form had first appeared in Delaunay's painting as early as 1906, possibly as a result of his exposure to Derain's London paintings of 1905 which used prominent spectral suns;[5] but this form began to be used consistently only with his Sun and Moon series of 1913. We first see a painted image of Blériot's airplane in *The Cardiff Team* of 1912–13[6]—Delaunay's first successful formulation of his idea of simultaneously experienced images, which reaches a climax in *Homage to Blériot*. The Eiffel Tower, of course, was a familiar motif in Delaunay's art from the famous series of paintings on that theme, begun at the end of 1909. The general compositional framework of *Homage to Blériot* was presaged by the 1913 painting *Sun, Tower, Airplane.*[7] But whereas this painting—and in large part the oil studies for *Homage to Blériot*[8]—uses mainly disintegrated circles (that is, circles intersected by spiraling and occasionally gridlike linear forms) and ties the colors together through tonal leveling, *Homage to Blériot* itself displays an exuberant flux of vividly contrasted colors in excited spinning circles.

Color contrasts, Delaunay said, were the "constructional ele ments of pure expression."[9] He had begun as a Neo-Impression painter and read the color theories of M. E. Chevreul, from wh he derived his own theory of "simultaneous contrasts."[10] Where the strokes and blocks of pure color in Neo-Impressionist paintir fused together in the spectator's eye and created, therefo "binary" contrasts, "simultaneous" contrasts retained the se rate identities of colors as they interacted simultaneously up the eye. In their interaction, the effect of movement was eng dered. The static presentation of the outside world created Neo-Impressionism was thus replaced by a display of movi colored light.

Homage to Blériot was exhibited at the Salon des Indépenda of 1914 under its full title, *First Solar Disks, Simultaneous Form; the Great Engineer Blériot.* Reviewing the exhibition in *L'Intr sigeant,* Apollinaire wrote: "The semicolon doubtless plays an i portant role here; its upper half, the period, represents an e while the comma acts like an Ariadne's thread through all the labyrinths of swirling Futurism."[11] "I am not now and I have nev been a Futurist; no critic has ever had reason to think otherwis Delaunay angrily replied. "I am surprised by M. Apollinaire's norance about the simultaneous contrasts that form the ba and the novelty of my art."[12] Apollinaire may be excused for c fusing Delaunay's and the Futurists' interest in simultaneity, both were interested in expressing the flux of a machine-a world. In Delaunay's case, however, this was inseparable from concern with color. It was color that bound together the specifica modern images; and it was the excitement and sense of mot created by color contrasts in themselves that conveyed the c stantly changing rhythms, the "poetry of modern life."

There is a postscript to the Delaunay-Apollinaire quarrel (wh was exacerbated by the Futurists joining in). The editors of *L transigeant,* clearly embarrassed by the affair, announced t they could not accept responsibility for Apollinaire's opinions, a Apollinaire felt compelled to resign.[13] The irony of the incident l in the fact that the title of the painting, prominently inscribed at bottom of the work itself, contains no semicolon—and it wa semicolon that had instigated Apollinaire's fanciful but provo tive description. Apollinaire, the writer, had relied on the cata and not on the work itself.

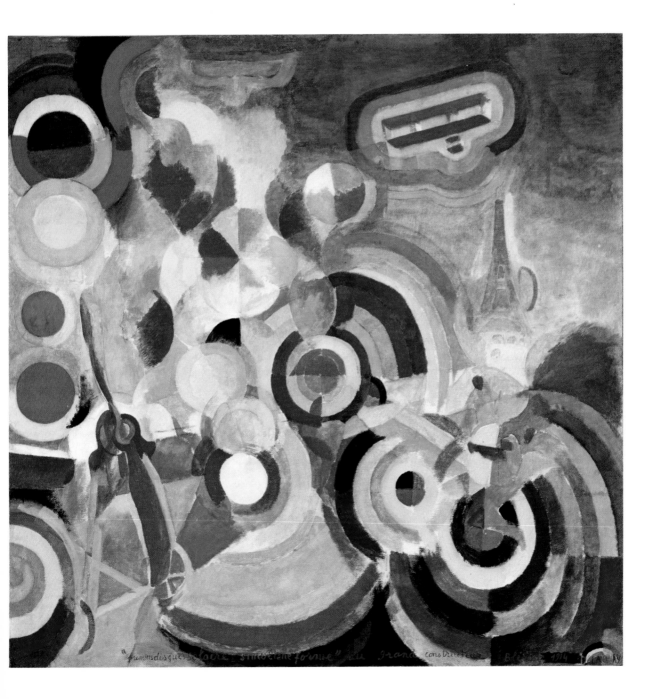

FERNAND LÉGER
Woman in Blue. 1912
Oil on canvas, 76³/₈ × 51¹/₄″ (194 × 130 cm)
Kunstmuseum, Basel, gift of Raoul La Roche

After a brief period of tonal, primitivizing Cubism in 1909–10, Léger created his first truly original style.[1] It climaxed late in 1912 with this definitive version of *Woman in Blue.* Léger's affiliation with Cubism had begun with an interest in sculptural form. "I wanted to push volume as far as possible," he said later.[2] In 1911, however, he became increasingly attentive to modern, urban imagery and developed what was to be a longstanding fascination with the contrasts of forms. Having noticed how soft billows of factory smoke contrasted with hard architectural forms, he painted a series of upright pictures with alternating vertical bands of detailed sculptural elements and broader silhouetted planes, affixed in places to the edge of the support.[3] All are large paintings by contemporary Cubist standards (*Woman in Blue* is some seventy-six inches in height). From the start Léger was a painter in search of a grand manner. The intricately modeled small-scale Cubism of Picasso and Braque was alien to his blunt nature. He sought instead a style both simpler in its mechanics and potentially more commanding in its effects: a purposefully dramatic and dynamic "epic" Cubism, a monumental public art appropriate to the scale of modern experience.

In the first mature work of his style of contrasts, *The Smokers* of 1911–12,[4] the large, flat elements literally describe puffs of white smoke contrasting with the angular shapes of buildings. In *The Wedding,* of spring 1912, the white forms have no literal meaning, and start to lose something of their rounded, sculptural character, while the smaller elements become more "tubist" than Cubist in form. *Woman in Blue* carries this method to a climax, with flat (either angular or rounded) planes of red, blue, black, and white (indebted, in part, to Delaunay's use of bright color) placed in contrast with the ascending columns of sculptural forms between them.

Interrupting the detailed crowding of small tubular forms with larger, and hence more independent, shapes has two main effec First, it sets back the smaller volumes of the painting and th increases its depth (although Léger's turning these small volum so that their broadest surfaces are uppermost assures their fron ity at the same time). This deeper space was essential to coherence of a large-scale art. Second, the large planes point the literal flatness of the surface. Although composed of sculptu and recessive forms, the painting is essentially frontal. It is a assertively compositional in its arrangement. That is to sa whereas in true Analytic Cubism the pictorial vocabulary seems emerge intuitively from the subject matter and grow outward just short of the edges of the painting, in Léger's case the who surface appears to be conceived as a single unit from the very sta as a large flat plane on which painted planes—and subsidia more sculptural elements—can be arranged. While Picasso a Braque "analyzed," Léger stylized, creating a vocabulary generalized contrasting forms—large against small, shall against deep, and soft against hard. These piled-up forms repe the edges of the picture support and thus guarantee that the larg planes—even those placed in the spatial center of the painting never detach themselves from their surroundings. Léger's plann dispersal of contrasting elements gives to his art in 1912 a stabili a control of the entire picture surface, and an increased scale or generally available to Cubism in its later Synthetic period.

Although Léger's methods of analyzing form were more conve tional than Picasso's or Braque's, in 1912 his organization of t picture surface was more advanced. This is not to say that Lég had already created Synthetic Cubism, but rather that the elemer we now regard as attributes of that style were an important part his earlier work. Literal flatness, unit-size difference, silhouett and flatly colored shapes, conventionalized representation, a even layered spaces—*Woman in Blue* depends upon all of thes

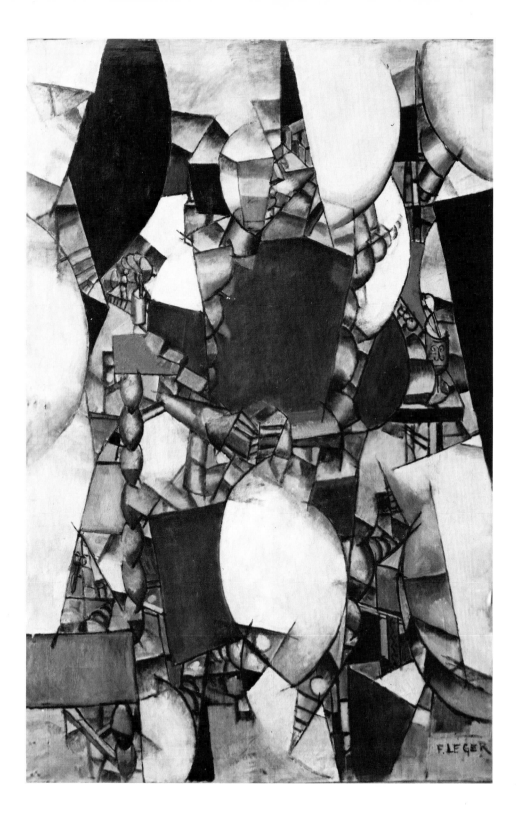

This *Contrast of Forms* belongs to a series of at least nine paintings of the same title that Léger painted in 1913, all of which contain what has been called a "kite motif" at the upper center surrounded by primarily tubular forms.[1] If, in 1912, Léger seemed fast to be developing toward a form of Synthetic Cubism, his paintings of 1913 represent in some respects a return to the firmly sculptural methods of his first Cubist works. Although they are certainly more volumetric than paintings by Picasso or Braque, they approximate far more closely than the 1911–12 paintings to the norms of Analytic Cubism. They are not, however, merely a reprise of Léger's first Cubist style. Their accommodation of abstract sculptural forms to a resolutely flattened surface would have been inconceivable without the example of the intervening work.

Possibly the most remarkable aspect of this painting is that its massed forms, though firmly volumetric, are also read as frontal and planar. Léger achieved this effect by separating the linear and planar elements he used to describe them. Following Cézanne, Picasso and Braque had adopted a differentiated linear and planar structure so as to locate their sculptural shading around first-established contour lines. In the developed Analytic Cubist style of 1910–12, small shaded planes model both subject and "background"—to either side of the linear framework—dissolving both equally across the surface. Léger's approach is different. Before 1913, his modeling emphasized interior forms only, and he modeled in a way still dependent on traditional chiaroscuro methods. Forms so distinct and self-contained in appearance risked becoming detached from their surrounding space—so Léger crowded his compositions so that little, if any, "background" is visible. Unlike Picasso and Braque, who canceled the difference between positive and negative elements, Léger made everything positive, and so it remained into 1913. Léger's "all positive" style gave him a surprising opportunity denied to

Picasso or Braque: to make his bulky forms the real subjects of his pictures; and to make his pictures nothing else but the contrast of such "real" generalized forms. As frequently is the case, an outsider's reading leads to innovations not possible within the original, narrowly defined style. The *Contrast of Forms* paintings of 1913 capitalize upon this opportunity, and are Léger's—and Cubism's—first fully abstract works.

They are, in fact, derived from Léger's immediately preceding landscapes,[2] but the forms are so anonymous that the naturalistic source is left far behind. The forms themselves are the subject. In the paintings of 1911–12 the broad flat planes which interrupted the volumetric forms spread their flatness over the paintings. When they disappeared, Léger needed a new way of fixing his elements in place lest they seem somehow to be *illustrations* of abstract forms, and thus lose the sense of abstract flatness of the previous work. Here the conventionalized nature of Léger's art proved to be an advantage. The stylized chiaroscuro modeling of his first Cubist paintings is repeated in a novel way. Dark contour areas are shaded toward highlights on the broad exposed centers of the tubes, forming a set of usually three discernible flat bands along their length. This helps to create a cohesive uniformity for the work, and at the same time animates it with a set of insistent directional stresses. By limiting himself to primary colors (with roughly applied whites as highlights), Léger guaranteed that no form would remain behind another, though the forms might be drawn as overlapping or intersecting one another. The unmodulated primaries (quickly painted to let the coarse ground show through) appear to belong to the same plane and thus "surface" the entire work. Moreover, since the outermost stripes of color never quite touch the drawn contours, the separate flatness of each color area is further ensured. Each contrasting form appears simultaneously as all volume and all flatness.

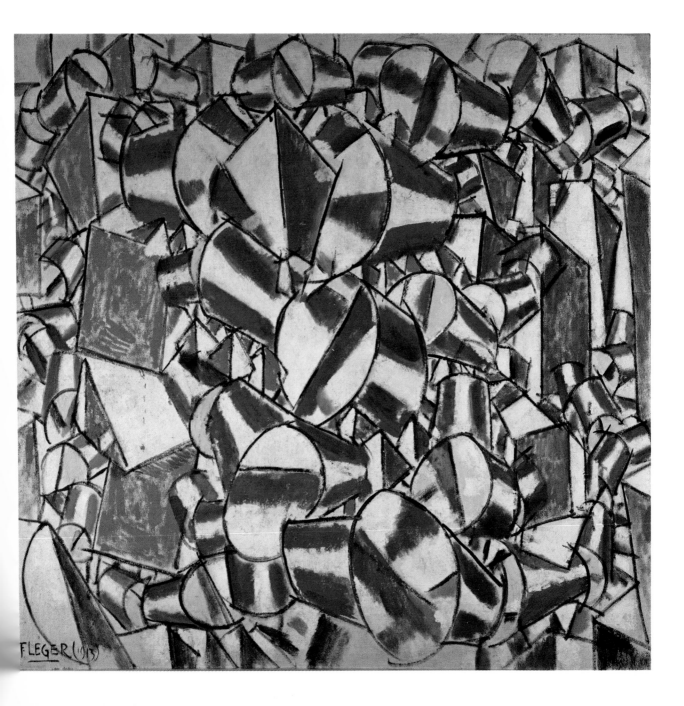

FERNAND LÉGER
Mechanical Elements. 1918–23
Oil on canvas, 83⅛ × 66" (211 × 167.5 cm)
Kunstmuseum, Basel, gift of Raoul La Roche

During the years following the First World War, that is, after Léger's completion of *The Card Game,* with its robotlike figures, in 1917,[1] Léger's art took a significant new turn. His interest in modern, mechanistic life became specific in his art. "Perhaps my experiences at the front and the daily contact with machines led to the change that marked my painting between 1914 and 1918," he said later.[2] "I was dazzled by the breech of a 75 millimeter gun standing uncovered in the sun: the magic of light on white metal. This was enough to make me forget the abstract art of 1912–13."[3] Before the war, Léger's forms had been so generalized as to express only by implication a modern iconography. From 1917, however, the previously abstract contrasting forms were given a new mechanical identity, and often combined with flat colored planes in dramatic relationships which themselves evoke the dynamism of modern living.

The combination of flat and volumetric elements was not, of course, new to Léger's art. It had characterized his paintings of 1911–12. In the postwar period, however, the earlier coordination of the two kinds of elements in parallel columns down an expansively flat surface was replaced by the superimposition of volumes on planes in a space deeper in some respects than hitherto. The modeling of the metallic-sheened cones and cylinders in *Mechanical Elements* is certainly more conventional than in the *Contrast of Forms* series. And yet, almost every volume is truncated to present a flat frontal surface to the viewer, while many are broken across such surfaces by flat bands of bright color which in their function are analogous to the summary bands of modeling in the *Contrasts*

of Forms: they integrate the volumes with the decorative flat surface of the composition. If illusions are offered more frankly than hitherto, they are presented in such a schematized way (as in contemporaneous works by Gris) that the integrity of the flat surface is not threatened.

Although at first sight the volumes all seem to be superimposed over planes, it is not finally possible to read this work through figure-ground relationships. Not only do the volumes push laterally across the surface even as they recede, or do they appear at times to be located behind some of the colored planes, but—most crucial—the enclosing contours of the volumes create a series of essentially linear patterns across the painting. As the modeling darkens to the outside of the volumes, the volumes themselves flatten and their contours—shared with the planes—involve them in the decorative jigsaw of the surface.

The feeling of rotation provided by this composition speaks of Léger's debt to Futurism, as does his machine-age optimism as a whole. The prominence of disklike forms, and high color, may be explained by his friendship with Delaunay. The grid structure of the background reflects his familiarity with the work of Mondrian and de Stijl painters—although at least one section of the grid (at the upper left corner) suggests its derivation from a strip of film. Léger's whole conception is cinematic: reality is fragmented; close-ups combine with generalities. The picture cuts from image to image. Images—and styles—separate themselves from their original contexts to become part of a new fictional epic that celebrates mechanical life.

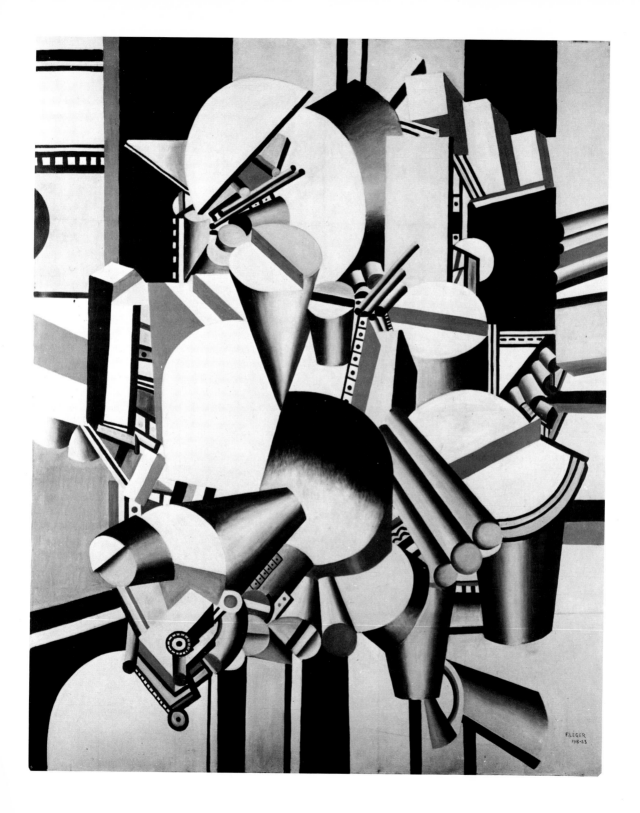

FERNAND LÉGER
Still Life. 1927
Oil on canvas, 44⁷/₈ × 57⁷/₈″ (114 × 147 cm)
Kunstmuseum, Bern

Léger's interest in precise mechanical forms was confirmed by his contacts with the Purist circle around Ozenfant and Jeanneret.[1] From 1923 onward, Léger was increasingly concerned with what the Purists called *objets types,* that is to say, certain manufactured objects which manifested in their simplicity the order, economy, and efficiency of man.[2] The objects that Léger painted were always more daring in their range than those the Purists attempted; in this important still life of 1927, organic objects appear with manufactured ones. Nevertheless, it was through his association with Purism that Léger objectified, as it were, the Futurist ethos of his machine-age imagery—creating a classicized representation of the same subject, a newly revised form of history painting befitting twentieth-century life.

In his celebrated article of 1924, "L'Esthétique de la machine," Léger insisted that "now a work of art must bear comparison with a manufactured object."[3] He also described his pleasure in seeing such objects carefully displayed in the window of a hardware store. One cannot but be reminded of still lifes like this one. Whereas previously Léger had contrasted forms, he now contrasts types: the schematically divided bottle and the undulating flowers; the compass with its accompanying circles and the fluttering—but frozen—leaves above. Of course, these different types of objects fulfill the same functions as more generalized forms did previously, that is, as purely abstract elements; but they also serve to demonstrate the variety and underlying economy that Léger found in specific instances of modern mass production, and in the natural world as well. The isolated placement of these forms against a disciplined architectural framework presents them as if in quotation, almost in the same way as artists of the past have quoted classical models to affirm the traditional authority of their art. For Léger, it was the classicism he saw in the present and the authority invested in objects as representations of their period that attracted him.

Besides the contrast of forms and types, we see here contrasting modes of representation. The flowers are fairly realistically presented, although their heads are bent up to become parallel to the picture surface and placed side by side to become organic counterpoints to the shiny button forms beside them. The bottle, however, is rendered in almost diagrammatic elevation; the compass is truncated; and some elements are so simplified that their identities are obscured. Léger's characteristic interlocking of flat and modeled forms persists, so that everything is resolved in terms of the flat surface. Nevertheless, something of the effect of an illusory space is given, with objects seeming at times to hover in front of the surface—though drawn back into place at others. In this still life, Léger encapsulates the development of his art of the mid twenties, presenting a disciplined pictorial display of truly monumental quality, but one in which a certain lighthearted freedom is yet present. The juxtaposition of unlikely objects never evokes any Surrealist connotations, but the free spatial movement suggested within this painting does have a connection—although as yet marginal one—with the turn to spatial illusionism that began to take place in Parisian painting toward the end of the twenties and became especially popular in the following decade. Even in 1927 Léger was beginning to loosen the architectural stability of his painting, and in subsequent works from this year objects are released from strict control to float freely in space. This still life was the last monument of his classicist view of the modern world.

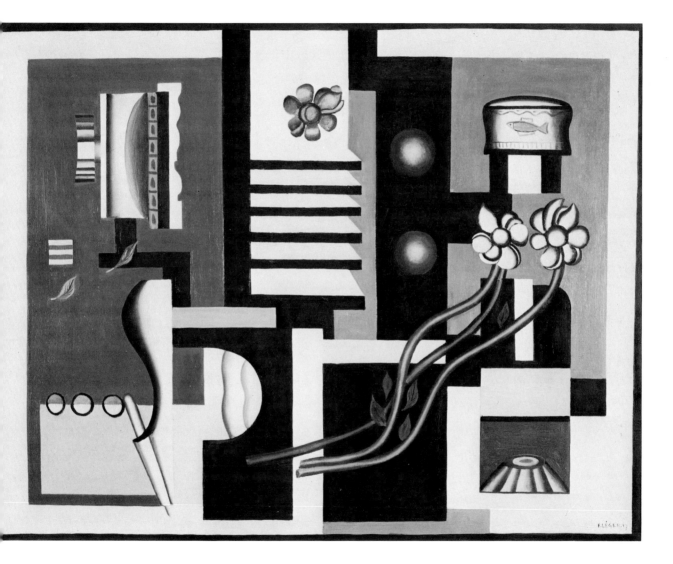

UMBERTO BOCCIONI
The Forces of a Street. 1911
Oil on canvas, $39^3/_8 \times 31^1/_2''$ (100×80 cm)
Private collection

The Forces of a Street was probably the first painting that Boccioni completed after his visit to Paris in October 1911, a visit that crucially changed the direction of his Futurist art, for it brought him into direct contact with Cubism for the first time. Futurist painting was then just over a year old.[1] Seeking to present a dynamic view of the modern world, one that fused objects and their urban environment in a frenetic state of flux, Boccioni and his friends had drawn mainly on the innovations of Neo-Impressionism and of Art Nouveau. From Neo-Impressionism they had adapted an overall structure of small brushstrokes expressive of the way light dissolves and mingles individual forms to create a continuous molecular field. From Art Nouveau they had taken the charged circulating line to create an impression of constant movement. From this amalgam they had created an emotionally expressionist—and somewhat Symbolist—art of dematerialized forms mingled together to create images of universal dynamism. The effect of Cubism on this first Futurist style was to modify its subjective and Symbolist tendencies in favor of a more structural art, to provide a set of new geometric rhythms particularly appropriate to paintings of urban subjects, and (through the use of these dislocated rhythms instead of fluid, continuous ones) to create an even more dynamic sense of the interrelationship of objects and environment.

Boccioni had seen Cubist paintings in reproduction in the summer of 1911 and had begun to geometricize his art even before his visit to Paris.[2] It was not until he saw Cubism at first hand, however, that his new geometric style was properly established. He later declared himself "absolutely opposed" to Cubism[3]—first, because the Cubists "obstinately continue to paint objects motionless, frozen," whereas he was seeking "a style of motion,"[4] and second, because the Cubists retained traditional studio subjects, while he believed "that there can be no modern painting without the starting point of an absolutely modern sensation."[5] Nevertheless, he learned from Analytic Cubism a way of decomposing solid forms and mingling them with their environment which cou more successfully express a Futurist ideology than the earli Futurist style—as *The Forces of a Street* reveals. In a tunnelli street, illuminated by the searchlight beams of street lamps, t successive states of the passage of a streetcar are represente Each state of its movement is plotted in linear outline, one abutti the next as it emerges from within the triangular tent of inten light. The sides of each image of the car are opened outward occupy the same plane as its roof, thus expressing both the swa ing progress of the car down the street and its noisy interpenetr tion with its surroundings. The wheels of the car, wrenched fr from its undercarriage, mingle with the surrounding shadowy transparent figures, some on the sidewalks, some seeming thrown out by the exploded forms of the car, but all striated by t refracted beams of light. Other linear elements, derived from t facades of buildings and from the pleated, telescoped forms of t sidewalk, enclose this mass of activity. Toward the bottom of t painting they are shaded in alternating planes of light and da Toward the top, the planes fuse around the intense white light

In paintings like this Boccioni developed his concept of "for lines" that express "the particular rhythm of each object, its inc nation, its movement, or, more exactly, its interior force."[7] That to say, he saw each object as possessed of an internal explosi power that, when released, would open it to its environmen "Force lines" represent the paths of objects exploded and set motion, and create the impression of a field of constant activity in which the spectator is empathically drawn. "Every object revea by its lines how it would resolve itself were it to follow the tende cies of its forces . . . These *force lines* must encircle and invol the spectator so that he will in a way himself be forced to strugg with the persons in the picture."[8] "Living art draws its life from t surrounding environment," Boccioni insisted. "How can we main insensible to the frenetic life of our great cities?"[9]

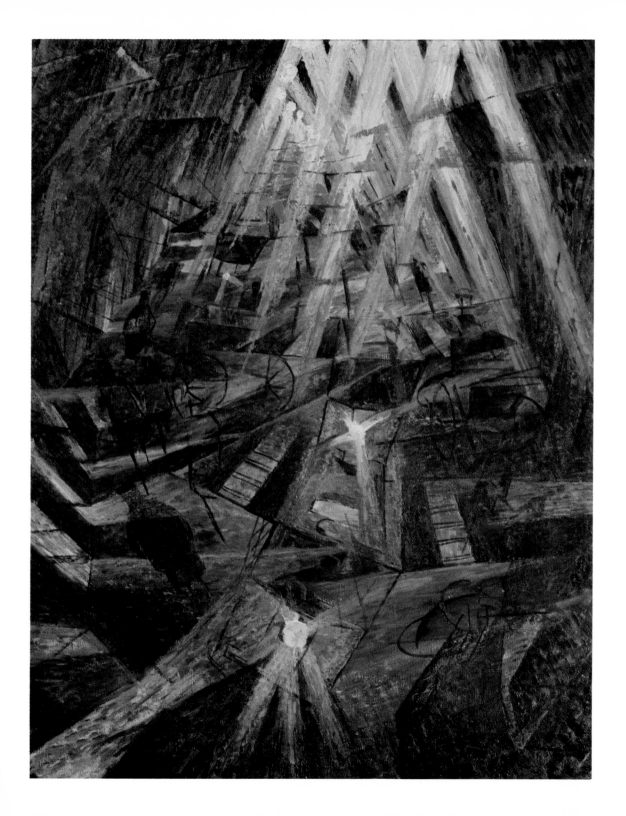

LE CORBUSIER (CHARLES-EDOUARD JEANNERET)
Still Life. 1927
Oil on canvas, 39³/₈ × 31⁷/₈" (100 × 81 cm)
Kunstmuseum, Bern

Charles-Edouard Jeanneret, better known under his architectural pseudonym of Le Corbusier, was introduced to the painter Amedée Ozenfant in 1918.[1] The outcome of their meeting was the movement called Purism. By that November, the first exhibition of Purist painting was taking place, and to accompany it Ozenfant and Jeanneret published *Après le cubisme.* As the title of this work suggests, Purism was a form of post-Cubism, though neo-Cubism perhaps best suggests its particular stance: as "scientific" a reaction to Cubism as Neo-Impressionism was to its parent movement. Purism, however, was "scientific" not only in method but in programmatic content as well.

In *Après le cubisme,* Cubist painting was condemned for its indifference to modern life, a life of science and mechanization. Futurism was no more than machine romanticism. Classicism and order were to be the watchwords of *L'Esprit nouveau,* and were to be expressed in painting by the application of "eternal," that is to say geometric, laws of composition and by the representation of simple geometric mass-produced objects. To paint commonplace objects of daily use, objects "of an extreme intimacy, a banality that makes them barely exist as subjects of interest in themselves and hardly lends them to anecdote,"[2] would itself make for a pure and unsentimental kind of painting, but added to this was the fact that the very anonymity of such objects was valued by the Purists for its own sake. In eulogizing simple mass-produced utensils, which the Purists called *objets types,* they thought of them as Platonic "absolute" objects from which all unnecessary and arbitrary features had been stripped by means of a quasi-Darwinian "Law of Mechanical Selection." "This establishes that objects tend toward a type that is determined by the evolution of forms between the ideal of maximum utility and the satisfaction of the necessities of economical manufacture, which conform inevitably to the laws of nature."[3] Hence, such objects as bottles, glasses, carafes, pipes, and so on, became symbols of the classic order of the machine age,

an economical and utilitarian order parallel to that of nature. In fa the objects the Purists chose particularly to represent were v similar indeed to those in Cubist still lifes, while the geome structures they adopted—notably the Golden Section and trian lar and grid-based compositions—had been used by Juan G and by the Cubists of the Groupe de Puteaux. The Purists, howev used their Cubist sources with new objectivity. This still life of 1 is a late Purist work and is somewhat more ornate and decorat than works of the earlier twenties—for, as with all of the reducti movements of the twenties, the early simplification eventu gave way to greater elaboration. Even here, however, the comp tion is geometrically organized. The cup, teapot, soda siph carafe, glass are rendered in a schematic side elevation, while top of the glass and end of the teapot's spout appear in plan. spite its heavy, even Baroque curves, the painting still has a fla of engineering drawing.

In the first number of *L'Esprit nouveau,* the Purists wrote hierarchy of geometric and free forms which, when combin would evoke *le bonheur.*[4] Compositions like this still life are i sense symbolic blueprints for an entire harmonically ordered e tence. By the time it was painted, Jeanneret had, under the na Le Corbusier, established his architectural reputation. In 1927 had completed the Maison Cook at Boulogne-sur-Seine and working on Les Terrasses at Garches. Not only are these vi composed like Purist paintings, with rectangular and curved ments within a grid-structured rectangular plan, but many of curved forms derive from the shapes of the *objets types* of paintings, whatever their utilitarian functions may be. It was no fact, a long step from the *objet type* to the *maison type* and to *maison outil* or *machine à habiter,*[5] the ideal—or perhaps bet idealized—mass-production house of Le Corbusier's work of twenties in which the Purists' classical-cum-mechanical ambiti found their most perfect expression.

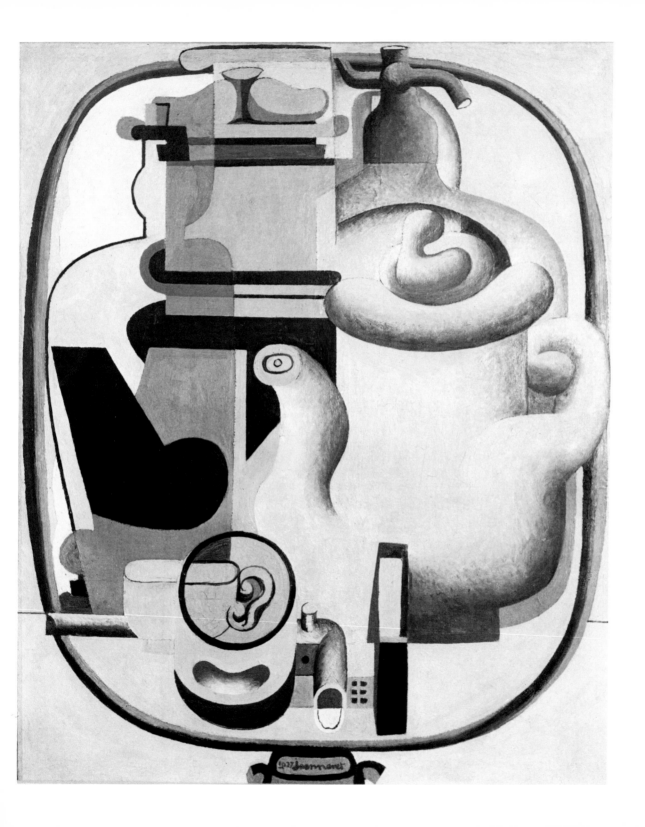

MARC CHAGALL
Dedicated to My Fiancée. 1911
Oil on canvas, $83^7/_8 \times 52^1/_4''$ (213 × 132.5 cm) (with frame painted by Chagall)
Kunstmuseum, Bern

Chagall's first Paris period of 1910–14 saw him allying imagery derived nostalgically from his native Russia with newly heightened and Fauve-inspired color and with increasingly geometricized structures indebted to Cubism. *Dedicated to My Fiancée* is the first major painting of a group of seminal works that Chagall made in the winter of 1911–12 when he moved to the artists' settlement La Ruche near the "Zone," where town and country met, and near the Vaugirard slaughterhouses. "I sat alone in my studio before my kerosene lamp," he recalled later. "Two or three o'clock in the morning. The sky is blue. Dawn is breaking. Down below and a little way off, they are slaughtering cattle, the cows low and I paint them."[1]

In 1910, Chagall had begun a series of paintings of a bare room, derived from a Russian peasant's cabin, with figures seated around a table and either a cow in the room itself (as in *The Yellow Room* of 1910)[2] or poking its head through a window (as in *The Drinker* group of works of 1911–12).[3] In *Interior II* of 1911,[4] the intruding animal knocks over a lamp, while a woman wearing a peasant headscarf leans over to touch the mouth of a man seated at the table. *Dedicated to My Fiancée* carries the same theme to a new pitch of hallucinatory intensity and inescapably erotic feeling. The irrationally displaced spaces of Chagall's previous paintings give way to an irrational disposition of forms down a surface of iconlike flatness. The strong red and gold paint which dominates the work particularly evokes something of the quality of an icon— except, of course, that the seated Madonna is scurrilously replaced by a bull-headed figure, around whose shoulders drape the limbs of the fiancée to whom the painting is dedicated.

The flattened space and latent geometricism of the painting speak of Chagall's familiarity with Cubist methods, but also of his studies of Baroque and Mannerist art. He himself described the work as "a sort of bacchanal, like those by Rubens, only more abstract."[5] It is recorded that reproductions of works by El Greco

littered his studio;[6] the zigzag angular composition may well o something to that source. Chagall worked on his paintings of t period from all sides, "as shoemakers do," he said.[7] This help account for the nonhierarchical disposition of the forms. The lin patterns created by the limbs of the figures and by the falling la carry the eye in a continuous but staccato movement across a around the surface of the painting, and Chagall's placement of three patterned areas, staggering them on the side edges of canvas, further accentuates this effect. The spontaneous hand and somehow molten color likewise add to the restlessness of image, as does the irrationally intertwined disposition of the t figures and the contrast of the two heads that form the focus the work. The "unreal" animal head is modeled realistically, wh the "real" woman's head is stylized into the form of a mask.

The title of the painting was provided by the poet Blaise C drars, with whom Chagall became particularly friendly in Paris offers no clue to the most puzzling parts of the iconography: animal head and the stream of spittle or smoke that connects t head to that of the fiancée. The painting tempts interpretation a kind of private allegory, but whether such interpretation refers Chagall's Russian sources, to the theme of the Minotaur (and artist's possible identification with this figure, as in Picasso's cc parable images), to the nightmare images of Fuseli, or to the m pastoral tradition exemplified by *A Midsummer Night's Dream* is likely to be a partial one. The stream emanating from the wo an's mouth may have a prosaic explanation. Probably refer to this painting in his review of the 1912 Salon des Indépenda Apollinaire noted that "the Russian Chagall is exhibiting a gol ass smoking opium. This canvas had outraged the police, but a of gold paint smeared on an offending lamp made everything right."[9] This powerful and emotive composition does ind evoke something of the character of a narcotic hallucination which the images of memory and imagination are fused.

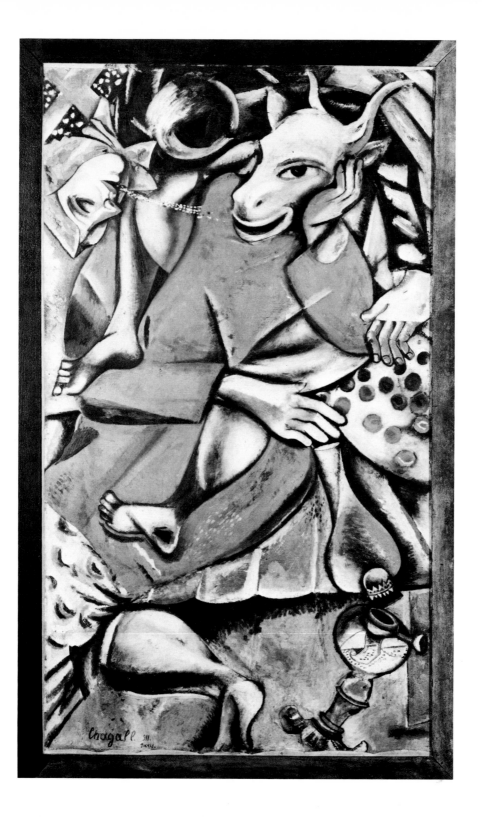

MARC CHAGALL
Jew in Black and White (The Praying Jew). 1914
Oil on paper, mounted on canvas, 39³/₈ × 31⁷/₈" (100 × 81 cm)
Collection Jürg Im Obersteg, Basel

In 1914 Chagall returned to Russia from Paris. He meant to stay only for a short visit but was cut off by the outbreak of the First World War, and eventually remained in Russia until 1922. The year 1914–15 was spent in his home town of Vitebsk, "a place like no other," he said later. Compared to Paris it was "a strange town, an unhappy town, a boring town."[1] Whereas in Paris he had rendered the images of Vitebsk in fantastic and irrational combinations, his face-to-face confrontation with the images themselves initiated a new, more realistic direction in his art. He painted what he called "documents" of Vitebsk, paintings of "hunchbacked, herringlike bourgeois, green Jews, aunts, uncles. . ."[2] The most important of these "documents" was a series of some six paintings of old men—beggars or itinerant Hasidic rabbis—whom Chagall brought into his parents' house and presented in stark, hieratic poses. Although certainly more realistic than his Paris paintings, this series of old Jews does not abandon the formal structures that Chagall learned in Paris. It combines in an altogether surprising manner psychological portraiture, Cubist-derived dislocations of form, and an element of imaginative fantasy.

The *Jew in Black and White* is the only one of the series with a completely religious theme. Its subject, however, was a beggar. "Another old man passes by our house," Chagall wrote. "Gray hair, sullen expression. A sack on his back . . . He enters and stays discreetly near the door."[3] It was Chagall who dressed him as if in prayer, with his father's prayer shawl around his head and shoulders and the phylacteries fastened to his head and arm. This is the most Cubist, or at least the most geometric, painting of the series, using the sharp, angular, and flattened forms of the Paris paintings, if anything accentuated here by the harsh contrasts of black and white and the zigzag contours, and set off by the subsidiary curvilinear rhythm around the praying hands and by the solidly modeled face. A remarkable tension is induced between the schematically painted hands, which are the focus of both the curvilinear and the angular forms, and the more naturalistically painted face. Although the face too is simplified into angular, diagonal planes which join themselves to the underlying geometric structure of the whole work, it is nevertheless so sculptural in form that it would float isolated from the rest of the composition but for the prayer shawl that encloses it. Both formally and iconographically the shawl is the nexus of the work.

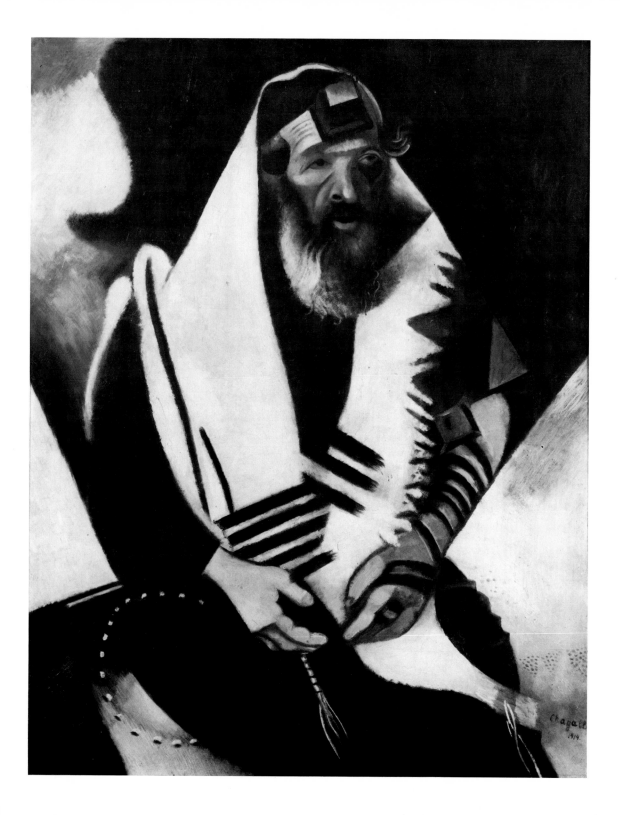

Something of the tension between head and hands that marks the *Jew in Black and White* also exists in the *Jew in Green.* In this painting, however, it is color that ties the two together: the yellow right hand repeats the color of the beard and hair, while the white left hand seems curiously empty in its flat, colorless form, mirroring the closed left eye of the face. Since the contrast of luminous green face and yellow hair is such an assertive one, the very absence of green beside the same yellow in the hands naturally evokes comparison with the head, and therefore returns our attention to that area. There we notice the combination of open and closed eyes— which in turn refers us back to the colored and noncolored hands. As with the *Jew in Black and White,* Chagall creates a vertical channel of dramatic and psychological interest, to which all else in the painting is related. The subject here was in fact a rabbi, known as the "preacher of Slouzk." "Imagine, seated at the table, in front of the samovar," Chagall wrote later, "a humble old man leans back in his chair. I look questioningly at him: 'Who are you?' 'What! You don't know me? You've never heard of the preacher of Slouzk?' . . . Have you seen the old man in green I painted? That's the one."[1]

In the background of the painting Chagall has introduced biblical texts which tell of God's words to Abraham that his were the Chosen People. Behind such an intense image as this, the text has far more than an ironic force. Chagall said that the text was intended as an "atmosphere in which the figure is immersed."[2] The color too provides a psychological atmosphere for the painting; Chagall spoke of it not as something arbitrary or decorative, but as revealing his sympathetic attachment to his subject. "I had the impression that the old man was green," he commented; "perhaps a shadow fell on him from my heart."[3] In all the paintings of the series, a particularized color range substantiates the formal design in creating a highly individual mood for each work.

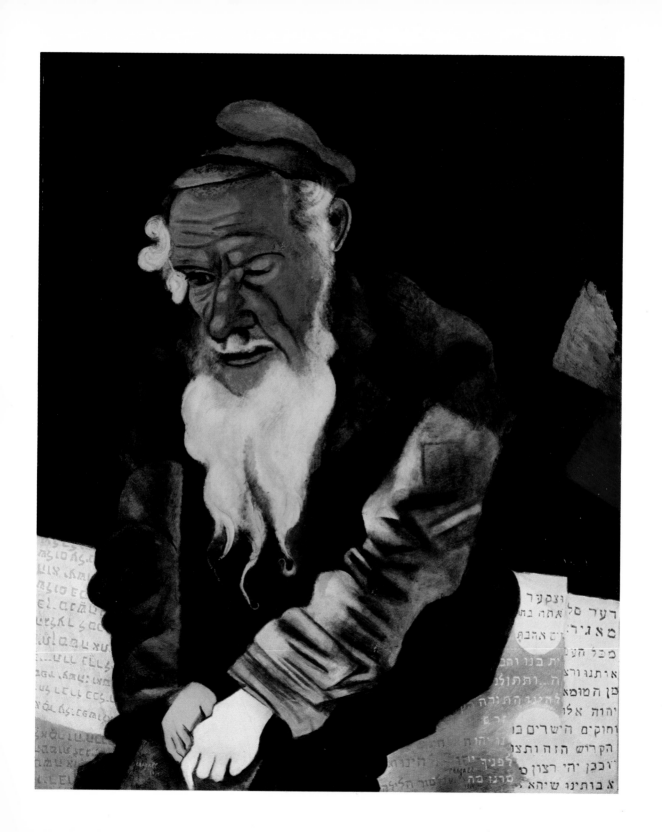

MARC CHAGALL
Jew in Red. 1914
Oil on paper, mounted on canvas, 39³/₈ × 31¹/₂″ (100 × 80 cm)
Collection Jürg Im Obersteg, Basel

If the *Jew in Black and White* is severe and dramatic in its harsh contrasts and the *Jew in Green,* bathed in the unnatural light, seems intense and spiritual, the *Jew in Red* is at once more earthbound but also more archetypal in representing the form of the Wandering Jew complete with stick and bag. In this case, it is tempting to see the figure as a symbolic image of Chagall himself, for instead of including a biblical text, he has listed—in Cyrillic, Roman, and Hebrew characters—on the curtain to the left of the picture the artists he admired: Cézanne, Courbet, Chardin, El Greco, Breughel, Fouquet, van Gogh, Cimabue, Giotto, and Tintoretto.[1] This is the least stylized of the three works under discussion. Except for the treatment of the hands—once more, the left hand is an "empty" white, while the right hand picks up the unnatural red of the background—it is a somber, realistic painting. There are nonrealist forms in the work—particularly the tiny stylized house tucked into the lower left corner of the painting—but only the faceted, angularized left hand and the pyramidal, diagonal composition overtly link it to Chagall's Cubist past. Of course, the flattened face with wide diagrammatic eyes ultimately refers to early Cubist sources (as well as to Chagall's pre-Paris work) and is,

in fact, far more two-dimensional than the faces of the two other works.

The effect, however, is finally more naturalistic. Likewise, there are certain passages of remarkably free and spontaneous brushwork, and certain dislocations in the drawing (the stick, for example, is broken as it passes through the hand), yet these are contained within an essentially realistic conception. It was perhaps its very realism that prompted Chagall to write in the names of the artists whose works he had admired in Paris: as a tribute to the great Western painters of monumental and psychological images, but also, perhaps, as a way of expressing his national and ethnic isolation from Western painting now that he was back in Russia. The artist as a wanderer returned from Europe emerges from behind the curtain inscribed with the names of Western artists. Just as the *Jew in Green* is an estranged and isolated figure, despite the accompanying text telling of his being one of the Chosen People, so this figure is estranged from the community of Western art. In this sense the painting is a poignant evocation of the atmosphere in which Chagall was immersed when he returned to his native Vitebsk.

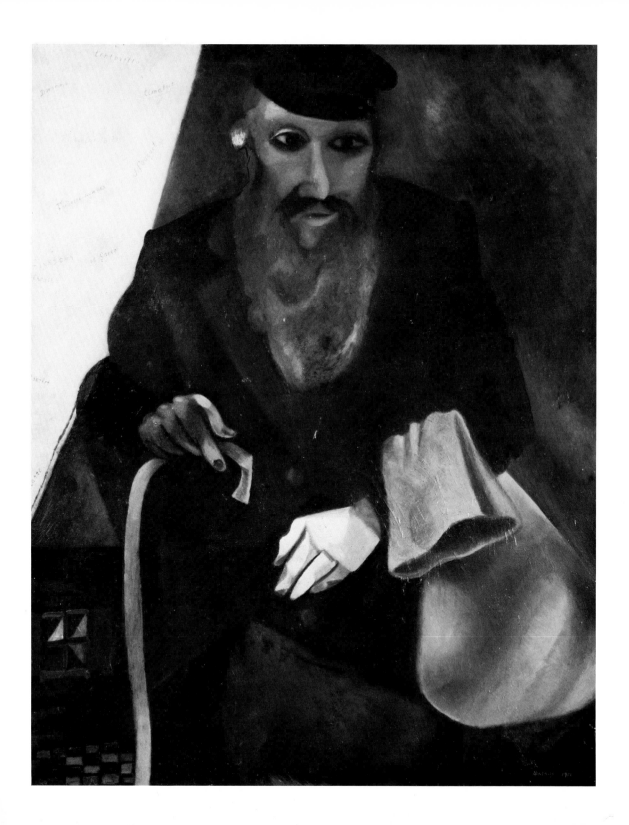

WASSILY KANDINSKY
Composition V. 1911
Oil on canvas, 74⁷/₈ × 108¹/₄″ (190 × 275 cm)
Private collection

In *Concerning the Spiritual in Art,* Kandinsky wrote of the three different groups into which he divided his paintings: *Impressions,* based on the direct observation of nature; *Improvisations,* largely spontaneous expressions of the inner character of things; and *Compositions,* each of which was "an expression of slowly formed inner feeling, tested and worked over repeatedly and almost pedantically . . . Reason, consciousness, purpose play an overwhelming part. But of calculation nothing appears: only feeling."[1] As these distinctions make clear, the *Compositions* were intended not only to go beyond the literal depiction of nature, but beyond the spontaneous abstraction from nature of the *Improvisations,* to something more deliberated and universal in feeling. The seven *Compositions* which Kandinsky painted before 1914 he considered his most important and ambitious works.[2]

For Kandinsky, deeply absorbed in the religious and the spiritual, the visible forms of things had come to seem obstacles to the representation of their inner character. A line, for instance, he wrote in his essay "On the Question of Form," can represent an object but also be viewed autonomously as an abstract form that releases the "pure inner sound" of the object in question. "In a painting, when a line is freed from delineating a thing and functions as a thing in itself, its inner sound is not weakened by minor functions, and it receives its full inner power."[3] By combining groups of such abstracted motifs in carefully planned *Compositions,* Kandinsky hoped to create his most intensively spiritual works: "They appeared before me in my dreams—indistinct and fragmentary visions, sometimes frightening in their clarity . . ."[4] He talked of the creation of a *Composition* as a "visionary birth."[5] The artist carried "within himself" the "fragmentary visions" and images; he developed them in studies and in ancillary paintings, and as the images were repeated they were simplified and abstracted to reveal their true "inner feeling." A *Composition,* therefore, was a symbol of pure spirituality and of the overthrow of materialism that Kandinsky spoke for in *Concerning the Spiritual in Art.* The spirit of his new *Compositions,* he wrote in the dramatic finale of that work, was organically related to "the reconstruction of the new spiritual realm, since this spirit is the soul of the Epoch of the Great Spiritual."[6]

As befitting symbols of a new epoch, the *Compositions* are all derived from eschatological motifs. *Composition V* was subtitled "Last Judgment" by Kandinsky, and in 1914 he referred to it as a "Resurrection."[7] Such titles were never intended to be literally descriptive; Kandinsky insisted that a *Composition* was in no

sense "the depiction of an event."[8] Nevertheless, it derived fr[om] such depictions, and by turning to the sources of *Composition* we can see how this great canvas took shape. It was begun in t[he] autumn of 1911 and completed on November 17 of that year.[9] 1910, Kandinsky had started painting Apocalyptic themes. M[ore] relevant to this work are a pair of *Last Judgments* of 1910 and 19[] (the second on glass),[10] two *All Saints* paintings of 1910 and 1911 and various paintings on glass from 1911 including another *[All] Saints* and two *Resurrections.*[12] From these more literal depiction[s] *Composition V* can be deciphered as showing the resurrection [of] the dead and the collapse of cities accompanying the trumpets [of] the Last Judgment. From the *Last Judgments* of 1910 and 1911 [we] can see that the upright form to the right of the triangle at the low[er] center is a decapitated saint rising and holding aloft his head (w[ith] striped hair).[13] Around this figure are other members of the res[ur]rected dead. Trumpets push down from the upper corne[r] sounded by angels whose hair streams out behind. The second *[All] Saints* painting (1911) is probably the most informative. It enab[les] us to see that the dark upright lines to the lower right corner a[re] derived from a saint, his face turned toward a trumpet above hi[m] and that the dramatic whiplash line which dominates *Composit[ion] V* comes from a tree beside this saint, but transposed across t[he] painting.[14] Likewise, the forms with red tips near the upper rig[ht] corner are indeed candles, and above the whiplash line, buildin[gs] collapse in flames as Elijah in his chariot passes by.[15]

The triangular form may derive from a Bavarian glass painti[ng] Kandinsky illustrated in the *Blaue Reiter Almanach,*[16] where it e[n]closed the eye of God, or it may be explained by way of Kandi[n]sky's theosophical interests.[17] We are also reminded that wh[en] Kandinsky described the development toward the Epoch of t[he] Great Spiritual in *Concerning the Spiritual in Art,* he used t[he] image of a triangle.[18] And from that book, moreover, comes t[he] following description of the overthrow of the materialist epoch [as] the spiritual one approaches: "As we rise higher in the triangle, w[e] find that confusion increases, just as a city built on the most corre[ct] architectural plan may be shaken by the uncontrollable force [of] nature. Humanity is living in such a spiritual city, subject to sudd[en] disturbances for which neither architects nor mathematicians ha[ve] made allowance. In one place lies a great wall fallen down like [a] house of cards, in another are the ruins of a huge tower which on[ce] stretched to the sky, built on presumably immortal spiritual pilla[rs]. The abandoned churchyard quakes, forgotten graves open, a[nd] from them rise forgotten ghosts."[19]

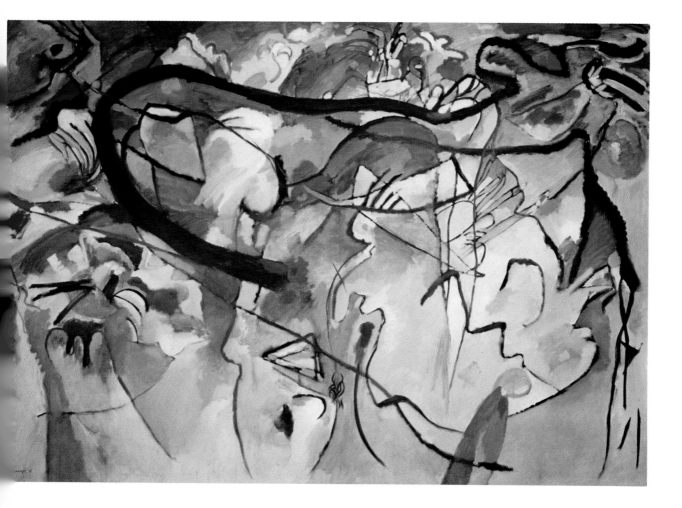

AUGUSTO GIACOMETTI
Chromatic Fantasy. 1914
Oil on canvas, 39³/₈ × 39³/₈″ (100 × 100 cm)
Kunsthaus, Zurich

Of the three Swiss artists bearing the name Giacometti, the sculptor Alberto Giacometti is of course the best known. The other two were painters: Alberto's father, Giovanni, and his father's cousin, Augusto. Giovanni Giacometti worked in a vein similar to that of his friend Amiet. Augusto Giacometti, however, was one of the pioneers of abstract painting, who had developed—at least by 1912—a colorful, allover nonfigurative style ultimately derived from the organic forms of Art Nouveau decoration.

From 1897 to 1901, Giacometti studied in Paris under the Art Nouveau poster and stained-glass designer Eugène Gasset, who was also the author of *La Plante et ses applications ornementales.*[1] Abstract but organic ornament was, of course, a quintessential part of Art Nouveau design, and as such influenced a wide range of early modern artists from Matisse to Klee. Since the forms of Art Nouveau ornamentation importantly derived from those of Symbolist art—and co-opted to themselves some of the metaphysical connotations of Symbolism—they could be seen as more than merely decorative forms. They were regarded as basic organic elements—meaningful as well as decorative—that expressed an underlying natural order behind specific appearances. All highly stylized ornamentation can be viewed in this way. Art Nouveau, however, showed that a Symbolist-based art could be realized in far less literary terms than Symbolist painting itself had used and for this reason was especially interesting to some of the early modernists, Giacometti included.

Around 1900, Giacometti began making ornamental designs based on a diagonal grid created by intersecting curvilinear lines, with the compartments of this grid filled in with decorative spots and patches.[2] This format derived in part from Giacometti's interest in stained glass, but the grid lines themselves were gradually dissolved, and by 1912 they served merely to lay out large square paintings of juxtaposed patches of vivid and contrasting impastoed colors.

The mosaiclike appearance of *Chromatic Fantasy* and similar works is certainly indebted to Neo-Impressionism, but the Neo-Impressionist touches cover a surface organized by the undulating lines of the Art Nouveau grid. Commenting on his readings in color theory, Giacometti wrote: "It is interesting to note that both Chevreul and Signac are concerned with giving color and the picture an attractive skin, like the skin of a ripe fruit."[3] Giacometti's own paintings have something of the effect of colorful skins covering underlying organic structures. What particularly interested him was "one question: how does nature proceed in its distribution of color? . . . Would it not be interesting to examine the question in order to determine whether there might not be a natural law hidden within? Should we not proceed in a way analogous or parallel to nature? . . . We would then paint as nature does and be essentially as true as nature is."[4] This is to say, Giacometti wanted to present colors in combinations and compositions derived from the study of nature, but without imitating specific naturalistic forms. His paintings do indeed achieve this effect. *Chromatic Fantasy* evokes comparison with arrangements of flowers or of colored stones, and seems at times to be an excerpted fragment from some larger organic flux, an overview of the natural world.

OSKAR KOKOSCHKA
Dent du Midi. 1909–10
Oil on canvas, $31^{3}/_{8} \times 45^{5}/_{8}''$ (79.6 × 115.7 cm)
Collection M. Feilchenfeldt, Zurich

The Dent du Midi is a peak in the Swiss Alps due south of the eastern end of Lake Geneva and close to the border with France. Kokoschka made his first visit to Switzerland late in 1909, after leaving the Vienna School of Arts and Crafts, where he had been a student since 1905. He spent the winter in Switzerland, visiting Leysin, Aigle, and Vevey near Lake Geneva before returning to Vienna in February of 1910. It was looking south from Leysin that he painted this picture.[1]

Kokoschka's pictures of this period are almost exclusively portraits. Landscapes are very rare indeed, for Kokoschka was principally interested in the psychological characterization and nearly caricatural distortion that portraiture best allowed. As a student in Vienna, he had been particularly interested in the work of Klimt and Hodler, and had associated himself with Josef Hoffmann's Art Nouveau workshops, the Wiener Werkstätte, from which amalgam he developed what became a deep-seated concern with graphic means of expression. His discovery of van Gogh and then of Munch corroborated this development, while serving to show Kokoschka a way beyond the ubiquitous lyricism and ornamentation of Viennese Secessionist art to something far more intense in mood. By 1908 he was a psychological portraitist, if not indeed already an Expressionist painter. In the beginning, however, his paintings were never as impastoed as those of his mentors, and so they remained until after his return from Switzerland. Although he sought an active and expressive surface for his work, it was in a very different way.

Kokoschka's earliest mature pictures were thinly and fairly evenly painted, but with bold calligraphic contours. In 1909 he began to scrape lines into the still-wet paint with the end of his brush, experimented with loose, almost random methods of paint application, and further thinned the paint at times to create a watercolorlike effect with areas of white ground showing through. This produced the feeling of an internal light source for the work. In the portraits, it seems as if Kokoschka is literally penetrating through the external features of the sitter with his graved lines to reveal an inner spirit. In this landscape, the same technique contributes to the effect of sharp wintry sunlight seen through a misty haze, but also gives the painting an intense and visionary quality that clearly belongs to the tradition of Northern Romantic art.

The fantastic forms are as much a part of this tradition as the fantastic light. Both the primitive peaks, created out of a chaos of form—scrubbed and smeared paint—and the restless, wiry drawing beneath look back ultimately to the emotive panoramic landscapes of the sixteenth-century North. Like Kokoschka's contemporaneous portraits, this painting has that utter frontality often favored by Expressionist artists. Its parallel zones of incident—the sled and racing dog, fence, line of trees, and mountains beyond—are disturbed only by the single tall pole, pushing up into the haze and daringly placed on a hill at the very edge of the work. We are invited to follow the composition up this hill—presumably the destination of the travelers—and then look back across the valley enclosed by the forms of the Swiss Alps.

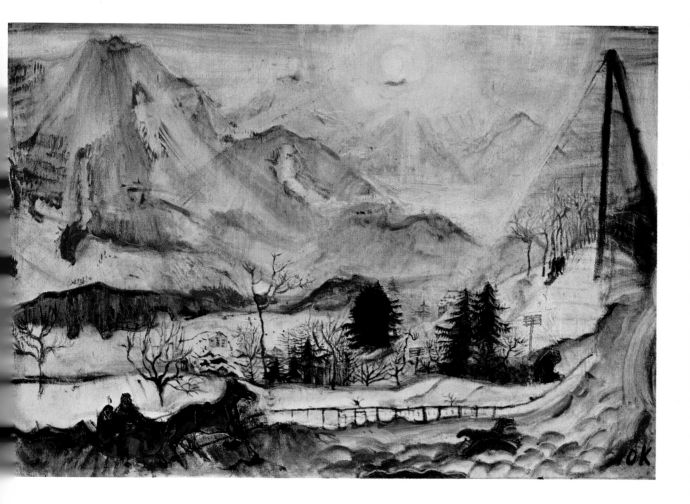

AMEDEO MODIGLIANI
Standing Nude (Elvira). ca. 1919
Oil on canvas, 36¼ × 23⅝″ (92 × 60 cm)
Collection Professor Walter Hadorn, Bern

As is the case with several other School of Paris painters, the romance of Modigliani's life and the tragedy of his early death have affected judgment of his actual work. If he is a popular artist, then equally the very popularity of his work can lead to its being underestimated critically. He occupies, however, an interesting and almost unique place in early modern painting, for he discovered a way of allying the new formal lessons of Cézanne and of primitive art to a traditional conception of picture-making, thus creating one of the few authentic alternatives to the amalgam the Cubists made of the same advanced sources.

Of course, Modigliani was influenced by the Cubists and learned about Cézanne and primitivism through Cubist interpretations, or at least immediately pre-Cubist ones. He arrived in Paris in 1906, took a studio in Montmartre in the vicinity of the Bateau-Lavoir, was soon in contact with Picasso, André Salmon, Max Jacob, and the rest, and therefore was present at the very birth of Cubism. But like a number of others in the same situation—the closest parallel is perhaps with André Derain—he was not ready to abandon immediately recognizable imagery, and his style never advanced beyond the stage where Picasso's was when Modigliani first saw his work in 1906. It was not, however, until 1909 that Modigliani found a way of revitalizing the archaic classicism of pre-Cubist painting, and that was through the mediation of Brancusi's post-Cubist sculpture. And it was not until 1914, when Modigliani returned to painting at Max Jacob's urging, that the lessons learned from sculpture were convincingly transposed to the two-dimensional. The paintings for which Modigliani is best known date from 1915 until his death early in 1920.

The series of upright and reclining nudes that are probably Modigliani's most famous works began in 1916. This portrait of Elvira—a model who appears in a number of late paintings[1]—belongs to a group of transparent-seeming works, all light in tonality and with loose, somewhat dappled brushstrokes. In most of Modigliani's mature paintings the figures are posed before dark backgrounds against which the sharply contoured areas of warm flesh are dramatically contrasted. The open, scumbled background of varied blues places this picture among the group of loosely rendered late works. The treatment of the flesh, however, is rather denser than that in most works with a similar background, being closer to that in pre-1917 paintings. Modigliani's painting during his last three years varies techniques considerably (within the basic stylistic framework), intermixing different manners and treatments, as in the present work. The flattened frontal solid of the body—a glowing terra-cotta color igniting into hot orange in the hands and the blushing face—is set off against the shimmering atmospheric background, to give to the picture a lightness and elegance, and to the unselfconsciously voluptuous figure a feeling of calm dignity in her self-contained pose. The perfect oval head with symmetrical features (offset, however, by the casual hair and slightly misaligned eyes) and the connecting pattern of analogous curves that outline the body and breasts bring to the design a crispness that stabilizes the picture. The blank eyes generalize and idealize the young model. Modigliani's is a light, graceful, and inevitably somewhat sentimental art never quite as commanding as the sources from which it derives. It is, nevertheless, not only a unique lyrical offshoot from Cubism—using modernist idioms in an unpretentiously charming manner—but a highly individual one too. The seductive but often innocent or wistful-looking nudes that are Modigliani's greatest accomplishments hold a place among the most unmistakable images of twentieth-century art.

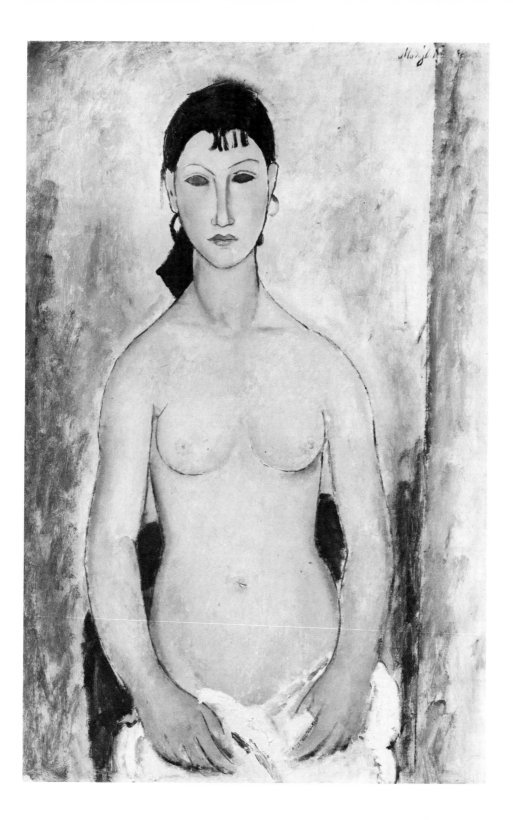

AMEDO MODIGLIANI
Portrait of Mario Varvogli. ca. 1919–20
Oil on canvas, 45³/₄ × 28³/₄″ (116 × 73 cm)
Private collection

The deep, resonant color harmonies of this portrait of the musician Mario Varvogli are typical of Modigliani's mature style. So too is the contrast of curvilinear drawing in the figure and geometric but asymmetric organization in the background. Here, as in the majority of Modigliani's paintings, color is the unifier while drawing creates contrasts. The reds, ochers, browns, and greens are of the kind that Modigliani made particularly his own, restrained but not somber, and close enough to each other in value so that the painting does not fragment itself into the shapes marked out by all the strong contours, yet with a sufficient balance of lights and darks to consolidate the sturdy design. The figure is placed exactly on the axis of an upturned T-shape formed by the russet door and lower section of the wall against the ocher of the rest of the background. Except for the face, hands, and shirtfront, the figure is darker in tonality than anything else in the painting. There are, in effect, three superimposed pictorial zones: ocher background, russet-red middle ground, and the brown and green figure in front. The progressive darkening of the colors creates these zones, but the colors are alike in kind. It is the drawing that provides the principal contrasts. The curvilinear drawing of the figure is developed around the geometric background's focal point. A long, graceful diagonal that starts with the coattail and ends by splaying into the two lapels is intersected (just by the left hand) by the continuous double curve of left leg and left arm, and everything in the picture is oriented to this spot. The schema entails an anatomically impossible but highly elegant pose for the figure, and it establishes the subtle linear rhythm that prevails throughout the painting.

The linearity that dominates Modigliani's art, as well as the elongated forms and curving diagonal poses, allies it to Italian Mannerist painting. Modigliani's is in fact a similarly sophisticated and stylized art which occasionally fails for its affectedness and facility but at its best reveals a highly refined feeling for pictorial organization. It is symptomatic that when, like many of his generation, Modigliani looked to African sculpture for inspiration, he turned to the delicate and linear Baulé style of the Ivory Coast—from which he derived the elongated oval head with small eyes set close to a long narrow nose and small mouth—as well as looking away from Africa, to archaic Greek art.[1] Modigliani belongs as much to the Neo-Classicism of early twentieth-century art as to its primitivism. His sense of design, however, is entirely modern; in this work the cropped-off figure is brought resolutely up to the front of the picture to fill out the frame and decoratively articulates and expands the pictorial space.

This painting was one of Modigliani's final works, if not indeed his very last. He died early in 1920 at the age of thirty-five. A sketch for this painting bears the inscription "Il Novo Anno / Hic Incip Vita Nova."[2]

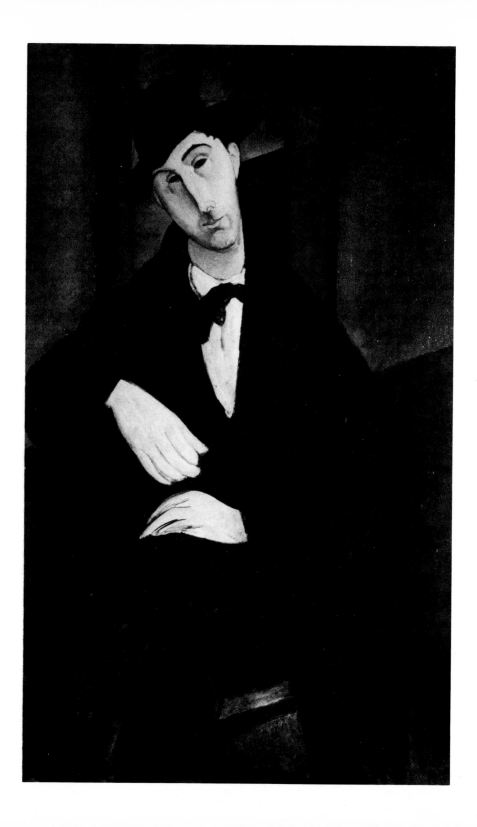

Arp's first "biomorphic" reliefs, of which *Madam Torso with Wavy Hat* is one of the boldest and most iconic, date from 1916, when Arp was associated with the Dada poets and painters in Zurich. The Zurich Dadaists' advocacy of the spontaneous and spiritual in the face of what they saw as a corrupt materialist world meant that the rectilinearity of Cubist art was opposite to their needs. Their ideologies derived mainly from German Expressionism, and particularly from Kandinsky and the Blaue Reiter group. Arp had been in contact with the Kandinsky circle (as well as with the Cubists) before moving to Zurich. In Zurich he developed what was in basis an Expressionist art—whose forms were intended to express an inner universal meaning—but he avoided the rhetorical element in Expressionism for a simplified formal vocabulary of primitive organic shapes.

"When he advocates the primitive," his friend Hugo Ball noted, "he means the first abstract sketch that is aware of complexities but avoids them . . . he likes the Middle Ages mostly for their heraldry, which is fantastic and yet precise . . ."[1] *Madam Torso with Wavy Hat* recalls the hieratic forms of heraldic designs. Its meandering contour, however, creates the feeling of growing forms. Although Arp has specified the subject as being a female figure, the relief admits of wider associations: of growth and change in animal and plant life in general. Arp's biomorphism looks back through Expressionism to Art Nouveau, and co-opts some of the generalized botanical associations of that style—the way in which serpentine lines evoke the feeling of continuous growth without having to define nature literally. Unlike Art Nouveau, however, Arp's curvilinear lines establish closed flat shapes. These shapes, therefore, become emblems of completed growth as well as implying (by virtue of their contours) the continuous organic process. "We don't want to copy nature," Arp wrote. "We don't want to reproduce, we want to produce. We want to produce like a plant that produces a fruit."[2] Talking of his "first experiments with free forms," he said: "I looked for new constellations of form such as nature never stops producing. I tried to make forms grow."[3]

From 1916, Arp developed a rich and poetic iconography of organic shapes suggestive of clouds, moustaches, leaves, navels—the range is wide—which he brought together in humorous and unexpected combinations. Even the most "natural" forms had anthropomorphic connotations, and each form could be easily modified to serve different functions. (Here the moustache shape becomes a wavy hat.) The very ambiguity of the forms endows them with a special humor. Arp's titles—at first sight helpful—in fact only add to the confusion of their interpretation. (A torso and wavy hat can easily be deciphered here, but only if we accept the proposition of a figure with a hat instead of a head and with three legs.) "The interpenetration and the realization of these objects were as variable as the weather," Arp said later, when he thought up descriptions in the form of short stories to explain what they represented.[4] His explanation of this relief is a model of brevity put to the service of Dadaist bafflement: "The bust of your hat tenderly greets the walnut of the closed doors."[5] Dada, Arp said, "is for infinite sense and definite means."[6]

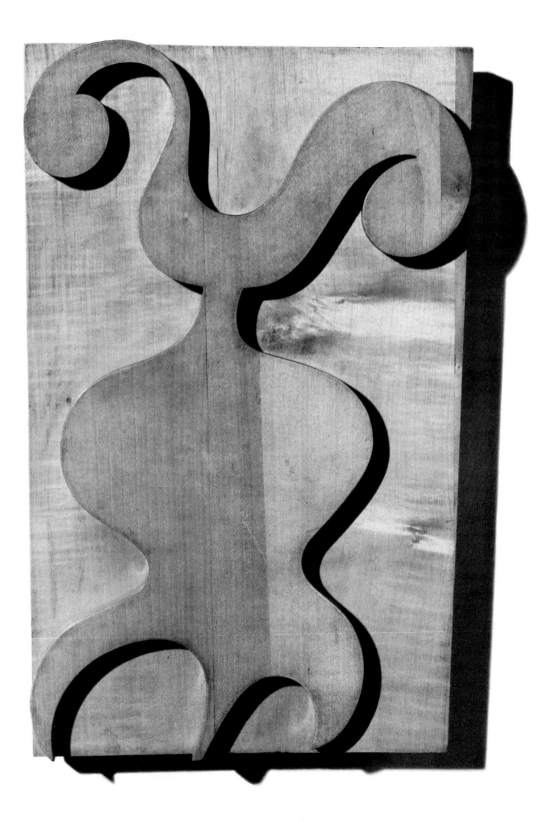

PIET MONDRIAN
Composition I. 1913
Oil on canvas, 33³/₄ × 29¹/₂″ (85.7 × 75 cm)
Galerie Beyeler, Basel

In May 1912 Mondrian began his first stay in Paris, which lasted just over two years. It was crucial in his development toward abstraction. While he had already seen Cubist paintings by Picasso and Braque exhibited in Amsterdam in the autumn of 1911, it was only in Paris that he began to create his own personal interpretation of Cubism, increasingly freeing his art from perceptual references and thus preparing for the total abstraction of his Neo-Plastic paintings. At first sight, many of the Paris paintings themselves appear to be abstract. As yet, however, he was still guided to an important degree by the stimulus of natural appearances. When the Dutch composer Jakob van Domselaer, who often visited Mondrian's studio in this period, was later asked what he saw there, he replied: "Trees. Nothing but abstract trees!"[1]

Trees had been the subject of Mondrian's earliest-known work in 1888.[2] In his developing years he had painted them in picturesque, naturalist, Romantic, Symbolist, and Impressionist manners, in increasingly hieratic arrangements. By the time of the Blue Trees series of 1908–9[3] we see the essential features that were to be simplified and abstracted in his work of the Cubist period: flattened, basically linear images spread out to fill the canvas surface in a continuous web of lines through which pockets of color are seen. The specific forms of the apple tree, which motivated these paintings, are gradually dematerialized to create an archetypal, romantic icon from a rudimentary vocabulary of elemental forms. By the time of the *Gray Tree* of 1912,[4] the skeletal framework is even more generalized as the web stiffens into a contrapuntal interweaving of tensed curve lines that provide a stressed horizontal accent for the painting. Mondrian would later talk of the horizontal as female and material in emphasis, as opposed to the male and spiritual vertical. Concurrently with works like the *Gray Tree,* he

was making paintings of upright trees. Iconographically, *Composition I* may be thought of as an attempt to balance the female and male principles in one painting. The dense curved lines intermingled with horizontals that spread across the lower center of the painting (supported upon a splaying tree-trunk form at the bottom) clearly relate it to the earlier works derived from an apple-tree image. Yet, this horizontal organic stress is more than matched by the slight predominance of vertical over horizontal in the format of the painting and by the webs of upright lines seemingly clustered around the central vertical axis. The composition therefore appears to be cruciform: the quintessential image of the resolution of contraries and, for Mondrian, the basic symbol of cosmic order. In works like *Composition I,* Mondrian loosens his previous attachment to particular instances of the natural world for abstracted spiritual images that distill the forms of reality into an elemental geometry.

Mondrian's experience of Picasso's and Braque's high Analytic Cubist paintings was especially profitable in this respect. They revealed a two-part structure of frontal facet planes and abbreviated geometric drawing which confirmed his own dissociation of line and plane; and Mondrian seized upon the elements of Cubist analysis to further simplify the components of his art. In the group of tree-based paintings probably from early 1913,[5] of which this one, he settled his art into the combination of vertical and horizontal lines, modified only by a few tense curves and with carefully applied patches of color in between (at first, mostly blues, and here, with ochers taking over in the Picasso-oriented Cubism of later 1913). Mondrian's intentions, however, were quite different from the Cubists', and his work remained diagrammatic rather than analytic in conception.

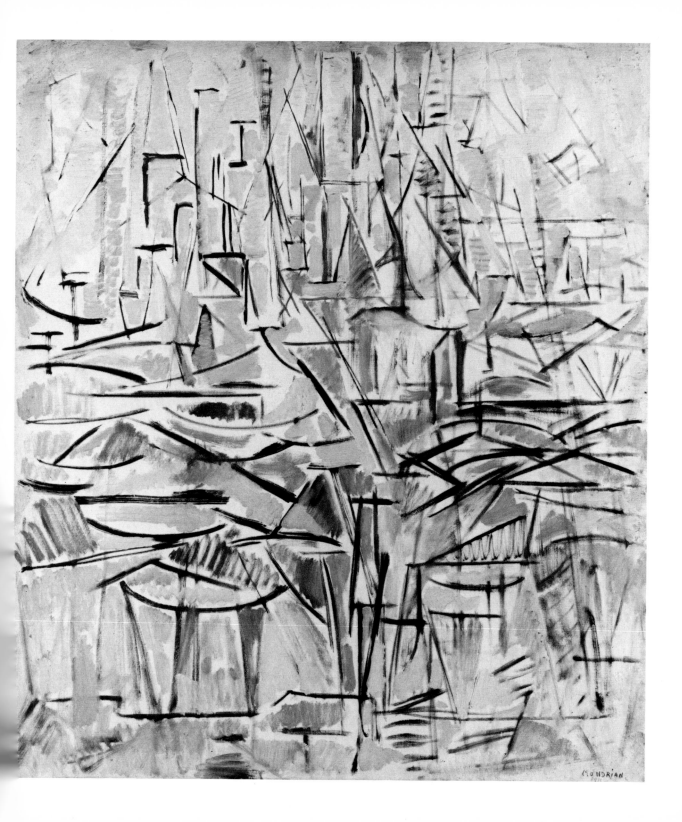

PIET MONDRIAN
Composition A (Black-Red-Blue). 1932
Oil on canvas, $21^3/_4 \times 21^3/_4''$ (55 × 55 cm)
Kunstmuseum, Winterthur

Ten years before he painted this picture, Mondrian had established what were to be the principal characteristics of most of his subsequent work: a square or vertical painting format enclosing squares or rectangles of relatively pure primary colors on a white background and structured by strong black lines that most often extended to the very edges of the painting surface. The development and purification of this formula occupied him throughout the twenties. After a gradual increase in pictorial openness from around 1925, effected principally by giving one rectangular area clear dominance over the others in size and by allowing it to be unbounded on one or two sides by black lines, he arrived at two basic compositional types which he developed in the period around 1928–32. The first used a basic quadripartite division, with the largest of the resulting areas placed at the upper right and with the area immediately below this one generally subdivided to form an inner square or rectangle. The second flanked the largest internal area (normally placed at the upper right or lower left) on two adjacent sides with smaller rectangular divisions.[1] *Composition A* belongs to the first type. Its prototypes go back to a group of paintings of 1927–28, and even to some painted in 1921–22, for Mondrian was continually recapitulating and refining his themes,[2] but when this format was established in 1928, it was fixed upon and used regularly for four years—with variations of color, spacing, size, and internal divisions, of course—becoming one of Mondrian's most classic images.

Indeed, this painting shows Mondrian's art at perhaps its purest and most characteristic. There are more austere paintings from the same period, but these are extreme extensions of the search for pictorial purity to which he was drawn around 1930. This, in contrast, appears to be one of the images which best summarize the development of Mondrian's art in the previous decade, showing the purity and harmony he had created in its most refined form before his turn to more complex structures. The companion *Composition B* from the same year replaces the main horizontal with

two thin parallel lines, initiating the series of optically active pictures that Mondrian painted throughout the thirties.[3] *Composition A* was created at the apogee of a development that had begun when Mondrian's Neo-Plasticism first was invented.

Mondrian was sixty when he made this painting. His pure Neo-Plastic manner had been established around his fiftieth year, though before then had come the superb early geometric paintings and, earlier still, highly individual interpretations of Cubism, Fauve-type color paintings, Symbolist-influenced art, and naturalistic work. If anything links this amazing body of work together it is its pervading romanticism of an almost mystical kind. Like the other great pioneers of geometric abstraction, Malevich and Kandinsky, Mondrian saw his work as the expression of internal and metaphysical meaning. He defined his Neo-Plasticism as "a plastically determinate aesthetic expression of the universal."[4] The universal was expressed by the "absolute" nature of the pictorial elements used—straight lines, pure and planar colors, equilibrious proportions—and by the resolution of contrasts between these "absolute" elements.[5] Hence, in *Composition A*, vertical (active or masculine) and horizontal (passive or feminine) lines are brought into harmony in the shape of a cross, itself expressive of cosmic harmony. The black image contrasted against a white ground is balanced by the presence of colors; and blue, an "inward" (or spiritual and universal) color, is matched by red, an "outward" (or worldly and individualistic) one.[6] Mondrian was not always consistent in the way he discussed the symbolism of his paintings, but even without his explanations it is evident that the lines and color areas that lie across the axes of the composition rest in a "dynamic equilibrium," and that the entire surface of the canvas is energized by the tension between the various elements. Whether or not we choose to follow Mondrian's explanations as to the particularized meaning of his art, he indisputably achieved a feeling of expansiveness and grandeur, as well as harmony of an ideal kind.

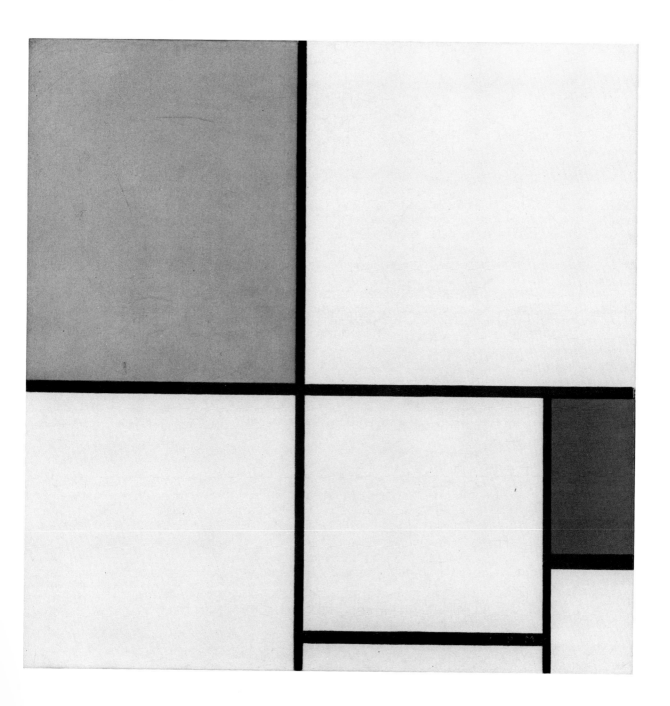

SOPHIE TAEUBER-ARP
Rectangular Relief. 1938
Oil on wood, 21³/₄ × 25⁵/₈ × 8⁵/₈″ (55 × 65 × 21.8 cm)
Kunstmuseum, Bern, gift of Mme Jean Arp

Sophie Taeuber was already making abstract collages and textiles when she met Hans Arp in Zurich in November 1915, and was already using quiet, simplified rectilinear forms none too dissimilar to the more precisely executed ones that Arp used at this time. Their subsequent friendship, collaboration, and marriage have sometimes led to Taeuber's being considered—despite her husband's protests—as Arp's follower, whereas it was, if anything, Taeuber's early works which held a lesson for Arp. This lesson was not about form but effect. The biomorphism which Arp developed in 1916 was entirely his own invention; its calm organic effects, however, were prepared for by the relaxed geometry and "limpid calm,"[1] as Arp has it, of Taeuber's 1915 collages. "I found, stripped down to the utmost," he wrote of Taeuber's early work, "the essential elements of an earthly construction: the spurting, the soaring of lines and planes toward the sky; the verticality of clear life; and the vast balance, the pure horizontality of peace extended into dream."[2]

No matter how severely geometric her work became, its geometry—like Arp's biomorphism—was conceived in symbolic terms: as creating forms of universalist significance. This linked her work not only to Arp's and the abstract Surrealists', but also to that of Mondrian, de Stijl artists, and the Constructivists. Even more than Arp, Sophie Taeuber mediated between the two wings of the abstractionist avant-garde between the two World Wars, and when in Paris, in the 1930s, the two wings began to come together in the free give-and-take of the new, eclectic abstractionists' organizations Cercle et Carré (1930) and Abstraction-Création (1931–36), she was important to their collaboration. She was editing the journal *Plastique* (1937–39) when she made this relief.

The thirties saw a great surge in the making of relief construc-tions, motivated in large part by the new interest in surface materials and in more dynamic and dramatic spatial relationships as artists sought to find new scope in the reductive vocabulary of geometric abstraction. The relief fulfilled the idea of a newly broadened application of this elementarist vocabulary and at the same time reinforced the abstractionists' contention that the elements of this vocabulary, as basic, universal symbols, were more "real" than representations of nature itself, more "concrete," as popular thirties terminology had it. Taeuber's reliefs belong to this background. They are, however, far more rigorous than most contemporary Paris reliefs, if far more organic in mood. *Rectangular Relief* uses only rectangular and circular elements, yet it evokes natural phenomena. The groupings of cut-out and jutting pieces are casual and relaxed; the bright colors appear to float in front of the dark, irregularly shaped ground. The remarkably adventurous format mediates between the incident it contains and the wider space of the wall, and draws in the surrounding space in some respects to create an effect of openness and of flux. Given the darkness of the ground, the prominence of circular forms, and the effect of rising movement the relief suggests, it is difficult not to see it in relationship to a night sky. Arp's comment on Taeuber's reliefs of this period confirm the naturalistic foundations of her abstract art: "From 1936 to 1938 she did a series of wood reliefs. Certain of these reliefs contain simple groupings of geometric forms, appliquéd, cut-out, or jutting. These reliefs are painted white, black, red, and blue . . . Most of the reliefs of the same period evolved from a circular background. Earth and sky are intermingled like waves. Dark-green leaves, deep-blue skies. These works have the solemnity of a wing, the splendor of a glittering jewel."[3]

Klee's preoccupation with nature was central to his art. From the natural world he developed a repertory of pictorial symbols, which expressed not the "finished image of nature," however, but rather "its genesis, the only essential thing."[1] He sought to orient himself to nature, he said, to approach "that secret realm where all growth is nourished by the same universal law." His symbols, that is to say, are conceptually derived. "They don't simply reproduce, more or less idiosyncratically, what our eye has seen," Klee said, "but cast into visible form our secret visions and insights." Klee's painting, therefore, mediates between the world of nature and that of the imagination, creating forms that are at one and the same time reflections of his own subconscious fantasies and records of the genetic processes of the external world.

The human figure, he insisted, is "a fragment of nature within the natural world."[2] When he painted the human figure, he was frequently drawn therefore to mythical or archetypal images and often to the images of classical mythology where particular figures are the representatives of natural phenomena. Here, Aphrodite is the goddess of love, but also of fertility and growth, of the reproductive forces of nature. The forms of the figure are also those of plants. The images of female genitalia grafted to each hip joint are also those of opening flowers, with pointed leaves or petals expanding to either side of the painting. The paired ceramic vases at each side of the figure likewise emphasize the meaning of the figure as a reproductive vessel. Their shapes mirror that of the whole torso, and also those of the exaggeratedly full breasts to which they are joined by the channellike arms. The open posture of the figure is itself, of course, highly erotic, making this one of the very rare images where the underlying sexual theme of Klee's art is

given specific form. In addition, it is the means by which Klee interweaves the figural image with the irregular grid of the surface, creating a metaphor for the relationship of human and natural structures—of the human figure as "a fragment of nature within the natural world." The curvilinear forms of the figure emerge from within the layered space structure; they change and modify that structure, but belong to it and return to it all the same. They can be seen as plants growing out of the earth.

The poetic content of Klee's art resides in large part in the somehow purely optical space that his paintings evoke. The space seems etherealized. Created as it is in this instance by the gridlike intersection of flat stripes of color, it appears to belong to and to be controlled by the flat rectangular shape of the picture surface. But since the color itself is transparent in effect, seeming to exude an internal light, the flatness of the work is not that of a tactile skin. It is, rather, that of a luminous screen, and as such expresses metaphorically both Klee's conception of his art as an imaginative projection of conceptual, internal imagery and his belief in an all-pervasive organic continuum which generates specific forms. This continuum "supplants tactile nature as the model of the unit and integrity of pictorial space."[3] Klee's concern with genetic processes and not the finished tactile images of nature meant that realist open-air space was inadequate to his needs. He turned to the shallow pictorial space he had seen in Cubism—particularly in Delaunay's coloristic version of Cubism[4]—and modified it to form miniature polyphonic fields of luminous color that create the illusion of a profound internal space, but one that seems to be back-projected, as it were, onto the screen of the painting. Art and nature confirm each other in this internal luminous continuum.

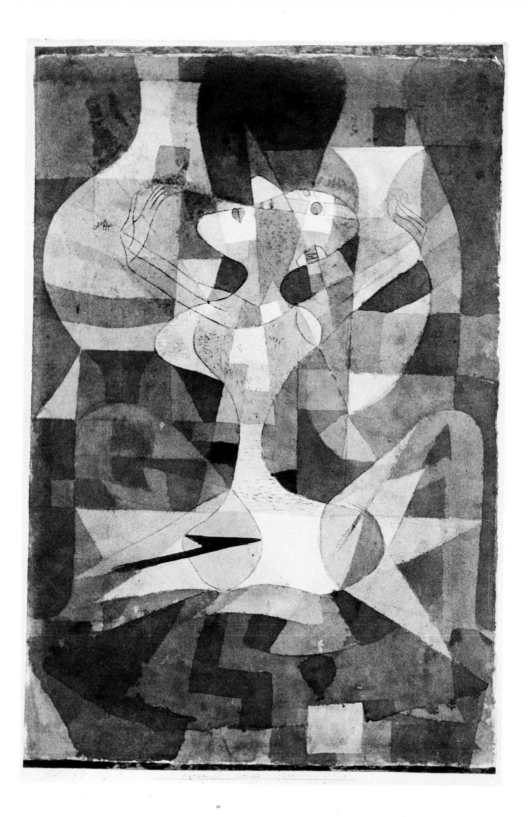

PAUL KLEE
Perspective of a Room with Occupants. 1921
Oil and watercolor on paper, 19¹/₈ × 12¹/₂″ (48.4 × 31.6 cm)
Kunstmuseum, Bern, Paul Klee Foundation

In 1921 Klee began teaching at the Bauhaus at Weimar. His contact with the architects there led to a series of perspective drawings of rooms, buildings, and whole cities. *Perspective of a Room with Occupants* recalls—if only at first glance—certain Bauhaus architectural drawings where the forms of interiors are geared to an imaginary three-dimensional grid that expresses the idealistic geometric continuity of the designed world.[1] Further inspection soon reveals how Klee has personalized—indeed subverted—the mechanically constructed world and has made it plainly illogical.

"When such a structure expands gradually before our eyes," Klee wrote, "it is easily joined by an association which acts as an enticement toward an objective significance. For every highly organized structure can with a little fantasy be made comparable with known structures of nature . . ."[2] From this we might assume that Klee sought not only to personalize the objective and anonymous, but to naturalize it as well through the addition of a fantasy ingredient. If not a repudiation of the machine-age aesthetic that was beginning to emerge at the Bauhaus, this work is at least an attempt to find in mechanical forms a kind of basic organicism: an organic sense of growth that breaks the enclosed geometry of the space grid, and uses geometry against itself, not as a sober rational device but as a witty and fantastic one.

With the help of a preparatory study that Klee made for this picture we can easily identify what is represented.[3] The interior is probably his own apartment at Weimar, with rugs on the floor, paintings on the left wall, and cabinets and bookcases toward the far corners.[4] To the lower right we see the keyboard of Klee's piano, and above it the lines on sheets of music. At the far end of the room,

beside the gathered curtain, is a door leading out to a short corridor, and guarding the entrance is the highly condensed form of Klee's cat with its curled tail looking like a musical symbol. The most fantastic elements, of course, are the occupants of the room, carpentered into the receding planks of the floor and the wall. They are probably intended as two different states of the same figures: earthbound, beginning to listen to the piano, then transported to float among the reverberating strings above. The earthbound figures share features and forms with those of the planked floor; the floating ones are upturned in the more dramatic perspective that contains them.

The alternate states of the figures also accentuate the ambiguous readings which other forms create. The room is presented in a curious state of flux where all relationships are provisional. To follow the receding lines of the floor is suddenly to be shifted to the elevated plane of the furniture to the right. To follow those that depict the furniture on the opposite wall is to be carried beyond the enclosing space of the room itself. In his preliminary study Klee put in a tentative enclosing horizontal at the top of the far wall, but did not transpose it to the finished work. As a result, this room becomes a funnel through which the dematerialized objects are transported on their way to an indefinite exterior space. But that space itself invades the transparent walls of the room. Despite the geometry, there are no stable volumes. Nothing is enclosed. Although they recede, the inscribed lines lie flat on the surface of the work; and all of them point to the open flat rectangle at the back that mirrors the shape of the painting itself and, like Klee's own painting, attracts the paraphernalia of Klee's daily life.

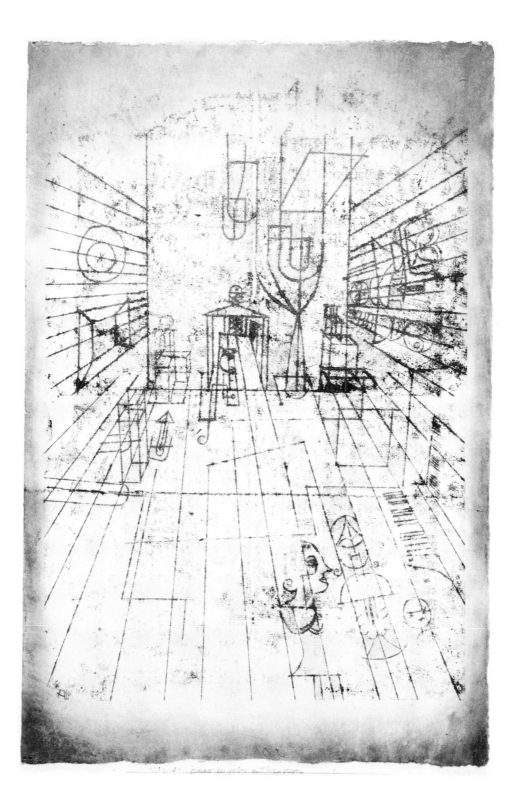

PAUL KLEE
She Howls, We Play. 1928
Oil on canvas, 17³/₈ × 22¹/₈″ (44 × 56 cm)
Kunstmuseum, Bern, Paul Klee Foundation

Art, for Klee, was an organic process that in its creation mirrored the processes of the organic world. His own art began with an investigation of line, and however much he enriched his formal vocabulary it was to line that he continually returned. In line drawing, as in no other pictorial method, Klee saw a way of expressing in the microcosmic form of his art the movement and growth that he saw in all forms of creation. "Art," he insisted, "is a likeness of the Creation. It is sometimes an example, just as the terrestrial is an example of the cosmic."[1] That is to say, the free movement of line on paper or canvas both symbolized the fact that "throughout the universe, movement is the rule," and presented an abstracted form of the specific realities it described. In 1920, Klee wrote: "Art does not render the visual, rather it makes visible. A tendency toward the abstract belongs to the essence of linear expression, hence graphic imagery by its very nature is apt to be both pattern-like and fantastic. It is also capable of great precision."

She Howls, We Play, one of a number of drawn paintings using a continuous melodic line that Klee began to produce in 1927, well exemplifies the precise, patternlike, and fantastic nature of his imagery. It also reveals, in almost diagrammatic form, his preoccupation with growth and movement and the way his art "makes visible" rather than "render[s] the visual," that is to say, is conceptual rather than perceptual in character.

The theme of growth is presented on at least three different levels in the work: first, in the subject; second, in the nature of the drawn line; and third, in the way that the line reveals the subject. The subject is an illustration of growth—of three young dogs at play with an older animal beside them. One continuous line describes each dog; the movement of a single line creates the image of a single animal. It is inevitable that we follow the movement of each line, and in so doing follow the creation of each image. Klee expected his art to be viewed in this way: we are to re-create his process of creation. "The work of art, then," he wrote, "results from physical movement; it is a record of such movement, and is perceived through movement." Here our re-creation carries a double weight, for in following the single line that creates each image, we follow both Klee's and each image's creation at one and the same time. Klee recognized this dual possibility of line as something that formed itself into images and yet preserved its own spontaneous autonomy. Indeed, it was something he deliberately fostered. "Elements must produce shapes," he wrote, "yet without sacrificing their own identities in the process." Insofar as line exists autonomously, it carries an abstracted meaning as a generalized record of the flux of creation; insofar as it forms itself into images, it specifies or "makes visible" particular instances of creation in a highly conceptual form.

In this work, Klee's line is fixed to the image of growth inherent in the subject (and in the line itself) in a very specific way. Of a painting similar to this, he said it was an "example of instantaneously fixed movements superimposed on one another."[2] Each continuous line gives birth to a multiplicity of aspects of the object it denotes, as if Klee had imagined a series of alternative forms for each animal and, in the process of drawing, had trapped these alternative forms in one linear cage. Such a feeling of the cagelike enclosure of multiple images is particularly apparent in the single animal. The three young dogs, in contrast, seem interrelated among themselves, although the lines that describe each one are in fact separate. Similarly, whereas the linear framework of the single animal is opened out to reveal a flatly isolated and formed image, that used for the young animals is altogether more excited and in flux. We have, therefore, juxtaposed images of the beginnings and completion of the creative process; and if we take Klee's title into account, it may not be amiss to see this work as a melodically drawn song of innocence and experience.

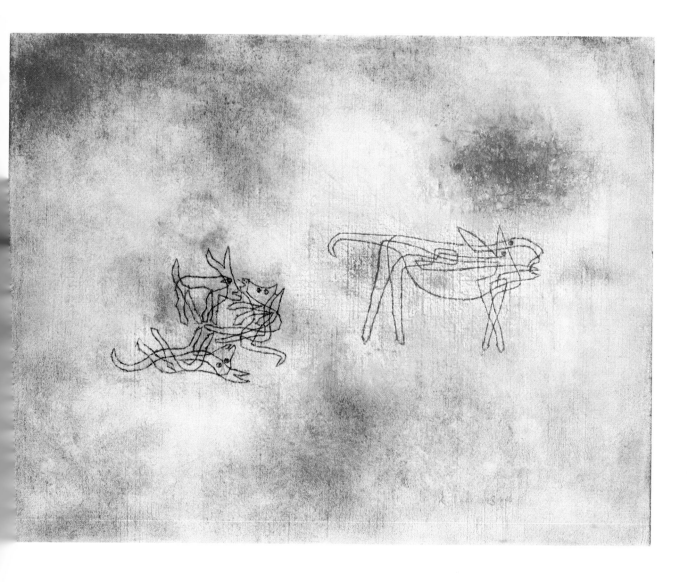

PAUL KLEE
The Creator. 1934
Oil on canvas, 16⁷/₈ × 21¹/₄″ (43 × 54 cm)
Kunstmuseum, Bern, Paul Klee Foundation

Among Klee's earliest extant drawings, those he made as a boy of five and six, is one of a Christchild in the form of a hovering angel with overlapping wings and arms radiating around its neck.[1] Among his very last works is a series of some fifty pictures of hieratic and stylized angels.[2] The flapping striped planes that hang beneath the arms of *The Creator* could be either wings or the tails of an open costume, but the spatial suspension of this transparent image—as well as its title—suggests that we interpret it as some form of unearthly figure. Klee identified artistic and cosmic creation. When he drew, he said, his hand was the "tool of a remote will."[3] Drawing itself meant "transferring an energy change" to canvas or paper. The symbols he created were intended to "reassure the spirit that it need not depend exclusively on terrestrial experience." Klee's ethereal but urgent *Creator* is inevitably an extraterrestrial image; not merely, however, an imagined representation of some deity, but also a representation—in the form of an imagined deity—of the burgeoning process of creation itself. The fanlike or flamelike forms ignite at the core of the image and are borne out across the plane of the canvas, as if in illustration of Klee's own words, "The creative impulse suddenly springs to life, like a flame, passes through the hand onto the canvas, where it spreads . . ."

The parallel-line style of this work emerged in Klee's art late in 1925 as one of a number of new graphic and pictorial devices of the mid-twenties. Technically, it is a more complex version of the continuous melodic line of works like *She Howls, We Play* (although, in fact, the melodic line emerged somewhat later) and like that method creates an effect of superimposed but transparent spaces and of continuous movement. The parallel lines themselves evoke something of the feeling of classical drapery, which is entirely in keeping with this hieratic image. Given Klee's musical interests, they might even be compared to lines of music (and even to stringed instruments) and the work itself be seen as a contrapuntal interweaving and overlapping of variations on a single theme. Klee himself talked of the use of parallel lines to create planes in entirely graphic terms: "Planes result from lines related to each other (as in watching a moving stream of water)." Some of the configurations do have a waterfall-like appearance. Others, however, warp as they develop, or are bounded at their perimeters by additional enclosing lines to give implied thickness to the planes. Alternatively, they intersect or interlock with adjacent configurations to create the impression of recessive space. But since every implied plane is transparent, the illusions thus created are returned and joined to the flattened surface of the work. Klee's method is, in effect, a stylized form of traditional striated hatching. That is to say it employs a set of flat linear signs that signify the movement of forms in space, but do so without implying an illusion of volumes. The opened-out striations in this work flatten the planes to the two-dimensional surface. In doing so, they are assisted by the openness of the image itself. From the core of the image, the planes reach out to the perimeters of the canvas. The lines that compose them spread their momentum across the work, but in their spreading co-opt to themselves the rigorous frontality of the expansive surface. Although by no means a large painting, *The Creator* possesses a grandeur and openness such as Klee increasingly sought in the work of his last years.

Among Klee's most impressive and innovative late works are a group of seven paintings from 1938 in a large horizontal format, of which *insula dulcamara* — some sixty-nine inches in length — is the most expansive and friezelike in form.[1] From 1932 Klee had begun to develop a new kind of heavy, brush-drawn line by expanding the usually delicate calligraphy of his previous work into thickened, barlike symbols. This development came possibly in response to Picasso's use of heavy drawing in the early thirties, which is known to have impressed Klee,[2] or to Miró's use of comparable methods. Whether or not it had an external stimulus, this development represents a dramatic resolution of Klee's own investigations into the pictorial ramifications of line drawing, which had been the most central feature of his art from its very beginning.

Klee nearly always used line as a descriptive element, but only rarely to describe volumes. Freed from the necessity of hollowing space, it was able to move in fluid trajectories across the surface of his works and to denote objects of the world — to form itself into signs for such objects — without representing them as solid, tactile bodies. Klee's linear signs were therefore, in a sense, autonomous and self-sufficient marks, producing shapes "yet without sacrificing their own identities in the process."[3] For them to function in this way, Klee's art had to remain fairly small in scale. Only in a small scale, comparable to that of a manuscript or a book, is one encouraged to scrutinize the separate lines that comprise each image. Had the picture area been larger, the thin, meandering lines would each have been subsumed within the images they bounded, and the sense of the work as an obsessive record of the mind's eye would have been lost. Only by keeping a sufficiently large ratio of line to surface area — and with a thin, calligraphic line this meant a miniaturist scale — could the highly intimate nature of the imagery be adequately presented.

In his last years, however, Klee seems to have been seeking a somewhat more monumental effect in his art, but one which would not sacrifice either the separation of lines from the images they created or the obsessive and introverted character of his style. His solution was to expand his lines in thickness as he increased the scale of his art. This, in fact, gave his lines far more autonomy than they had had before: each line was now a shape in itself, one of a number of drawn, but flat, elements that laid themselves out across the flat surface of the work. This painterly line was one of Klee's most productive discoveries. It led to an increasing sense of openness in his art. The improvisatory lines inflect and structure the flat pictorial surface. The varied greens, blues, and pinks that stain the surface interlock with the superimposed drawing; that is to say, surface and drawing are joined together in a fluid and miragelike space. For the first time, Klee could lay out his pictures in open, disjunctive compositions with lines that carry an absolute pictorial force. In works of this kind, Klee liberated himself — in a way, more completely than ever he had before — from Cubist-derived conceptions of drawing and space, and pointed the way to the expansive field painting that appeared in post–Second World War art.[4]

Klee's signs, however, still carry a highly particularized meaning. This painting suggests an island inhabited with strange animals or with snakes, and behind it a ship steaming past between the rising and setting moon. It was suggested to Klee that he name the work "Calypso's Island."[5] Instead, and more enigmatically, it became *insula dulcamara,* Dulcamara's island. Dr. Dulcamara, the itinerant quack doctor in Donizetti's opera *L'Elisir d'amore,* did not, however, inhabit an island; but the illogical entanglements of the opera's plot, as well as its springlike, carefree atmosphere, are entirely appropriate to Klee's work.

PAUL KLEE
Glass Facade. 1940
Crayon on burlap, 27⁵/₈ × 37¹/₂″ (70 × 95 cm)
Kunstmuseum, Bern, Paul Klee Foundation

Klee spoke of color as "the most irrational element in painting,"[1] yet he controlled it as precisely as any other component of his art. Since his whole art was in a sense "irrational," freed from the constraints of ordinary logic, color provided a natural support. Unlike line, however, color does not offer readily decipherable meanings. Even in Klee's most abstract linear works, we can find in the shapes that form themselves some kind of recognizable imagery. Color is somehow more inaccessible. The meanings we find there must necessarily be more generalized, more abstract. It is in this sense that color is more "irrational" than any other pictorial component. Colors evoke moods or states rather than images— and for Klee the function of his art was to reveal the generalized states of existence rather than their specific instances. This said, however, we must remind ourselves that line was more central to Klee's art than color, for line—at least as Klee used it—mediated between the general and the particular. It opened a path to "the essence that hides behind the fortuitous"[2] by allowing the observer to experience, as he follows the lines forming themselves into images, the sense of movement and growth that Klee held to be the most essential state of all. Color could not do this as readily. Nevertheless, Klee did, in some works, evoke an image of growth through color.

Fixed in the leaded bars of their glass facade, the colors of this meditative work speak both individually and in constantly moving groups. Klee has limited himself here to six basic hues—to blues, in major and minor key; three associated reds, one pure and declamatory, one whitened to a pink close in tone to the minor blue, and one orange brown; and an emerald green—set against a chocolate ground. In his teaching, Klee compared the effects of color to that of music. Given his own admiration for Bach, it is tempting to view this work as structured after the patterning of a fugue, with changes of register represented by the modifications of the basic rectangular unit, and the colors carrying the theme in their different voices throughout the work. One's experience of the painting is certainly close to the experience of contrapuntal structures, as sets of colors successively present themselves to the eye, each set recalling another of a different register in a continuous interweaving which is rigorously ordered by the self-contained perimeters of the work. This movement, of course, is fixed in a single moment of time. We might wonder whether Klee had been thinking of that familiar definition of architecture as "frozen music" when he entitled the painting *Glass Facade.*

Painted in the very last year of Klee's life, the *Glass Facade* looks back to the series of "magic squares" that Klee began in the early twenties. No other painting, however, so clearly suggests a stained-glass window as this does. It is curious that Klee allows so specific an image to be called to mind, although all of the magic squares look back ultimately to Robert Delaunay's window paintings which Klee probably saw in Paris in 1912.[3] Possibly he wanted to emphasize in yet another way "the essence that hides behind the fortuitous," in this case behind the transparent luminous color of the glass facade. As ever, the external sign was conceived of as key to some "secret realm," a realm—"whatever you call it dream, idea, imagination—[that] is not to be taken seriously until it has been given bodily shape in the work of art, through the creative procedure that is suited to it."

JOAN MIRÓ
The Table (Still Life with Rabbit). 1920
Oil on canvas, 51¼ × 43⅜" (130 × 110 cm)
Collection Gustav Zumsteg, Zurich

The Table, or *Still Life with Rabbit,* as it is also called, is the most important and advanced of Miró's still lifes of 1920. It is a crucial painting in his development in that it shows him beginning to turn away from the Cubism that dominated his work that year, and presages both the ornamental and the austerely "primitive" qualities of his subsequent art.[1] It is, in fact, ornamental, austere—and Cubist—at one and the same time. The richly decorated surface is dominated by a table that is stiff and iconic despite its nearly Baroque forms. Much of the decoration is derived from Cubist geometry. The upward-tilted tabletop and the background and the floor that seem to radiate from around the table are particularly Cubist in derivation. They are so treated as to efface any impression of deep space and establish the two-dimensionality of the picture surface. Having done this, however, Miró shows no qualms about introducing specifically realistic forms: the rooster, rabbit, and fish laid out on the table. Of the objects on the table, only the pitcher is presented in a geometricized form: to flatten its volume to the patterned surface of the canvas. Cubism was useful to Miró—to push back volumes and to fill out spaces—as a means to his flat, frontal, and stiffly decorative art.

We must presume that Miró's decision to combine scrupulous realism in the living—or once living—objects and stylized geometry in the manufactured ones was deliberate. But the reason that these two modes exist so comfortably side by side is that Miró's methods of stylization themselves bridge the gap between the abstract and the realistic. The abstract geometry of the background and floor, the stylized geometry of the pitcher, the ornamental geometry of the tabletop—and even the trompe-l'oeil geometry of the patterned cloth—all share a common formal vocabulary. One form of representation is set against another, and the very structure of the painting contains them all.

There is, nevertheless, a certain willful incongruity in the juxtapositions within this painting. Although they are far from the mysterious Surrealist juxtapositions of Miró's later work, they still release a definite emotional charge. Of some slightly later still lifes, Miró wrote: "To communicate emotion through objects you must love them immensely because you may be sure that in the contrary case you will make a picture wholly without interest . . . When I paint, I caress what I am making, and the effort to endow it with a meaningful life tires me enormously."[2] The scrupulously detailed execution speaks of Miró's emotional attachment to the objects represented, but so does the somewhat "primitive" character of the drawing. There is certainly a keenly felt contrast between the geometric structure of the painting and its decidedly rural subject. The environment is that of Cubist Paris; the objects it contains refer nostalgically to the countryside of Miró's Catalonia. The ridged table even evokes the shape of the barnyard of Miró's farm as he painted it the next year.[3] The objects on the table are the produce of the farm and the countryside. They evoke a feeling of the kitchen: the fish, flesh, fowl, and vegetables, and pitcher of oil for cooking them. They also comprise a rudimentary typology of natural forms. A kind of animal menagerie set out at the corners of the flattened table, they foretell the symbolic vocabulary of Miró's subsequent work.

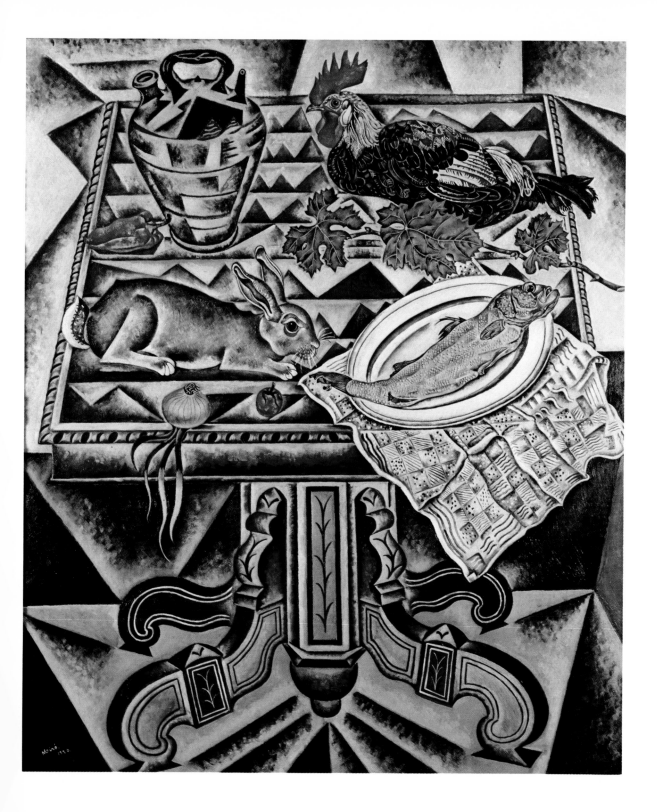

JOAN MIRÓ
Circus Horse. 1927
Oil on canvas, 51$\frac{1}{4}$ × 37$\frac{1}{2}$" (130 × 95 cm)
Private collection

One of the Surrealists' favorite relaxations was to visit the Cirque Médrano at the foot of Montmartre. This possibly supplied the inspiration for Miró's dozen or so paintings on the theme of the circus horse which he made in the period 1925–27.[1] It has been suggested, however, that the motivation for works like this one was Alexander Calder's miniature-scale circus which he presented in his studio from 1927;[2] this could not have initiated the Circus Horse series as a whole, but it could have stimulated the large number of circus paintings that Miró made in 1927. Either way, Miró, like the other Surrealists—and like many earlier modern painters in Paris—enjoyed the circus, and from his youth had made drawings of clowns, acrobats, bareback riders, and all the other performers of the circus ring.

The Circus Horse paintings are among the most purely spontaneous of Miró's images, and among the most seemingly abstract as well. Miró cautions us, however, that "for me a form is never something abstract; it is always a sign for something."[3] By itself this painting may be fairly impenetrable; when the series is viewed as a whole, however, a common iconography can be deduced: a ringmaster with a long whip making a horse circle around him in a circus ring. Here the trapezoid at the center of the painting indicates the head of the ringmaster, who stands inside the circus ring denoted by the heavily drawn fragment of a circle at the lower right. The ringmaster's arms metamorphose into the sinuous line of a whip that encircles him and directs the path of the horse but also takes the form of the horse itself. From comparison with the other paintings of the series, it is apparent that the lines meandering into the lower left corner of the canvas stand for the horse's back legs and that its head is at the very top of the painting, indicated by the parallel horizontal lines of its mane.[4] The spot with protruding hairs at the upper right could conceivably be a doubled-back tail, though it would be far more consistent with Miró's basic iconographical system to see it as the sex organ of the horse.[5] If the painting is thus interpreted, the body of the ringmaster also becomes a part of the horse circling around him—its front legs, in fact, as it passes by this section of the circus ring—and the head of the ringmaster is also the horse's heart.

The style of the painting is determined by the loose improvisational drawing that Miró initiated in his art late in 1924. In the group of ambitious masterpieces that followed works like *The Table*—namely, *The Farm* of 1921–22 and *The Tilled Field* and *The Hunter* of 1923–24[6]—Miró put the rectilinear geometry of Cubism behind him (though not the Cubist sense of the canvas as a flat resistant plane), while creating from the stylized realism of his earlier work a language of condensed, shorthand hieroglyphs. At first these were scrupulously rendered records of mental free association, but late in 1924 Miró began freely associating in the act of painting itself; the particular forms the signs took were spontaneously or automatically produced. This led to a liberated style of drawing that opened out across the canvas yet was still descriptive, though in an essentially signlike way—even to blending the functions of drawing and writing in its meandering narrative form. Whereas the painstakingly executed signs were always resolutely flat against their flat grounds—being ultimately derived from contours, or other significant details, freed from the opaque Synthetic Cubist planes of Miró's earlier work—the open, automatic drawing of the painting tends to affect actively the pictorial field that it inhabits. Because it does not enclose solid shapes, it does not cut back in depth but stays affirmatively on top of the surface. Yet it changes the surface in its passage, warping it at some points, seeming to push it out laterally at others. The tension between the organic nature of the drawing and the geometry of the shape of the painting, between the flatness of the drawing and the space that it evokes, between its decorative, abstract character and significant meaning—all this is essential to Miró's *peinture poésie* at perhaps its most evocative in the mid- and later twenties.

CHAIM SOUTINE
Child with a Toy. ca. 1919–22
Oil on canvas, 32 × 25³/₈″ (81 × 64.5 cm)
Collection Jürg Im Obersteg, Basel

If the Bateau-Lavoir in Montmartre, the stronghold of the original Cubist circle, was the house of form in pre–First World War Paris, then La Ruche in Montparnasse was the center for color. It was there, on the rue Dantzig, that Léger, Delaunay, and Chagall lived, and there that Soutine settled down when he came to Paris from the Lithuanian part of Russia in 1913. Like many other foreign painters arriving in Paris, Soutine was attracted to the museums, especially the Louvre. He was affected to some extent by most of the modern, or at least pre-Cubist, painting that he saw, and even by the buckling forms of Delaunay's 1909–11 work (which appear in painterly disguise in some of Soutine's Céret and Cagnes landscapes of 1919–22), and by the diagonal accents of Chagall's first Paris period. It was, however, to the Old Masters that he principally looked, and whom he sought to emulate. He sought, in effect, to reproduce the expressiveness of Old Master painting using the methods of early modernist Paris, and above all, color.[1]

Soutine used high modern color, but in an essentially tonal manner derived from his admiration of Rembrandt and of Venetian painting. This helps to account for some of his difficulties in resolving his Céret and Cagnes paintings, which used a wide color range. Each color had to be shaded separately, either with a dark tone of that color or with its complementary. It was difficult, therefore, to avoid either uniformly muddying the color to bring the painting together or preserving high color, at the risk of formal incoherence. Faced with such a choice, Soutine opted for incoherence, for color

could not be sacrificed. In a remarkable series of early portraits, however, he discovered that tonally modeled color was best served by limiting its range, and found particular eloquence in using one or two resplendent hues, with red a favorite, as in this richly painted *Child with a Toy*. A wider color range required far purer pigments, and far more self-conscious and deliberately modern a temperament—such as Matisse and the Fauves possessed. Variations on a single rich hue, or pair of hues, formed the link with the great *malerisch* colorists of the past that Soutine so desired.

Soutine was always a painterly colorist. If impasto inhibits the visibility of color when many colors are used, it enriches it in a near-monochrome painting like this—and Soutine's touch was instinctive and telling in a way almost unique in modern painting. Always serving color (and never surface for its own sake), it finds in the substance of oil paint an extraordinary range of chromatic expression. Even when Soutine relied overmuch on the sentimental or sensational in the characterization of his subjects, and thus falsified the very personal quality of his art, his handling of colored paint can still be admired for its own sake. When he quietens and consolidates his subjects—avoiding the obviously dramatic, as he does here—he does in fact marry the pathos of his admired Old Masters to an exhilarating spontaneity and intensity of method that—though seeming conservative in some company—is altogether modern.

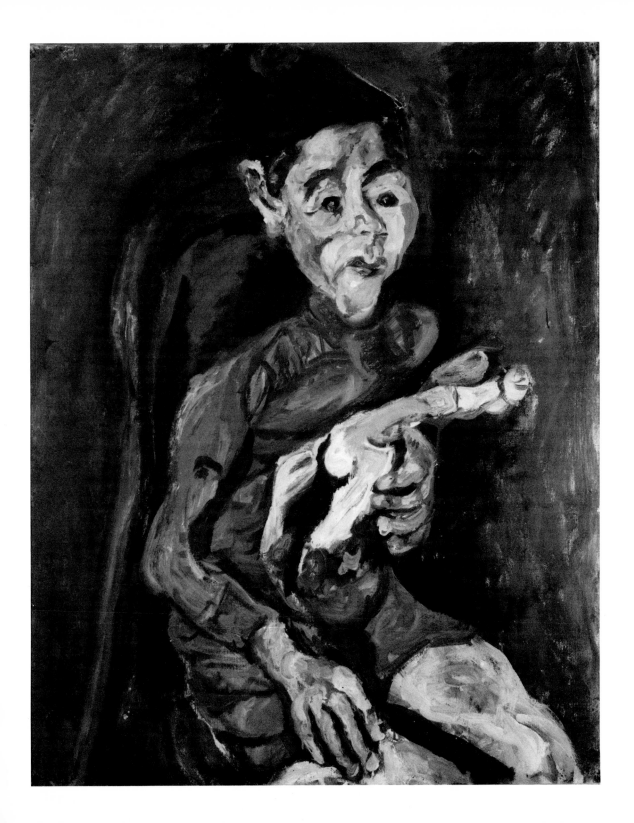

ALBERTO GIACOMETTI
Annette. 1951
Oil on canvas, 31⁷/₈ × 25⁵/₈" (81 × 65 cm)
The Alberto Giacometti Foundation, Zurich

Giacometti's art is so often interpreted in Expressionist terms—as revealing the anxiety and alienation of contemporary life—that one may be excused for forgetting that Giacometti himself saw it as something utterly objective and even impersonal.[1] If it does indeed express alienation, it does not do so directly in a psychological sense. Giacometti saw himself as a realist artist, painting or sculpting the whole, exact appearance of things. The representation of wholeness meant representing things at a distance. "Our eyes can see things whole only on a small scale," he insisted. "As soon as we approach things closer, there set in exaggerations and distortions in perspective that destroy the impression of the whole."[2] Whereas figures across a street or a room can be seen as complete forms, "if they get too near, six feet, say, I don't really see them any more . . . they fill your whole visual field, don't they? And you see them out of focus. And if you get a bit closer still, there's no seeing them at all any more. Anyway, it's not done, I mean you could touch each other. Which takes you into another domain."[3] Aspiring to transcribe the appearance of a figure as fully and objectively as possible, Giacometti found himself painting his isolation and estrangement from the figure in question. If Giacometti's paintings and sculptures do express alienation, it is the alienation that the act of representation itself creates. As he painted, Giacometti looked coldly and analytically, sublimating other than visual sensations, distancing himself psychologically from his model, even when it was his wife Annette. "After Annette had posed the whole afternoon," Jacques Dupin recalled, "Giacometti gazed intently at her that evening in the café. Annette, surprised: 'Why are you looking at me that way?' Alberto: 'Because I haven't seen you all day.'"[4]

Sight cannot, of course, be totally isolated from the other senses, but Giacometti does isolate it to a very considerable degree. The basis of his art is almost entirely optical, presenting figures that are apparitions, enveloped and possessed by their surrounding space. Since space and distance were central to his painting, color had to be avoided. Color, Giacometti felt, adhered to the surface. Thinly painted gray or beige monochrome became the equivalent in paint of space. Space was not bound to objects; it isolated them from their surroundings and gave them their identity. Giacometti's figures respond to the pressure of their surrounding space. This is what makes their forms contract and condense and their masses compress as they shrink into narrower frames. Yet, despite their unusual density, they are weightless and somewhat transparent, as if they were no more than materializations of space itself. The overlaid drawing in this figure of Annette expresses not only the masses of the body, but the different spatial positions of the various masses as they appear when projected onto the frontal plane. Frontality was essential to Giacometti's art. It best revealed a figure's appearance ("When a person appeals to us or fascinates us we don't walk all around him")[5] and allowed distance to be precisely expressed. Here the painting area is isolated within an inner frame. This reinforces one's awareness of the flatness of the picture surface, and hence of the fact that space and mass are themselves being transposed into the two-dimensional, so that they warp and distort except at the focus of vision, the frontal upper part of the model represented. Outside that focus, her very form is allowed to disintegrate. The internal frame thus limits the spatial field and focuses vision within it. But if it reinforces the flatness of the painting in doing so, that flatness is simultaneously withdrawn. Even that frontal mass is made to seem apparitional. is (as is often noted) like looking at a mirror on a wall.[6] The image of the figure is definitely located in the space beyond the canvas, yet seems as if its original is on our side. As in a mirror reflection, the image appears to be doubly distanced from us, and as with a mirror, the surface that mediates between the real and its reflection is at one and the same time known to contain the illusion and yet invisible to us when the illusion is seen. Only by ignoring the imagery do we see the surface that engenders it, and then only as an immaterialized grisaille.

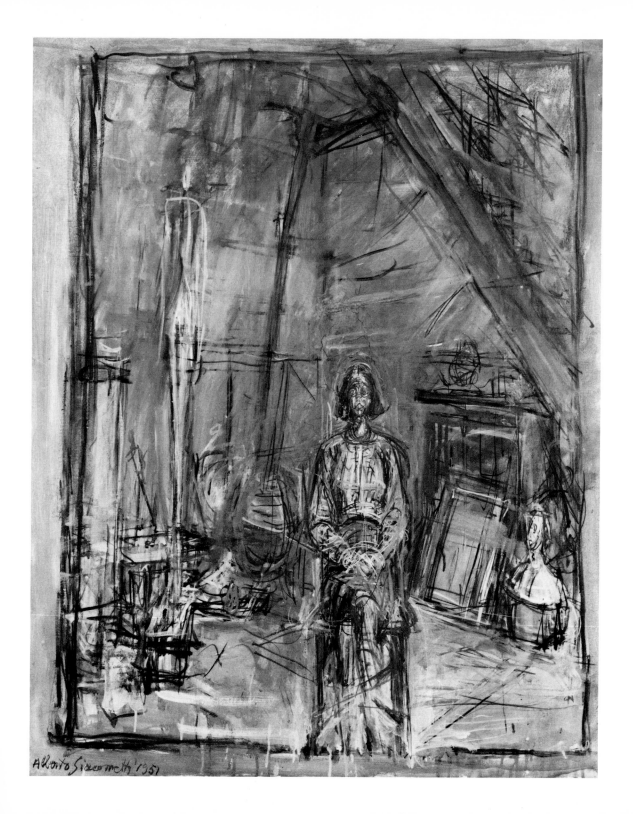

JEAN DUBUFFET
The Cellarman. 1946
Oil and mixed media on canvas, 18¹/₈ × 15″ (46 × 38 cm)
Private collection

With the "Macadam" series of 1945–46,[1] to which this painting belongs, Dubuffet began to use the found and natural materials that are among the principal features of his art. The materials of this series are small stones and pebbles, sand, and sometimes fragments of glass, compacted together either with oil paint or with a bituminous binder—in fact, materials essentially similar to those used in the process of road construction which gives the series its name. The forms as well as materials have this same connotation, looking as if they had been flattened into the surface by a road roller. The image Dubuffet used, however, was that of a flatiron: "The objective of painting," he said, "is to animate a surface which is by definition two-dimensional and without depth . . . Let us seek ingenious ways to flatten objects on the surface; and let the surface speak its own language and not an artificial language of three-dimensional space which is not proper to it . . . The objects represented will be transformed into pancakes, as though flattened by a pressing iron."[2]

In the same year that he began the Macadam series, Dubuffet started collecting what he called "Art Brut," works in all media "as little indebted to customary art or cultural models as possible and of which the authors are obscure individuals, alien to the milieu of professional artists."[3] The motivation for this collection ultimately derived from Dubuffet's reading of Dr. Hans Prinzhorn's *Bildnerei der Geisteskranken,*[4] a book which deeply impressed him. The Art Brut that he brought together was not intended as a collection of the art of the insane as such (though some half of it was of this nature). Rather, Dubuffet had derived from Prinzhorn a belief that universal imagery could be created only by those freed from cultural inhibitions, and therefore looked for inspiration to the work of socially isolated and usually schizophrenic individuals alienated from contemporary culture and professional art. Their work—like that of children in some respects—is not made for a conventional art audience, but for the private satisfaction of the makers and (unconsciously) as a way of ordering the surrogate world that they inhabit. For Dubuffet, this should be the function of all art. The task of the artist is not to create pleasing images for an art community of which he is a member, but to conjure up images to structure the essentially alienated world to which he properly belongs.

In holding these beliefs and giving them expression in his art, Dubuffet shows himself a sophisticated inheritor of the Dada-Surrealist tradition. His knowledge of that tradition confirmed his confidence in the innate creativity of those outside the mainstream culture—and confirmed his opposition to purely aesthetic standards of judgment. It also provided technical examples for the creation of a modern "anti-cultural" art. As was the case within Dada, Dubuffet's opposition to aesthetic standards was expressed through aesthetic means. His earliest paintings were in an impastoed form of late decorative Cubism, from which derives the emphasis on flatness and on surface texture—though the way the surface is treated looks to the "automatic" methods of the Surrealists. In the joint emphasis on "natural" surface and on conceptual, linear imagery, Dubuffet is a successor of Ernst and of Klee. The humor that underlies a great deal of his work—even such at first sight forbidding images as this—also recalls these same artists. With Dubuffet, however, we are not essentially dealing with the imagery of dreams or with apparitional fantasies. There is an earthy literalness about much of his work that links its surfaces to the post–Abstract Expressionist "matter" painting of Dubuffet's contemporaries and its imagery to certain early forms of Pop Art. Yet, Dubuffet's special brand of vernacular fantasy art defies easy categorization. He has been one of the last of the great individualists produced by the School of Paris.

NOTES

Any publication of this scope necessarily relies very heavily on existing research. In these notes, however, I have made no attempt to survey—or even to summarize—the considerable literature on each of the thirty-six artists discussed, since this catalog is not essentially documentary in emphasis. Except in the cases where I am specifically indebted to a particular analysis or discussion, the notes simply refer the reader to widely accessible sources for the quotations cited (English-language sources being given wherever possible) and for the comparative works adduced, with exegetical notations to the more detailed of the commentaries. The numerals in boldface type that precede each group of notes indicate the page number to which the notes refer. J.E.

20 1. Letter to Schuffenecker, Oct. 8, 1888. See John Rewald, *Post-Impressionism: From van Gogh to Gauguin,* 2nd ed. (New York: The Museum of Modern Art, 1962), p. 196.
2. For details see Georges Wildenstein, *Gauguin* (Paris: Les Beaux-Arts, 1964), no. 454.
3. Illustrated in Rewald, *Post-Impressionism,* p. 500.

22 1. For Monet's Water Lily series in general, see Dennis Rouart and Jean-Dominique Ray, *Monet Nymphéas,* with a catalogue raisonné by Robert Maillard (Paris: Hazan, 1972), and William C. Seitz, *Claude Monet: Seasons and Moments* (New York: The Museum of Modern Art, 1960).
2. Forty-eight were thus exhibited at the Durand-Ruel Gallery, Paris, in May 1909.
3. Claude Roger-Marx, "Les Nymphéas de M. Claude Monet," *Gazette des beaux-arts,* June 1909, p. 529.
4. This discussion is largely derived from the author's "Monet's Series," *Art International,* Nov. 1974, pp. 28, 45–46.

24 1. For examples of works from this series see P. A. Lemoisne, *Degas et son oeuvre,* vol. 3, *Peintures et pastels, 1883–1908* (Paris: Brame & de Hauke, 1946).
2. From George Moore, *Impressions and Opinions* (1891), quoted by John Rewald, *The History of Impressionism,* 4th ed. (New York: The Museum of Modern Art, 1973), p. 525.
3. Rewald, *Impressionism,* p. 526.
4. Quoted by François Fosca, *Degas* (Geneva: Skira, 1954), p. 83.
5. See Lemoisne, *Degas et son oeuvre,* vol. 3, nos. 1231–34, and Dennis Rouart, *The Unknown Degas and Renoir in the National Museum of Belgrade* (New York: McGraw-Hill, 1964), no. 27.
6. Rouart, *The Unknown Degas and Renoir,* p. xv.
7. Quoted by Fosca, *Degas,* p. 89.

26 1. See J.-B. de La Faille, *The Works of Vincent van Gogh* (New York: Reynal, 1970), p. 201, no. F. 432.
2. See Rewald, *Post-Impressionism,* p. 240, note 54.
3. De La Faille, p. 201, no. F. 432.
4. The portraits of Roulin are de La Faille, nos. F. 432–36, F. 439, F. 1458, F. 1459, S.D. 1723.
5. Quoted by Rewald, *Post-Impressionism,* p. 233.
6. Ibid., p. 224.

28 1. See de La Faille, no. F. 629.
2. Quoted by Rewald, *Post-Impressionism,* p. 322.
3. Ibid., p. 320.
4. De La Faille, no. F. 629.

30 1. See Meyer Schapiro, "The Apples of Cézanne: An Essay on the Meaning of Still Life," *Art News Annual,* no. 34, 1968, pp. 34–53, for extensive discussion of this theme.
2. Roger Fry, *Cézanne: A Study of His Development* (New York: Macmillan, 1927), p. 47.

32 1. This discussion is largely derived from the author's "Drawing in Cézanne," *Artforum,* June 1971, pp. 51–57.

34 1. See Dora Vallier, *Henri Rousseau* (Paris: Flammarion, 1970), nos. 6, 21, 23. Many problems remain with regard to the dating of Rousseau's work. See particularly Vallier, *Rousseau,* pp. 87–88; Henri Certigny, *La Vérité sur le Douanier Rousseau* (Paris: Plon, 1961); Roger Shattuck, *The Banquet Years* (New York: Harcourt, Brace & Co., 1958), pp. 63–66.
2. Letter of Dec. 12, 1907, printed in Certigny, *Rousseau,* p. 300.

36 1. E.g., *Child among Rocks,* ca. 1895 (Vallier, *Rousseau,* no. 86).
2. E.g., *Portrait of a Child,* 1908 (Vallier, *Rousseau,* no. 207).
3. Rousseau is sometimes credited with nine children. However in letters of 1907 he confirms that he had seven (Certigny, *Rousseau,* pp. 297, 304).
4. See Certigny, *Rousseau,* pp. 223 ff.
5. Theodore Reff, "Harlequins, Saltimbanques, Clowns, and Fools," *Artforum,* Oct. 1971, p. 36.

38 1. For listings of Rousseau's exhibited works see Dora Vallier, *Henri Rousseau* (Cologne: Du Mont, 1961), pp. 311–17.
2. See Vallier, *Rousseau* (1970), no. 48.
3. Vallier, ibid., publishes a photograph of Loti taken in 1904, as does Certigny (*Rousseau,* p. 247), who perversely insists, however, that it is unlike the painting (pp. 255–57).
4. Vallier, *Rousseau* (1970), no. 32.
5. See Vallier, *Rousseau* (1970), no. 72, and Certigny, *Rousseau,* pp. 140–41.
6. Vallier, *Rousseau* (1970), no. 224. This is one of Rousseau's few securely dated works.
7. See Certigny, *Rousseau,* pp. 255–57.
8. See Leroy C. Breunig, ed., *Apollinaire on Art: Essays and Reviews 1902–1918* (New York: Viking, 1972), p. 347.
9. See Shattuck, *The Banquet Years,* p. 39.
10. It is interesting to note the similarity between Rousseau's Loti portrait and Léger's famous representation of his ideal modern figure, *Le Mécanicien* of 1920 (National Gallery of Canada, Ottawa).

40 1. *Les Soirées de Paris,* Jan. 15, 1914. *Apollinaire on Art,* p. 340.
2. See John Elderfield, *The "Wild Beasts": Fauvism and Its Affinities* (New York: The Museum of Modern Art, 1976), pp. 43–

3. See Vallier, *Rousseau* (1970), nos. 112, 151, and Henri Certigny, *La Vérité sur le Douanier Rousseau: Addenda no. 2.—Le Conseil Municipal de Paris et Les Artistes Indépendants* (Paris: La Bibliothèque des Arts, 1971), pp. 85, 90, fig. 22.

4. Quoted by Daniel Catton Rich, *Henri Rousseau* (New York: The Museum of Modern Art, 1942), p. 47.

5. Société du Salon d'Automne, 3^e Exposition (Paris, 1905), no. 1365.

6. The Paris journal *L'Illustration* commented in its issue of Nov. 4, 1905, p. 294, that whereas Rousseau was not appreciated at the spring Salon des Indépendants, at the Salon d'Automne his picture was given a place of honor. The work was purchased by Vollard after Rousseau had proposed that the state buy it.

7. *Apollinaire on Art,* pp. 350–51.

8. Rich, *Rousseau,* p. 19.

9. Vallier, *Rousseau* (1970), no. J. 16.

10. See Shattuck, *The Banquet Years,* pp. 79–80.

2 1. Quoted in Thomas M. Messer, *Edvard Munch* (New York: Abrams, 1973), p. 52, in a discussion of this painting.

2. In 1892, however, this same street was the venue for one of Munch's most emotionally charged early works, *Evening on Karl Johan Street* (collection Rasmus Meyers, Bergen; illustrated in Messer, *Munch,* p. 71).

4 1. Quoted by Carola Giedion-Welcker, *Paul Klee* (New York: Viking, 1952), p. 108.

5 1. See Peter Selz, *Ferdinand Hodler* (Berkeley: University Art Museum, 1972), p. 56.

2. For a discussion of Hodler's concept of "Parallelism" see Selz, *Hodler,* passim, and for its implications for Hodler's draftsmanship Phyllis Hattis, "Ferdinand Hodler: Draftsman," in Selz, *Hodler,* pp. 99–106.

3. "Ferdinand Hodler on His Principles of Art and on Klimt" (1904), reprinted in Selz, *Hodler,* pp. 117–18.

4. Reprinted in Selz, *Hodler,* pp. 111–13, from which the quotations which follow are derived.

5. 1. "The Mission of the Artist" (1897), reprinted in Selz, *Hodler,* pp. 119–25.

1. See the exhibition catalog *Vallotton* (Paris: Musée National d'Art Moderne, 1966), no. 8. The picture is there dated to 1892. In a letter of Jan. 1893, however, Vallotton talks of his still working on the painting. See Gilbert Guisan and Doris Jakubec, eds., *Félix Vallotton: Documents pour une biographie et pour l'histoire d'une œuvre,* vol. 1, *1884–1899* (Paris: La Bibliothèque des Arts, 1973), p. 238.

2. See *Vallotton,* no. 8, and *Vallotton: Documents,* pp. 235–37, 267–68.

3. Rijksmuseum Kröller-Müller, Otterlo. See *Maurice Denis* (Paris: Orangerie des Tuileries, 1970), no. 46.

4. See above, p. 46, note 2.

52 1. For his extension of the bathing theme, however, see *Vallotton,* no. 14.

54 1. "Formulations on the Two Principles of Mental Functioning" (1911), *Freud: Standard Edition* (London: Hogarth Press), 1958, vol. 12, p. 224.

2. The cartoon is reproduced in Christian M. Nebehay, ed., *Gustav Klimt: Dokumentation* (Vienna: Galerie Christian M. Nebehay, 1969), p. 262.

56 1. Quoted in André Fermigier, *Pierre Bonnard* (New York: Abrams, n.d.), p. 13.

2. To Georges Besson, ca. 1943–44. Quoted by Stanislas Fumet, "Bonnard comme expression française de la peinture," *Formes et couleurs,* vol. 6, no. 2, 1944, pp. 13–26.

3. Quoted by Fermigier, *Bonnard,* p. 88.

4. "Les Besoins individuels et la peinture" (1935), quoted in John Rewald, *Pierre Bonnard* (New York: The Museum of Modern Art, 1948), p. 40.

58 1. Quoted by Rewald, *Bonnard,* p. 51.

2. Quoted by Charles Terrasse, *Bonnard* (Paris: Floury, 1927), pp. 127–30, and Rewald, *Bonnard,* p. 49.

3. Ibid.

4. Fermigier, *Bonnard,* p. 88.

60 1. Quoted by Fermigier, *Bonnard,* p. 154.

2. See Rewald, *Bonnard,* p. 48.

62 1. A. Lamotte, "Le Bouquet de roses: Propos de Pierre Bonnard, recueillis en 1943," *Verve,* vol. 5, nos. 17–18, 1947, pp. 73–75, an important statement of Bonnard's methods, quoted extensively in Rewald, *Bonnard,* p. 40.

2. Ibid. (For a description and discussion of Bonnard's working methods see Rewald, *Bonnard,* pp. 51–53.)

3. Ibid.

64 1. The essay is discussed in Rewald, *Impressionism,* pp. 376–78, and with reference to Vuillard in John Russell, *Edouard Vuillard* (Greenwich, Conn.: New York Graphic Society, 1971), pp. 17–18.

2. Thadée Natanson, "Vuillard as I Knew Him" (1948), in Russell, *Vuillard,* p. 109.

3. Quoted by Russell, *Vuillard,* p. 18.

4. For Vuillard's decorations, see especially James Dugdale, "Vuillard, the Decorator," *Apollo,* Feb. 1965 and Oct. 1967.

66 1. George Mauner, *Three Swiss Painters: Cuno Amiet, Giovanni Giacometti, Augusto Giacometti* (Pennsylvania State University Museum of Art, 1973), p. 10, a work to which this discussion is indebted.

2. *Über Kunst und Künstler* (Bern, 1948), p. 57, quoted by Mauner, *Three Swiss Painters,* p. 12.

3. Mauner, *Three Swiss Painters,* cat. no. 6.

4. *Uber Kunst und Künstler,* pp. 84–87, quoted by Mauner, *Three Swiss Painters,* p. 16.

68 1. Letter to E. Picard, June 15, 1894, cited in John Rewald, "Odilon Redon," in *Odilon Redon, Gustave Moreau, Rodolphe Bresdin* (New York: The Museum of Modern Art, 1962), p. 39.
2. Confidences d'artiste" (May 1909), in Redon's *A soi-même* (Paris: Floury, 1922), pp. 11–30.
3. Letter to A. Mellerio, Aug. 1898. *Lettres d'Odilon Redon* (Paris and Brussels: van Oest, 1923), pp. 33–34, extensively quoted in Rewald, "Redon," pp. 24–25.
4. See note 1 above.
5. See note 3 above.
6. See Rewald, "Redon," p. 44.
7. See note 2 above.

70 1. For comments on Rouault and Fauvism, from which the following is derived, see Elderfield, *Fauvism,* pp. 61–62.
2. *Gil Blas,* Oct. 17, 1905.
3. Matisse, "Notes of a Painter" (1908), reprinted in Jack D. Flam, *Matisse on Art* (London: Phaidon, 1973), p. 36.
4. According to Mr. Joseph Müller, as cited by Pierre Courthion, *Georges Rouault* (New York: Abrams, n.d.), p. 145 and p. 379, note 85, a work to which my discussion of this painting is indebted.
5. Courthion, *Rouault,* p. 145.
6. Ibid.
7. Statement to Jacques Guenne (1924), quoted by Courthion, *Rouault,* p. 145.
8. *Gil Blas,* Sept. 30, 1907, quoted by Courthion, *Rouault,* p. 145.

72 1. See Elderfield, *Fauvism,* pp. 51–56, from which this discussion is partly derived.
2. See Alfred H. Barr, Jr., *Matisse: His Art and His Public* (New York: The Museum of Modern Art, 1951), frontispiece.
3. See Barr, *Matisse,* p. 75.
4. See Barr, *Matisse,* p. 320.
5. Flam, *Matisse on Art,* p. 37.

74 1. "Matisse Speaks to His Students, 1908: Notes by Sarah Stein," in Barr, *Matisse,* p. 552.
2. Barr, *Matisse,* p. 345.
3. "Notes of a Painter" (1908), Flam, *Matisse on Art,* p. 38.
4. See Elderfield, *Fauvism,* pp. 97 ff.
5. "Conversation with Louis Aragon" (1943), Flam, *Matisse on Art,* p. 94.
6. "Testimonial" (1951), Flam, *Matisse on Art,* p. 137

76 1. See Barr, *Matisse,* p. 242.
2. For the others in the group, see *Henri Matisse: Exposition du Centenaire* (Paris: Grand Palais, 1970), cat. nos. 219 B–D.
3. For example, the bronze *Seated Nude* of 1923–25 and the paintings *Nude on a Blue Cushion,* 1924, and *Seated Nude with Tambourine,* 1926 (respectively, *Henri Matisse,* cat. nos. 241, 170, 175).

4. Barr, *Matisse,* pp. 336–37, 320.
5. "Notes of a Painter on His Drawing" (1939), Flam, *Matisse on Art,* p. 82.
6. "Jazz" (1947), Flam, *Matisse on Art,* p. 112.
7. See William Tucker, "Four Sculptors, Part 3: Matisse," *Studio International,* Sept. 1970, pp. 82–87, for more detailed comparison of Matisse's sculptures and découpages, to which my remarks ar indebted.
8. Barr, *Matisse,* p. 367.
9. "Testimonial" (1951), Flam, *Matisse on Art,* pp. 136–37, from which the quotations which follow also derive.

78 1. See Christian Zervos, *Pablo Picasso* (Paris: Cahiers d'Ar 1932–), vol. 1, no. 360, and Pierre Daix and Georges Boudaille *Picasso, the Blue and Rose Periods: A Catalogue Raisonné of th Paintings, 1900–1906* (Greenwich, Conn: New York Graphic Soc ety, 1967), no. XVI.13. The most recent scholarly study of this wo appears in Franz Meyer et al., *Picasso aus dem Museum of Moder Art, New York, und Schweizer Sammlungen* (Basel: Kunstm seum, 1976), pp. 24–26.
2. Cf. Zervos, vol. 1, nos. 361, 366, and Daix and Boudaille, no XVI.14–15.
3. Daix and Boudaille, no. XV.11.
4. Daix and Boudaille, no. XVI.12.
5. Zervos, vol. 1, no. 384; Daix and Boudaille, no. XV.62.

80 1. Zervos, vol. 2, part 1, no. 134. For discussion of the relati of this to contemporary works by Picasso, see Christian Geelha "Pablo Picassos Stilleben *Pains et compotier aux fruits sur u table:* Metamorphosen einer Bildidee," *Pantheon,* no. 28, 1970, 127–40, and Meyer et al., *Picasso,* pp. 38–40, both of which a discuss its derivation from Picasso's figure composition *Carna au bistrot* (Zervos, vol. 2, part 1, no. 62), a work itself influenced Cézanne's Cardplayers compositions.
2. See William Rubin's discussion of these two aspects of Céz nism in his *Picasso in the Collection of The Museum of Modern* (New York: The Museum of Modern Art, 1972), p. 48.

82 1. Zervos, vol. 2, part 2, no. 362. See Meyer et al., p. 54, for most recent discussion of this work.
2. See Meyer's discussion of the contemporaneous *The Poet* an even more striking use of the same device (Meyer et al., p. 5

84 1. See Meyer et al., p. 56.
2. Thanks go to my colleague Carolyn Lanchner for suggest that the stenciled letters be deciphered in this way.
3. Rubin, *Picasso,* p. 72.

86 1. See Reff, "Harlequins, Saltimbanques . . ." (above, p. note 5) for an important discussion of this theme.
2. See Meyer et al., pp. 94–96, for discussion of this wor relation to other Salvado-Harlequin portraits of 1923.

88 1. Quoted in K. E. Maison, *Art Themes and Variations* (York: Abrams, n.d.), p. 22.

2. For the other copies, as mentioned below, see Jean Sutherland Boggs, ''The Last Thirty Years,'' in Roland Penrose and John Golding, eds., *Picasso in Retrospect* (New York: Praeger, 1973), pp. 197–240. See also the discussion of this work in Meyer et al., pp. 148–52.

3. The description is Leo Steinberg's. See his ''Picasso's Sleepwatchers,'' in his *Other Criteria: Confrontations with Twentieth-Century Art* (New York: Oxford University Press, 1972), pp. 93–114.

4. *Minotaur and Woman Asleep,* June 18, 1933. Illustrated in Steinberg, p. 100.

5. See Steinberg, p. 101.

6. See Rubin, *Picasso,* pp. 138–40.

90 1. See Meyer et al., pp. 176–78, on this painting, and pp. 172–76 for associated works. Also: Boggs, ''The Last Thirty Years'' (above, p. 88, note 2), and for the artist-and-model theme, Michel Leiris, ''The Artist and His Model,'' in Penrose and Golding, pp. 243–62.

2. Cf. Roland Penrose, *The Sculpture of Picasso* (New York: The Museum of Modern Art, 1967), pp. 190–91.

3. E.g., *The Painter at Work,* 1964 (Penrose and Golding, p. 236). This image, of course, goes back to Picasso's early works.

4. See Boggs, pp. 235–36.

92 1. See John Golding, *Cubism: A History and an Analysis, 1907–1914,* 2nd ed. (New York: Harper & Row, 1968), pp. 66–68. For details of other L'Estaque paintings see *G. Braque* (Edinburgh: The Royal Scottish Academy, 1956), cat. no. 13.

2. See Elderfield, *Fauvism,* p. 131.

3. *Gil Blas,* Nov. 14, 1908.

4. For this same effect in Picasso's work see Rubin, *Picasso,* p. 48, and above, p. 80.

5. Even at the height of his Fauve period Braque was already affected by Cézannist techniques. See Elderfield, *Fauvism,* pp. 84, 124.

6. See Elderfield, *Fauvism,* p. 124.

7. See the photograph by Kahnweiler of the motif of this work in Rubin, *Picasso,* p. 202.

94 1. For this characteristic in Analytic Cubist paintings see Rubin, *Picasso,* p. 68.

2. ''Braque—la peinture et nous: Propos de l'artiste recuellis par Dora Vallier,'' *Cahiers d'art,* Oct. 1954, pp. 15–16.

3. See Golding, *Cubism,* pp. 81–82.

4. Quoted in *G. Braque* (Edinburgh, 1956), p. 31.

96 1. See Angelica Z. Rudenstine, *The Guggenheim Museum Collection: Paintings 1880–1945* (New York: The Solomon R. Guggenheim Museum, 1976), vol. 1, pp. 43–46, for discussion of the group of works. Rudenstine suggests, however, that the Basel painting was the earliest and sees a progressive flattening and integration of forms through the other works. My belief that the Basel painting was probably the last depends upon its increased freedom from local coloring, its highly refined variations in depth,

and on the fact that the trompe-l'oeil nail does not have a functional purpose but a purely pictorial one (in the Guggenheim Museum's *Violin and Palette* the nail supports the palette hanging on the wall). It is, of course, by no means impossible that the paintings were worked on concurrently.

2. ''La Peinture et nous,'' p. 16.

3. See Robert Rosenblum's fine analysis of this painting in his *Cubism and Twentieth-Century Art* (New York: Abrams, 1960), pp. 57–58, to which this discussion is indebted.

4. ''La Peinture et nous,'' p. 16.

98 1. See *G. Braque* (Edinburgh, 1956), pp. 32–34, for discussion of the group.

2. See Elderfield, *Fauvism,* p. 83.

3. See *G. Braque* (Edinburgh, 1956), p. 32.

4. Quoted in *G. Braque* (Edinburgh, 1956), p. 31.

5. Hand-drawn lettering, however, had appeared in Braque's *The Match Holder* of 1910. See Henry R. Hope, *Georges Braque* (New York: The Museum of Modern Art, 1949), pp. 48, 52–53.

6. Quoted in *G. Braque* (Edinburgh, 1956), p. 33.

7. The best discussion of the pictorial implications of the Cubists' use of typographical elements—to which these comments are indebted—appears in Clement Greenberg, ''Collage,'' *Art and Culture* (Boston: Beacon Press, 1961), pp. 70–83.

8. See note 6 above.

100 1. For comparable works see *Juan Gris* (Paris: Orangerie des Tuileries, 1974), cat. nos. 77, 78, 81, 143, 144.

2. Quoted by Golding, *Cubism,* p, 115.

102 1. *Méditations esthétiques: Les Peintres cubistes* (Paris: Figuère, 1913), p. 76.

2. See John Golding and Christopher Green, *Léger and Purist Paris* (London: The Tate Gallery, 1970), p. 92.

3. *Du Cubisme à l'art abstrait,* edited by Pierre Francastel, with an oeuvre catalog by Guy Habasque (Paris: S.E.V.P.E.N., 1957), p. 129.

4. Ibid., p. 126. For detailed discussion of this painting, see Franz Meyer, ''Robert Delaunay, *Hommage à Blériot,* 1914,'' *Jahresberichte der Offentlichen Kunstsammlungen,* 1962, pp. 67–78.

5. See Elderfield, *Fauvism,* pp. 35, 40.

6. Habasque, cat. no. 125.

7. Habasque, cat. no. 123.

8. Habasque, cat. nos. 138, 139.

9. Habasque, p. 155.

10. For a discussion of Delaunay's color theories in relation to Chevreul's see Gustav Vriesen and Max Imdahl, *Robert Delaunay: Light and Color* (New York: Abrams, 1967), pp. 44–46, 79 ff.

11. *Apollinaire on Art,* p. 358.

12. Ibid, p. 504.

13. For details of the whole controversy see *Apollinaire on Art,* pp. xxvi, 503–6.

104 1. This and the following discussion of work by Léger are in part derived from the author's ''Epic Cubism and the Manufactured

Object," *Artforum,* Apr. 1972, pp. 54–63.
2. Quoted in *Léger* (Paris: Musée des Arts Décoratifs, 1956), p. 78.
3. See Golding, *Cubism,* pp. 153–54.
4. See Rudenstine, *The Guggenheim Museum Collection,* vol. 2, pp. 452–54 for discussion of the chronology of the works mentioned here.

106 1. Christopher Green, "Fernand Léger and the Parisian 'Avant-garde,' 1909–1921" (Ph.D. dissertation, Courtauld Institute of Art, University of London, 1973). Cited by Rudenstine, *The Guggenheim Museum Collection,* vol. 2, pp. 461–64, where the Contrast of Forms series is discussed.
2. Green, pp. 96–101. Cited by Rudenstine, vol. 2, p. 464.

108 1. Collection Rijksmuseum Kröller-Müller, Otterlo.
2. Quoted in Katharine Kuh, *Léger* (Chicago: The Art Institute of Chicago, 1953), p. 22.
3. Ibid., p. 23.

110 1. Discussion of these contacts is best found in John Golding and Christopher Green, *Léger and Purist Paris* (London: The Tate Gallery, 1970).
2. See below, p. 114.
3. *Bulletin de l'effort moderne,* nos. 1 and 2, Jan. and Feb. 1924. Reprinted in Golding and Green, pp. 87–92.

112 1. For the Futurists' relation to Cubism see Marianne W. Martin, *Futurist Art and Theory, 1909–1915* (Oxford: Clarendon Press, 1968), pp. 104–19, to which this discussion is indebted.
2. See Martin, *Futurist Art and Theory,* pp. 105–8. Martin believes this painting may have been begun before the Paris trip (p. 111).
3. Preface to the catalog of the Feb. 1912 Futurist exhibition at Bernheim-Jeune Gallery, Paris. Quoted in Joshua C. Taylor, *Futurism* (New York: The Museum of Modern Art, 1961), p. 127.
4. Ibid.
5. Ibid.
6. This painting is best deciphered with reference to a drawing of 1911, illustrated by Martin, *Futurist Art and Theory,* plate 79, and discussed there, p. 112. A description of a streetcar ride remarkably similar in atmosphere to this painting appears in "Futurist Painting: Technical Manifesto," Apr. 1910. See Taylor, *Futurism,* p. 126.
7. The concept was first expressed in the Bernheim-Jeune catalog preface. See Taylor, *Futurism,* p. 128.
8. Ibid.
9. "Manifesto of the Futurist Painters," Feb. 1910. Quoted in Umbro Apollonio, ed., *Futurist Manifestos* (New York: Viking, 1973), p. 25.

114 1. The precise date of their first meeting is still in some doubt. See Golding and Green, pp. 16 and 23, note 15.
2. Ozenfant and Jeanneret, *La Peinture moderne* (Paris, 1926), as quoted by Reyner Banham, *Theory and Design in the First Machine Age,* 2nd ed. (New York: Praeger, 1967), p. 211, in a useful discussion of Purist ideas.
3. Ibid.

4. See Golding and Green, p. 49.
5. See Banham, pp. 212–13 and ff., for the relationship of Le Corbusier's architecture to Purist ideas.

116 1. Chagall, *Ma Vie* (Paris: Stock, 1931), p. 153.
2. Franz Meyer, *Marc Chagall* (New York: Abrams, n.d.), p. 122.
3. Ibid., pp. 123, 138, cat. no. 74.
4. Ibid., p. 120.
5. Ibid., p. 150.
6. Chagall, *Ma Vie,* p. 154.
7. Meyer, *Chagall,* p. 162.
8. Ibid., p. 145.
9. *Apollinaire on Art,* p. 214. Chagall refers to the incident in *Ma Vie,* p. 162.

118 1. Chagall, *Ma Vie,* p. 174.
2. Fanina W. Halle, "Marc Chagall," *Das Kunstblatt,* no. 6, 1922, p. 510. Quoted by Meyer, *Chagall,* p. 217, whose account of the Jew paintings (pp. 221–22) is the principal source for this and the following two commentaries.
3. Quoted by Meyer, *Chagall,* p. 219.

120 1. Chagall, *Ma Vie,* p. 175.
2. Quoted by Meyer, *Chagall,* p. 221.
3. Ibid., p. 222.

122 1. According to Meyer (*Chagall,* p. 221), the names of Pollaiuolo, Signorelli, and others originally appeared but were erased.

124 1. *Concerning the Spiritual in Art,* 1912 (New York: Wittenborn, 1947), p. 77.
2. See W. Kandinsky, *Kandinsky 1901–1913* (Berlin: Der Sturm, 1913), p. xiii. For details of the others in the series, see Sixten Ringbom, *The Sounding Cosmos: A Study in the Spiritualism of Kandinsky and the Genesis of Abstract Painting* (Åbo: Åbo Akademi, 1970), pp. 150–51.
3. W. Kandinsky and F. Marc, eds., *The Blaue Reiter Almanac,* 1912 (New York: Viking, 1974), p. 166.
4. Kandinsky, 1918. Quoted by Rudenstine, *The Guggenheim Museum Collection,* vol. 1, p. 230.
5. See Ringbom, *The Sounding Cosmos,* p. 151.
6. See note 1 above and Ringbom, *The Sounding Cosmos,* p. 4.
7. See Ringbom, *The Sounding Cosmos,* pp. 150–51.
8. *Kandinsky 1901–1913,* p. xxxviii. See Rudenstine, *The Guggenheim Museum Collection,* vol. 1, pp. 230–31, on this point.
9. According to Will Grohmann, *Wassily Kandinsky: Life and Work* (New York: Abrams, n.d.), p. 119.
10. Grohmann, *Kandinsky,* cat. nos. 47, 664.
11. Ibid., cat. nos. 610, 623.
12. Ibid., cat. nos. 666, 667, Ringbom, *The Sounding Cosmos,* 72.
13. The next stage of abstraction of this figure is seen in Ringbom, *The Sounding Cosmos,* figs. 71, 72.
14. Various other elements in *Composition V* may be deciphered

by looking for transposed images from *All Saints,* 1911. Such transpositions were not at all unusual in Kandinsky's work of this period; see Ringbom, *The Sounding Cosmos,* figs. 71, 72, and p. 155, for discussion of the manipulation of images from work to work.

15. For elements of Kandinsky's Last Judgment imagery see Ringbom, *The Sounding Cosmos,* pp. 162–64.

16. *The Blaue Reiter Almanach,* p. 58.

7. See Ringbom, *The Sounding Cosmos,* p. 157.

8. *Concerning the Spiritual in Art,* pp. 29–30.

9. Ibid., p. 31.

26 1. See Mauner, *Three Swiss Painters,* p. 121, a work to which his discussion is indebted.

Ibid., cat. nos. 122, 123.

Die Farbe und ich (Zurich, 1934), pp. 18–29, quoted in Mauner, *Three Swiss Painters,* pp. 123–24.

Ibid.

28 1. See Edith Hoffmann, *Kokoschka—Life and Work* (London: Faber & Faber, 1947), cat. no. 26, and Hans Maria Wingler, *Oskar Kokoschka* (Salzburg: Galerie Welz, 1958), cat. no. 30.

0 1. See A. Ceroni, *I Dipinti di Modigliani* (Milan: Rizzoli, 1970), nos. 269–72. For the problems involved in the dating of Modigliani's oeuvre, see F. Russoli, "Modigliani e la critica," *La Biennale Venezia,* no. 33, Oct.–Nov. 1958, pp. 7–15.

2 1. This point was made by Robert Goldwater, *Primitivism in Modern Art,* rev. ed. (New York: Vintage Books, 1967), pp. 236–38.

See Ceroni, *Modigliani,* p. 85.

4 1. *Flight Out of Time: A Dada Diary* (New York: Viking, 1974), 53.

Arp on Arp: Poems, Essays, Memories (New York: Viking, 72), p. 139.

"Looking" (1958), in James Thrall Soby, *Arp* (New York: The Museum of Modern Art, 1958), p. 12.

"Arpadian Encyclopedia" (1957), in *Arp on Arp,* pp. 355–58.

Arp on Arp, p. 357.

Ibid., p. 238.

1. Michel Seuphor, *Piet Mondrian: Life and Work* (New York: Abrams, n.d.), p. 98.

See Robert P. Welsh, *Piet Mondrian, 1872–1944* (Toronto: The Gallery of Toronto, 1966), cat. no. 1.

See Seuphor, cat. nos. 169–200, for Mondrian's tree paintings, 8–13.

See Welsh, cat. no. 66.

Seuphor dates the group to 1912 or ca. 1912 (cat. nos. 193 ff.). Welsh suggests ca. early 1913 (conversation with the author; see his cat. nos. 68, 69). Joop Joosten suggests mid-1913 ("Mondrian: Between Cubism and Abstraction," in *Piet Mondrian, 1872–* [New York: The Solomon R. Guggenheim Museum, 1971], p.

138 1. See Welsh, pp. 192–94, for discussion of these basic compositional forms.

2. See Welsh, p. 192.

3. For *Composition B* see Seuphor, cat. no. 376.

4. "The Rationality of Neoplasticism," *De Stijl,* vol. 1, no. 5, 1917–18, pp. 49–54. Reprinted in Hans L. C. Jaffé, *De Stijl* (London: Thames & Hudson, 1970), pp. 61–62.

5. "Neoplasticism as Style," *De Stijl,* vol. 1, no. 2, 1917–18, pp. 13–18. Jaffé, p. 49.

6. "The New Plastic as 'Abstract-Real Painting': The Plastic Means and Composition," *De Stijl,* vol. 1, no. 3, 1917–18, pp. 29–31. Jaffé, p. 55.

140 1. *Arp on Arp,* p. 271.

2. Ibid.

3. Ibid, p. 223. The artist's full title for the work is very precise as to its components: *Relief rectangulaire, cercles découpés, carrés peints et découpés, cubes et cylindres surgissants; polychrome, fond vert foncé.*

142 1. Klee, Lecture to the Jena Kunstverein, 1924. Quoted in Will Grohmann, *Paul Klee* (New York: Abrams, [1954]), pp. 184–89, 365–67, from which the further quotations in this paragraph also derive.

2. Grohmann, *Klee* [1954], p. 369, quoting Klee's *Pädagogisches Skizzenbuch* (1925).

3. Clement Greenberg, "On the Role of Nature in Modernist Painting," *Art and Culture,* p. 173.

4. Klee visited Delaunay's studio in Paris on Apr. 11, 1912, but did not record what he saw there. It is often reported that he saw Delaunay's *Windows* paintings—and may indeed have done so—but there is no evidence that he saw them before July of 1912, when two were shown at the Moderner Bund in Zurich and Klee wrote an enthusiastic review in *Die Alpen,* Aug. 1912.

144 1. Cf. Banham, *Theory and Design,* pp. 284, 295, 299.

2. See note 1 to p. 142 above.

3. Illustrated in Will Grohmann, *Paul Klee* (New York: Abrams, The Library of Great Painters [1967]), fig. 61.

4. Klee's apartment is briefly described in Grohmann, *Klee* [1954], p. 68.

146 1. "Creative Credo" (1918), from *Schöpferische Konfession* (1920), quoted in Grohmann, *Klee* [1954], pp. 97–98, 162, 181, from which the further quotations in this commentary also derive.

2. Grohmann, *Klee* [1954], p. 267.

148 1. Illustrated in Grohmann, *Klee* [1954], p. 33.

2. For discussion of these works see Grohmann, Klee [1954], pp. 350, 357.

3. For this and the following quotations in this commentary, see note 1 to p. 146 above.

150 1. For details of the entire group, see Grohmann, *Klee* [1954], pp. 334 ff.

2. Ibid., p. 82.

3. See note 1 to p. 146 above.

4. See Andrew Kagan, "Paul Klee's Influence on American Painting, Part II," *Arts Magazine,* Sept. 1975, pp. 84–90, to which the above is indebted.

5. Grohmann, *Klee* [1954], p. 68.

152 1. Grohmann, *Klee* [1954], p. 268.

2. See note 1 to p. 146 above.

3. See note 4 to p. 142 above.

4. See note 1 to p. 142 above.

154 1. For other 1920 still lifes see Jacques Dupin, *Joan Miró: Life and Work* (New York: Abrams, n.d.), cat. nos. 69, 70. For Miró's immediately subsequent development see William Rubin's discussion of Miró's *Table with Glove* (1921) in his *Miró in the Collection of The Museum of Modern Art* (New York: The Museum of Modern Art, 1973), p. 16.

2. Letter to Roland Tual, July 31, 1922. Quoted in Rubin, *Miró,* p. 19.

3. Dupin, *Miró,* cat. no. 76.

156 1. See Dupin, *Miró,* cat. nos. 201–13.

2. Rosalind Krauss and Margit Rowell, *Joan Miró: Magnetic Fields* (New York: The Solomon R. Guggenheim Museum, 1972), p. 124.

3. J. J. Sweeney, "Joan Miró: Comment and Interview," *Partisan Review,* Feb. 1948, p. 208.

4. See Dupin, *Miró,* pp. 168, 173.

5. The sexual imagery in Miró's work is extensively discussed in Rubin, *Miró,* and Krauss and Rowell, *Magnetic Fields.*

158 1. This point is frequently made about Soutine's art, but its implications have never been better expressed than in Clement Greenberg's "Soutine," in his *Art and Culture,* pp. 115–19, to which this commentary is indebted.

160 1. See Robin Campbell, "Alberto Giacometti: A Personal Reminiscence," *Studio International,* no. 2, 1966, p. 47.

2. François Stahly, "Der Bildhauer Alberto Giacometti," *Werk,* June 1950, pp. 181–85. Cited in Reinhold Hohl, *Alberto Giacometti* (New York: Abrams, 1972), pp. 274–75.

3. Quoted by David Sylvester, "The Residue of a Vision," in *Giacometti* (London: The Tate Gallery, 1965), and in Hohl, *Giacometti,* p. 276.

4. Cited in Hohl, *Giacometti,* p. 276.

5. See note 2 above.

6. This point is most aptly made by Hohl in *Giacometti,* p. 170, and in his *Alberto Giacometti* (New York: The Solomon R. Guggenheim Museum, 1974), p. 36.

162 1. For the Macadam series as a whole, see: Michel Tapié, *Mirobolus, Macadam & Cie: Hautespâtes de J. Dubuffet* (Paris: Drouin, 1946); Max Loreau, *Catalogue des travaux de Jean Dubuffet, fascicule II: Mirobolus, Macadam et Cie* (Paris: Pauvert, 1966); Max Loreau, *Jean Dubuffet* (Paris: Weber, 1971), pp. 35–46.

2. J. Dubuffet, *Prospectus et tous écrits suivants* (Paris: Gallimard, 1967), vol. 1, p. 74, cited by Margit Rowell, *Jean Dubuffet* (New York: The Solomon R. Guggenheim Museum, 1973), p. 24.

3. Dubuffet, *Prospectus,* vol. 1, pp. 167–68, cited by Rowell, *Dubuffet,* p. 20.

4. See Rowell, *Dubuffet,* pp. 17–20, for a revealing discussion of the importance of Prinzhorn to Dubuffet.

Photography Credits Photographs not acknowledged below were supplied by the owners or custodians of the reproduced works, who are cited in the captions. Kunstmuseum, Basel: 21, 41, 85, 87, 97, 105, 109, 127, 161; Kunstmuseum, Bern: 95, 115, 135, 141, 143, 145, 147, 149, 153; Galerie Beyeler, Basel: 77, 137; Gad Borel-Boissonas, Geneva: 157; Klaus Burkard, Winterthur: 101, 139; Cosmopress, Geneva: 93, 111, 151; Walter Drayer, Zurich: 29, 31, 33, 35, 39, 43, 45, 47, 51, 59, 61, 65, 71, 75, 79, 125, 127, 133, 155, 161, 163; Foto Heri, Solothurn: 55; Colorphoto Hans Hinz, Basel: 81, 89, 99, 103, 113, 117, 119, 123, 159; Fotoatelier Gerhard Howald, Bern: 63, 69, 131; H. Humm, Zurich: 57; Galerie Rosengart, Lucerne: 91, 107; Schweizerisches Institut für Kunstwissenschaft, Zurich: 49, 53, 67; Michael Speich, Winterthur: 27; Kunstverein, Winterthur: 23, 37, 129